CHARLES C. ELDREDGE

W9-AQA-649

BOOKS BY JAMES THOMAS FLEXNER

DOCTORS ON HORSEBACK
(*Dover reprint*)

AMERICA'S OLD MASTERS
(*Dover reprint*)

WILLIAM HENRY WELCH
AND THE HEROIC AGE OF AMERICAN MEDICINE
with Simon Flexner (*Dover reprint*)

STEAMBOATS COME TRUE

FIRST FLOWERS OF OUR WILDERNESS:
AMERICAN PAINTING, THE COLONIAL PERIOD
(*Dover reprint*)

JOHN SINGLETON COPLEY

THE POCKET HISTORY OF AMERICAN PAINTING

THE TRAITOR AND THE SPY:
BENEDICT ARNOLD AND JOHN ANDRÉ

THE LIGHT OF DISTANT SKIES:
AMERICAN PAINTING, 1760–1835

GILBERT STUART

MOHAWK BARONET:
SIR WILLIAM JOHNSON OF NEW YORK

THAT WILDER IMAGE:
THE NATIVE SCHOOL OF AMERICAN PAINTING
FROM THOMAS COLE TO WINSLOW HOMER

GEORGE WASHINGTON:
THE FORGE OF EXPERIENCE, 1732–1775

THE WORLD OF WINSLOW HOMER
with the editors of Time

GEORGE WASHINGTON:
IN THE AMERICAN REVOLUTION, 1775–1783

The biographies of Copley and Stuart were based
on the shorter accounts contained in *America's Old Masters*

The Light of Distant Skies

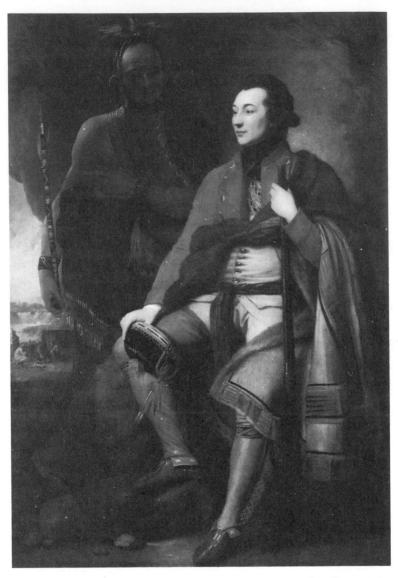

BENJAMIN WEST: Colonel Guy Johnson (*Courtesy National Gallery of Art, Mellon Collection*)

The Light
of Distant Skies

AMERICAN PAINTING

1760-1835

by James Thomas Flexner

DOVER PUBLICATIONS, INC.

NEW YORK

TO HELEN THOMAS FLEXNER

COPYRIGHT © 1954, 1969 BY JAMES THOMAS FLEXNER.
All rights reserved under
Pan American and International Copyright Conventions.

Published in Canada by General Publishing Company, Ltd.,
30 Lesmill Road, Don Mills, Toronto, Ontario.
Published in the United Kingdom by Constable and Company,
Ltd., 10 Orange Street, London W C 2.

This Dover edition, first published in 1969, is an unabridged republication, with minor corrections, of the work originally published in 1954 by Harcourt, Brace and Company.
This edition contains a new Preface by the author and a new Publisher's Note. The Catalogue of Illustrations has been updated to reflect changes in ownership since 1954, and the illustrations have been rearranged for readier reference.

Standard Book Number: 486-22179-2
Library of Congress Catalog Card Number: 68-54073
Manufactured in the United States of America
DOVER PUBLICATIONS, INC.
180 Varick Street, New York, N. Y. 10014

PUBLISHER'S NOTE

SECTIONS of *The Light of Distant Skies: American Paint-ing, 1760–1835* were delivered in 1952 as a series of Lowell Lectures. The book was prepared with the assistance of a Guggenheim Fellowship. Before publication, chapters appeared in *The World of History: Great Historical Writing*, New American Library, 1954; *Antiques;* and *The Pennsylvania Magazine of History and Biography*.

The Light of Distant Skies was selected by the American Bookseller's Association as one of the 200 "best and most important titles published in the United States" during the four-year period 1953–1957. It was chosen by the Carnegie Corporation for distribution to libraries in the Commonwealth countries, and was also included in the famous "White House List" during the administration of President John F. Kennedy.

Although complete in itself, *The Light of Distant Skies* is the second in Mr. Flexner's three-volume history of American painting as an expression of American life. The beginning volume, *First Flowers of Our Wilderness: American Painting, The Colonial Period*, was written under a Library of Congress Grant-in-Aid for Studies in the History of American Civilization and published in 1947 by Houghton Mifflin Co., who awarded it their Life-in-America Prize. The third volume, *That Wilder Image: The Native School of American Painting from Thomas Cole to Winslow Homer*, was published in 1962 by Little, Brown and Company, and received from the Society of American Historians its Parkman Prize for history written as literature.

In this reprint the same illustrations have been used as in the original edition, but they have been distributed throughout the text for readier reference, and, in many cases enlarged. The publishers have updated some notations of ownership in the Catalogue of Illustrations.

PREFACE
TO THE DOVER EDITION

TODAY, when interest in the history of American culture is an ever-augmenting blaze, my early books on the subject are reappearing to warm themselves at a fire which, in a more chilly environment, they had helped to kindle. As each volume approaches renewed publication, I have felt it incumbent upon me to read again what I once wrote and confide to contemoprary readers, in a new preface, my present reaction to the old volume.

The Light of Distant Skies deals to a considerable extent with the lives and works of artists who were subjects of interest to their contemporaries, and concerns a period when publications on art were beginning to become voluminous. I was thus faced during the preparation of this book with no such dearth of sources as had made hazardous my previous volume on American Colonial painting. My job here was not so much to cut new trails, as to work beside by colleagues in clearing away the second growth which had obscured old roads during many decades of neglect. And then, of course, there was the need to look at the view from the hilltops that were reached, trying to temper the judgments of the artists' contemporaries with that hindsight which is the peculiar possession of the historian.

The only large error in *The Light of Distant Skies* that I am conscious of has been righted in this edition. Hand in hand with my colleagues, I accepted *The Deluge* as one of

Washington Allston's most important works. That we were all wrong has been demonstrated by the owner of the canvas, the Metropolitan Museum. As these pages now acknowledge, *The Deluge* was painted by Joshua Shaw.

Rereading has shown me nothing else—except an occasional slip or misprint—that I have wished to change. *The Light of Distant Skies* seems to me as sound today as when I first trusted it to find its own way through the world's labyrinthine alleys, including the dark ones where rival scholars lurk with brickbats.

<div style="text-align: right">J. T. F.</div>

New York City
May, 1968

CONTENTS

ILLUSTRATIONS

xiii

The Light of Distant Skies

CHAPTER ONE

The Toga of Benjamin West

T HE Quaker-bred American painter, Benjamin West, walked the streets of London, shopping for a sword. It was a nervous mission, since he had no real basis for deciding exactly what kind of sword to buy, and he felt that it would be disastrous if he appeared before George III dangling a socially incorrect weapon. As West's equally provincial pupil, Charles Willson Peale, explained, the painter considered it essential that he seem "to belong to the higher orders of society" when he answered a royal command to bring his canvas, *Agrippina with the Ashes of Germanicus* (Pl. 2) to the palace.

West was right to be nervous about the interview, more right than he realized. When in 1768 he finally ushered his tremendous picture into George III's presence, a catastrophe seemed imminent, since the artist, the painting, and the monarch were, on the surface at least, completely out of place in each other's company.

Educated in distant America, West had only a bowing acquaintance with the classics, yet *Agrippina* was a scholarly reconstruction of classic times, composed like an ancient sculptured low relief. Its message was one that should annoy

any monarch. A confirmed republican, who regarded aristo-
cratic thinking as "artful, systemising policy" that "clouded
and dulled the human mind," West had painted a bourgeois
homily. Agrippina was shown carrying through the streets the
ashes of her husband, a popular hero who had been murdered
by a tyrant's minion; the populace is expressing the indigna-
tion that finally led to the suicide of the evil minister. Ac-
companied by dejected children, her face bleak with mourn-
ing, she exemplified not the flashing beauty of upper-class
ideals, but the sentimental piety beloved by the middle
classes. However, the eyes that now studied the picture be-
longed to that top of the British aristocratic arch, the King;
indeed, to the very King who was making the last effort in
British history to restore the autocratic power of the crown.

Yet when George III walked out of the room, he was not
departing in anger, but was on his way to summon the Queen,
so that she too might admire the masterpiece. That afternoon
began one of the closest friendships in history between a mon-
arch and a painter, a friendship that was to have a major in-
fluence not only on the art of America, but on the painting
of the entire Western world.

That such seemingly disparate elements formed a stable
compound was not the result of chance, but reflected the
inconsistencies of thought and action forced on all men by
a time of rapid social change. For centuries the middle classes
had been rising in power at the expense of the aristocrats;
trade had wrestled for economic and political dominance with
the ownership of land. Now the moment had come when the
balance of power was ready to shift. Already clouds of revo-
lution were gathering over America, presaging a storm that
was to rage in Europe for a full century. When the skies

cleared at last, the sun shone on a new world. Almost everywhere the middle classes were in control, and their power was menaced not by the vanquished aristocracy, but by a new enemy they had created with their own hands, by those disinherited slaves of the machine, the proletariat.

The spirit of a time is larger than any philosophy of party; every man shares to some extent the ideas of every other. Since eighteenth-century England was already well on the road to change, no Englishman could be altogether conservative or completely liberal; no pattern of behavior was so rigid that it was not modified by its opposite. The radical painter and the autocratic King had much in common.

Indeed, West had been dreaming of a royal interview when, a poor boy dressed in ragged homespun, he had jogged down a Pennsylvania lane on the same horse with a playmate. His companion announced proudly that he was going to be a tailor, and argued that this was a better profession than painting. But West, who had read European books on art, replied, "A painter is a companion of kings and emperors."

His playmate laughed. "You are surely mad; there are neither kings nor emperors in America."

"There are plenty in other parts of the world," replied West. He leaped off the horse. "You may ride alone. I will not ride with one willing to be a tailor!"

The son of a tinsmith turned innkeeper, West * had started to draw as a child, striking wonder into the hearts of his rural Quaker neighbors. He was called to the frontier city of Lancaster and then to Philadelphia, where, although still in his teens, he became a leading portraitist. The local connoisseurs

* The birth and death dates of all American artists mentioned will be found in Bibliographies Arranged by Artists, pp. 257-269.

took up a subscription to send the young man, whom they regarded as a genius, abroad for study. This was a radical move. Although painting had flourished in British America for a century, West was the first important American painter to cross the ocean to the art galleries of the Old World.

The instant West reached Rome, he created a sensation. To the aesthetes who haunted the city of long-dead monuments that remained the artistic capital of the world, the American seemed the personification of a philosophical principle. The old medieval conception that the human race, the unfortunate result of original sin, was naturally bad had suited aristocratic prejudices since it gave sanction for the suppression of the individual. But the rising middle class, self-made and jubilant at the new opportunities opening up to them, insisted that men were born angels but corrupted by evil institutions forced on them by kings. It followed that an individual who had never known social restraints would be perfect. Philosophers began discussing the "Noble Savage," but no one had seen him.

Silhouetted against the falling masonry and mossy columns of Rome, the Quaker artist from America seemed an exotic vision. The Roman aesthetes did not know or care that Philadelphia was a great city full of luxury; they were more interested to learn that West had talked with Indians. Word went down the broad boulevards that the Noble Savage himself had come from wild America to study civilization's greatest artistic remains.

Everyone wanted to be present when the savage met culture face to face. A cavalcade of carriages, each crowded with connoisseurs, accompanied West to the Vatican. They watched as he was suddenly confronted with the *Apollo*

Belvedere. "My God," cried West, "how like a Mohawk warrior!" The connoisseurs were delighted, for his remark had tied together the old and the new, identified the ancient Rome they loved with the innocence they longed for.

West's own need was for a similar synthesis, for he had brought with him from America basic conceptions that he now discovered were contradictory. Educated by that extreme leveling sect, the Friends, he had been imbued with a middle-class philosophy in all things. He believed that a hero was made not by birth but by character, and that only republican institutions could create a noble world. All men were equal before the Lord; God could inspire the most humble to a true vision, and that vision was certain to be opposite in almost every respect from the doctrines of the Catholic church. The object of life was to be good and of art to teach virtue. As he wrote years later, the works of the greatest masters, "considered without reference to the manifestations which they exhibit of moral influences, possess no merits beyond the productions of the ordinary paper-hanger." *

On the other hand, West, isolated in his homeland from the European pictures about which he had read, had never doubted that they were the perfection of perfections, that ho would want to rebuild his own provincial style according to their canons. What was his horror to discover that the famous names, whom he had admired *in absentia,* had painted propaganda for the aristocratic life, the Catholic church, and—so he believed—the seven deadly sins. Virgin worship was a particular detestation to the Quakers, yet Christ was commonly shown as a baby in His mother's arms. Heaven was made to look very like a royal court, and you would never have guessed

* The spelling and punctuation in all quotations have been modernized.

that the disciples had been simple people, for they dressed like lords. West could not help concluding that painting had been used "to inflame bigotry, darken superstition, and stimulate the baser passions."

His political and moral sense urged him to shun such pictures, but his old aesthetic convictions and the new testimony of his eyes argued that they were beautiful. The resulting struggle within his mind brought on a nervous breakdown.

The conflict that had prostrated West was so much a product of the times that it was duplicated in many other skulls. Johann Joachim Winckelmann, a German shoemaker's son who had become a Roman critic, was just evolving a theory that yoked the art of the past to bourgeois needs. So widespread was the demand for such a synthesis that Winckelmann's brand of neoclassicism swept the Western world, driving into exile older aesthetic doctrines. West was fortunate in being on the scene when this powerful conception was formulated; he knew Winckelmann and studied with Winckelmann's earliest painter-disciple, Raphael Mengs. Soon he was led out of the confusion that had made him ill, and restored to the self-confidence that characterized his entire career except for those few nightmarish months.

Winckelmann recognized that the concept of the Noble Savage had its impractical side; you could not expect Europeans, even those most avid for purity, to substitute paint for clothes, and hunt with bow and arrow down the Corso. Another ideal was needed, and in a society that was still dominantly aristocratic, it should not be too radical. Like many political theorists, Winckelmann twisted the age-old interest in classical times to suit bourgeois ends. He based his aesthetics on the republican era of Greece and Rome. If an artist

wished to depict uncorrupted man whose natural goodness ruled, let him paint the heroes of those glorious days. His models should be ancient statuary, which showed humanity at its basic best—intellectually because of the democracy under which the people lived; physically because the Greeks possessed a system of hygiene, now lost, which shaped their bodies until form was perfectly suited to function. As West explained it, the *Venus de' Medici* was lovely because it expressed fully "the peculiar excellencies of women: . . . a virtuous mind, a modest mein, a tranquil deportment, and a gracefulness in motion."

Defining the technique according to which this subject matter should be depicted, Winckelmann made a similar amalgam of the old and the new. He followed the puritanical notions of the bourgeoisie, who were inexperienced as connoisseurs, by banning from painting all that was sensuous. Color, the imitation of fine stuffs, the depiction of appealing flesh; these were censored as unworthy of noble spirits. "A picture," he pontificated, "in order to be excellent must be as sagely reasoned as a lesson in metaphysics." Desiring a pure simplicity, a calm grandeur, he wished painting to imitate the virtues of sculpture: beautiful outlines and cold colors. Among painters he admired particularly the intellectual artists of the Florentine school, with Raphael at their head.

The final element in this bouillabaisse was fathered by the rising scientific spirit. A restless desire for exact knowledge of that antiquity which had been talked about for so long had recently inspired excavations at Pompeii and Herculaneum. The painter, Winckelmann wrote, should use the findings of archaeology to make his reconstruction of classic times completely accurate.

Although Winckelmann's doctrines repeat many theories that had inspired such seventeenth-century painters as Poussin and Le Brun, they seemed revolutionary to his contemporaries, since classicism had gone underground for three-quarters of a century, while the French court became increasingly powerful and taste reacted from discipline toward freedom and sensuality, toward Watteau, Boucher, and Fragonard. Furthermore, some of his concepts were new, particularly the emphasis on archaeological accuracy, and the insistence that pictures must be more than spiritual, must be active "schools of virtue."

West absorbed Winckelmann's doctrines with the eagerness of a suffocating man breathing oxygen. They came to him as revealed truth, since they reformulated in more up-to-date and sophisticated form ideas he had known in rural Pennsylvania. The philosophical arguments that made outline seem nobler than color gave sanction to a basic characteristic of the untutored painting of the American Colonies. And, as a boy, West had imbibed from books the neoclassicism of Poussin. That his knowledge of the classics themselves remained slight was only a minor impediment. When he was asked by William Henry, an ingenious gunsmith in the wilderness city of Lancaster, to paint *The Death of Socrates* (Pl. 1), he had replied that this sounded like a fine subject, but who was Socrates? Henry told him the story. Depicting classical characters with as much freedom as if they had been compatriots, West enlarged a tiny print into a highly emotional picture: the brutish indifference of the helmeted soldiers contrasts with the philosopher's benign nobility as he prepares to drink the poison, and with the grief of the disciples down whose contorted faces stream painted tears. To Winckelmann, the

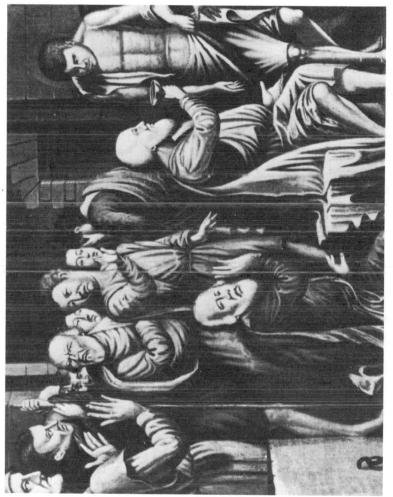

1 BENJAMIN WEST: Death of Socrates [detail] (*Courtesy Mrs. Thomas H. A. Stites*)

romantic ardor that makes this picture moving would have seemed a crass violation of the classical spirit, yet West, on his arrival at Rome, had already turned his imagination to ancient history.

Reforms, even those most logically in accord with their times, take a little while to be completed. Thus, Raphael Mengs was unable to throw overboard his training in baroque modes. His paintings were more neoclassical in subject matter than technique. While under his influence, West sometimes painted seductive heroines and bouncy cupids. Such pictures as *Angelica and Medoro* suited Roman taste; West was hailed as the "American Raphael."

In 1763, he went to London, intending only a flying visit on his way back to America, but the paintings he had brought with him from Italy created such a sensation that he decided to settle. On his own now, thinking of himself as no longer a student, he quickly subordinated the smatterings of baroque techniques he had picked up in Rome. Veering back to the hard outlines and metallic hues of the American vernacular, he became the first painter anywhere in the world to apply the new classical theories in their entirety.

Although aristocrats still coursed London's streets in their fine carriages and commissioned Reynolds to paint their mistresses in his lush manner, England had become basically a middle-class nation; the aristocrats themselves were often tainted with the new spirit. When West exhibited his canvases in 1766, they spoke to the heart of a great public that had been unconsciously longing for paintings suited to its prejudices. Reynolds noted that "the great crowd of the year is around Mr. West's pictures," while a rhyming reviewer

eulogized West's "happy art," that "steals through nature's inlets to the heart, pathetic, simple, pure through every part."

However, West could not eat admiration, and his sudden celebrity did not break down the age-old English prejudice against buying modern pictures. The aristocrats knew that it was infinitely more knowing to collect yellowed canvases attributed to the great names of the past; and the bourgeoisie were not self-confident enough to pay large sums for pictures discarded by their social betters. After one connoisseur had long-windedly preened himself on his advanced taste in admiring West's *Pylades and Orestes,* he was asked why he did not buy it. "What could I do with it?" he replied. "You surely would not have me hang up a modern English picture, unless it was a portrait!"

West turned to the Church of England for support. His suggestion that he paint altarpieces depicting moral tales from the Bible made headway for a time, then foundered on the old rock of Puritan prejudice. But the churchmen were delighted with his homilies from the antique. The Bishop of Bristol commissioned *The Parting of Hector and Andromache,* while the mighty Archbishop of York, Robert Hay Drummond, commissioned *Agrippina with the Ashes of Germanicus* (Pl. 2).

Agrippina illustrated Tacitus' description of the arrival of the hero's remains: "As soon as the fleet appeared in the deep," the harbor front was filled "with a sorrowing multitude, eagerly asking each other 'whether they should receive the landing in silence or with some expression of feeling?' Nor was it clearly determined what course would be the most suitable, when the fleet came slowly in." As soon as Agrippina "descended from the ship, accompanied by her two infants,

2 BENJAMIN WEST: Agrippina with the Ashes of Germanicus (Courtesy Yale University Art Gallery)

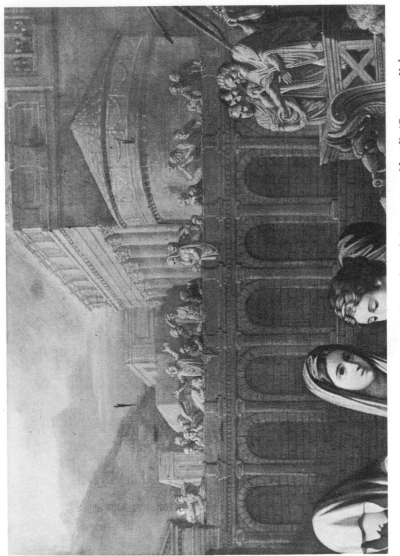

3 Benjamin West: Agrippina with the Ashes of Germanicus [detail] (*Courtesy Yale University Art Gallery*)

and bearing in her hand the funeral urn, her eyes fixed stead-
fastly upon the earth, one simultaneous groan burst from the
whole assemblage, nor could you distinguish relations from
strangers, nor the wailings of men from those of women, nor
could any difference be discerned, except that those who
came to meet her, in the vehemence of recent grief, surpassed
the attendants of Agrippina, who were exhausted with con-
tinued mourning."

West's painting is a restrained funeral hymn, imbued with
calm and gentle sadness. The color is on a low key. Dominat-
ing the picture are the light bluish-grays worn by the widow
and her children, which become slightly darker in the robes
of her attendants. The brightest tint is a subdued red in the
plume on the helmet of a mourning soldier on the left.

Although individual figures and groups are well painted
and emotionally moving, the canvas as a whole is more im-
pressive as a historical document than as an aesthetic master-
piece. Is the cramped perspective, which makes the sailboat
seem embedded in the quay, the result of lack of skill, or
perhaps of borrowing from classic low reliefs which notori-
ously pile up their distances? In any case, it is disturbing. The
composition does not carry its formal structure from the realm
of the mind to the action of the eye, which travels from group
to group with an unpleasant bumpy motion. Very odd is the
difference in the way the figures are painted on the three
planes. Those in the foreground—the central group and the
two wings that approach the spectator—are stylized yet nat-
uralistic depictions of the statuary of Greece's "golden age."
But the little knot of persons on the balcony in the right mid-
dle distance (Pl. 3), resemble, with their heavy draperies and
exaggerated lines, less the sculpture of Phidias than the more

primitive statues of an earlier date that Wincklemann would have despised. And on the masonry in the background we see figures that seem to have escaped from *The Death of Socrates:* distorted visions race and scream and throw their arms heavenward in hysterical emotion. The calm imperatives of classicism reign only where the artist's will was most active: although the featured players express their grief with suitable sobriety, the supers reveal the ardors and excitements of the emerging Romantic movement.

Today, the picture seems unstable, like a tadpole that has grown the legs of a frog. But no contradictions were manifest to West's contemporaries, for they lived in the same moment of transition as the painter. Delighted to see beauty and virtue walking hand in hand, Archbishop Drummond tried to raise 3,000 guineas by subscription so that West could continue his noble labors untroubled by financial cares. When the subscription failed, Drummond tried for royal patronage. He made West's fateful appointment with George III.

It was indicative of the turmoil into which the breakdown of old imperatives had thrown British society that the monarch, although the highest aristocrat, was as enthusiastic a moralist and family man as any greengrocer. His nobles shuddered with anticipatory boredom when invited to court, for the King would go to bed early, after a healthful walk on the terrace, and at six the next morning would be knocking on the bedroom doors of his children to ask how they had slept. George considered his own nobles sinful men; he refused to patronize their favorite painter, Reynolds.

A baroque artist not overly concerned with virtue, Reynolds, nonetheless, felt obliged to expound neoclassicism in his *Discourses* to the pupils of the Royal Academy. The grand

style, he stated, was achieved by "the exertion of the mind" not the emotions: reason was used to subordinate the specific to general principles; color was kept secondary to form. An artist who wished to be great should paint scenes out of history in the manner of the Roman, Florentine, and Bolognese schools. Since the Venetian, Dutch, and Flemish traditions emphasized color and "accidental" detail, they departed "from the great purposes of painting," and should be imitated only by those willing to practice a lesser, "ornamental style."

Among landscape painters, he gave high rank only to Claude, who "was convinced that taking nature as he found it seldom produced beauty." By generalizing like a historical painter, Claude sought "perfect form," yet Reynolds wondered whether "landscape painters have a right to aspire so far." As for genre, since it was committed to showing man in his natural state, not refined by thought, it was irrevocably "a little style where petty effects are the sole end."

His own practice of portraiture, Reynolds continued, forced an artist to depict "a particular man and thus a defective model." Efforts to "raise and improve" a portrait by generalizing the face to express all humanity and changing the dress "from a temporary fashion to one more permanent," damaged that essential end, the likeness. "Such of us as move in these humbler ranks of the profession are not ignorant that, as the natural dignity of the subject is less," a descent to "embellishment," to all the little tricks of the "ornamental style" was necessary.

In his heart, Reynolds may have been glad to escape, because of the low rank he gave his pictures, from the rigors of his theories, yet he cast longing eyes on the royal patronage that could enable him to shine as a historical painter. West

secured in one afternoon what forever remained beyond Reynolds's grasp.

Deeply moved by *Agrippina,* George III instantly commissioned another classical scene, *Regulus Leaving Rome.* The King came to believe that West was the greatest painter of his time, a genius worthy even of a monarch's friendship. George had been told that his exalted station required him to be as great an art patron as any Medici, but he was uncertain in matters of taste. He found it comforting to rely on West for all aesthetic decisions, even for rulings on how the Queen should arrange her jewels. He was, the painter explained, "attentive to communication but wanted direction in deciding." He could be persuaded to commission any canvas that West desired to paint. At first, the American sold him subjects that read like a syllabus of ancient history.

So suited to the times, the neoclassical taste activated many English painters. Gavin Hamilton, who lived at Rome and was most celebrated as an excavator, had exhibited at London less advanced pictures in this mode a few years before West. Angelica Kauffmann, the charming Swiss artist who is rumored to have been loved by Reynolds but in love with West, delighted England between 1766 and 1781 with her toga-wrapped sentimentalities. The quarrelsome James Barry leaped into the antique arena during the 1770's, while John Flaxman harnessed classical draftsmanship to trade through his designs for Wedgwood. The list could be greatly extended, yet West was generally considered the outstanding member of the school. As the art chronicler Whitley wrote, his neoclassical canvases made him "the popular idol, . . . regarded by some as the probable founder of a school in England that might rival or excel those of Italy."

Engravings after the American's painting circulated on the Continent, where they were pirated to serve a widespread demand. In France, they encouraged the emergence of the style that became, under the leadership of Jacques Louis David, the official art of the Revolution and the Empire. Although neoclassicism is commonly regarded as primarily a French movement, the French historian, Pierre Locquin, states that West and the English school anticipated the French by ten or twelve years.

Neoclassicism was an expression of bourgeois thought, and England became a bourgeois nation before France. America anticipated even England, but no sophisticated style could develop in the Colonies where the necessary technical expedients were almost unknown. Yet an American who studied in that nexus of world aesthetic currents, Rome, and then worked in England seemed selected by fate to step to the head of the procession as West had done.

The painting methods West had brought with him to Rome had been in no profound way opposed to Winckelmann's doctrines. In this he differed from David, who had been well grounded in the baroque manner of Vien and Boucher. David could only banish his early interest in texture and hue after a struggle, and it was one secret of his greatness that he never succeeded. Although West's lack of painterly knowledge contributed to the speed and completeness with which he applied the new manner, it made his pictures shallow.

The ancients played no real part in the culture of the largely self-educated Colonial, for the pine chips flaring in his home and the homes of his Pennsylvania neighbors had lighted not Tacitus but the Bible. Had West succeeded in his first attempt to sell religious paintings to the Church of England, he might

never have bothered with Agrippina and Regulus. As it was, the adulation showered on his neoclassical canvases did not keep him from realizing that he was not really interested in togas and the Doric order of architecture. They served their purpose by making him famous, but once fame was solidly in his hands, he used his prestige to pioneer in more radical directions.

CHAPTER TWO

Evolution *vs.* Revolution

THE first important American-born artist to return to these shores from European study was Benjamin West's pupil, Charles Willson Peale. The wife he had left behind him in Maryland may well have looked forward to his arrival with trepidation as well as eagerness. How would two years in London have changed her husband; would he be too grand for her now? Would the former saddler's apprentice have been made into a fine gentleman, another Sir Joshua Reynolds?

When his square-rigged ship docked in 1769, the answer became startlingly clear. Far from being dressed in lace and carrying a sword, Peale still wore the clothes, quite battered now, in which he had left home. He had been so enraged by the attitude of the British government toward the Colonies that he had refused to bring back with him any English goods, except the painting materials he had been forced to buy since none were manufactured in America. Smiling, he reported West's horror at his refusal to pull off his hat when his master's patron, the King, rode by.

To his family, Peale derided ideas he had heard promulgated by the connoisseurs of London. It was hard to believe,

19

but those fops argued that "genius for the fine arts is a particular gift and not an acquirement; that poets, painters are born such." One would think that painting was a special world, apart from the rest of life! Peale's own experience convinced him that this was completely untrue. Having completed his apprenticeship to a saddler, he had taught himself a succession of trades: upholstering, chaise making, watchmaking, brass founding, silversmithing, and painting. For a time, he had practiced them all together until mounting debts forced him to flee the sheriff and concentrate on the most portable of his occupations, art. He painted himself out of debt and into reputation. In 1766, some Annapolis gentlemen, remembering what acclaim had accrued to the Philadelphians who had sent West abroad, took up a subscription to send Peale to West.

Peale intended to specialize in miniature painting. However, during his twenty-five months in London he was not, as he himself wrote, "contented with knowing how to paint in one way, but he engaged in the whole circle of arts, except at painting in enamel. And also at modeling, and casting in plaster of Paris. He made some essays at metzo tinto scraping." When these efforts left time heavy on his hands, he repaired West's locks and bells, or scraped on the violin he had made for himself during the ocean crossing.

As a showpiece, he brought back to America a tremendous portrait of William Pitt done in that newest fashion, the neoclassical taste. The statesman is shown standing in a toga beside a votive altar, and every square inch of the canvas is crowded with such mixed symbolism as "the statue of British liberty trampling under foot the petition of the Congress at New York," and an Indian with "a bow in his hand, and a

dog by his side, to show the natural faithfulness and firmness of America." From this picture, he made an engraving almost two feet high with which he hoped to overawe the Colonials. However, instead of commenting on the exquisite taste of the classic imagery, the Americans looked at the face, decided it was not a good likeness, and refused to buy. Peale's high spirits were not dampened. He launched contentedly into that manufacture of unexotic portraits which was the economic backbone of American art.

For more than a century, such painting had flourished in British America. Although crude according to European standards, the pictures had often been vital and beautiful. The eagerness of the native limners to follow foreign styles was frustrated, generation after generation, by their inability to ascertain accurately what those styles were. For information, they had to rely on books full of technical terms and practically devoid of illustration, or on rare and expensive engravings which gave them, in the words of Trumbull, "forms, expressions, characters, and light and shadow"; but no hints as to brush stroke or color. Foreign-trained artists made periodic painting trips to these shores, and sometimes settled here, but almost without exception they were inferior workmen who had been unable to make a good living at home. The product of European provincialism, their work was often almost as direct and homely as that of the self-taught American painters.

Although they sucked what sustenance they could from imported delicacies, for day-to-day nourishment the native limners had to rely on their own inspirations. A consistent style developed in America. It wore an overlay of sophistication as a settler might wear imported clothes, but underneath

the body was clumsy, strong, provincial. The pictures were at their best when the artists attempted only such simple effects as could be achieved by simple means. Bodies and faces were reduced to uncomplicated designs based on the geometric patternmaking typical of untutored artists. Color was added as a decorative afterthought. Such paintings could never give that exact visual impression of nature which in those days artists desired so avidly, yet sometimes the painters, in paring away complications of light and movement and form, uncovered basic principles of character and meaning. Long before the term was invented, they groped toward Expressionism.

A modern Expressionist makes a choice among many available methods, selecting those most suited to his vision, but the early American painters had been forced to build on the few and thin techniques that came to hand. That so many of their expedients were personal or local inventions, extemporized to answer immediate practical needs, often gave their pictures great validity. Yet even the most brilliant mind cannot conceive for itself those accumulated riches which are the result of many brilliant minds working through generations. Although American Colonial art had grace and strength and sincerity, it remained a series of tunes set down with the simplest harmonies.

Increased prosperity at home, increased movement back and forth across the ocean, were certain to bring American painting into closer contact with European schools: primitivism could not for long reign supreme. Yet major questions remained: Would the change be gradual or sharp; would the old rugged sincerity fuse with the new wisdom or be overwhelmed?

Benjamin West, who had made new beginnings in Europe, had resolved to stay there. Since Peale was the first of his pupils to come home, the likenesses that artist now painted in Maryland, Delaware, Virginia, and Pennsylvania give important indications as to the future directions of American art. When Peale discarded the metaphorical approach of his *Pitt*, he discarded everything he had learned in England that was more than a refinement of the style he had practiced before he had left home. He adhered to the method of seeing that had long been typical of the Colonial South. Aristocratic conceptions had been conned from prints after the English masters, whose actual works Peale had now seen. Men were shown as noble and refined, women as gentle, gracious, handsome. They stood before backgrounds indicating taste and opulence. Personality was of secondary importance to social class. But into such elegant compositions a disturbing literal mindedness tended to obtrude. Peale, for instance, placed William Paca in a noble pose before tastefully arranged classical accessories, yet recorded what Reynolds would have glossed over: the Maryland patrician was much too fat.

The intention was not satiric but intimate: Peale's portraits are warmed by the friendliness of his own temperament. That crabbed New Englander, John Adams, wrote, "Peale is from Maryland, a tender, soft, affectionate creature. . . . He is ingenious. He has vanity, loves finery, wears a sword, gold lace, speaks French, is capable of friendship and strong family attachments and natural affections." Adams might have been describing the paintings as well as the painter.

Governor Thomas Johnson and Family (Pl. 4) is an ambitious picture which reflects Peale's virtues and his faults. The composition is superficially knowing—there is an old mas-

ter in its lineage somewhere—yet fundamentally naïve. Although the governor's pose is elegant, he has forgotten it to look lovingly at his wife; and the children, far from being the correct little adults of eighteenth-century convention, look mischievous and immature and delightful. Certainly, Peale had difficulty sticking to his easel, he was so anxious to play with their dog.

The artist who had faced George III's carriage with his hat firmly on his head was determined to do things his own way. He experimented with pigments, and thus his colors were more impermanent than those of his less well-trained contemporaries. Even in his lifetime, as he commented, they faded. But time played no bad tricks on him. Today, his pre-Revolutionary paintings have an all-over hue of soft greens and tans and blues that accords well with their gentle designs.

When Peale's beloved daughter Margaret died in infancy and his wife wanted him to immortalize the vanished spirit in a portrait, he did not restore roses to the cheeks and activity to the quiet limbs, but painted the corpse stiff in death, with the useless medicines on the table beside it. Mrs. Peale objected that this was too gruesome, so Peale gave the picture life by sewing on an extra piece of canvas and adding a likeness of the mother weeping over her child. The resulting image (Pl. 5) has the simple emotionality of a votive painting in some primitive Mexican shrine. The London connoisseurs Peale had so recently left behind him would have thought it vulgar, disgusting, and crude.

Peale was followed home, between 1767 and 1770, by three other foreign students: Abraham Delanoy and Matthew Pratt, who had also worked under West; Henry Benbridge, who had studied independently in Italy and London. They had

299c

4 Charles Wilson Peale: Governor Johnson and Family (*Courtesy C. Burr Artz Library*)

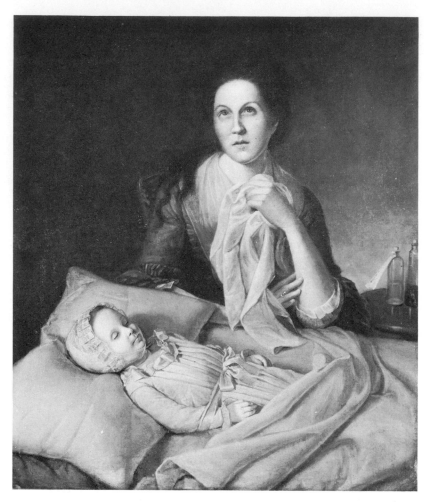

5 CHARLES WILLSON PEALE: Rachel Weeping *(Courtesy Charles Coleman Sellers)*

changed their styles in Europe even less than Peale had done. Pratt's *Cadwallader Colden and Warren de Lancey* (Pl. 7) is typical in that, despite touches of sophistication, it depends for its basic effect on the rigid organization and unpoetic viewpoint of the Colonial vernacular. Indeed, the first wave of Americans with foreign training made so little impression on American art and taste that the leading painter in the Colonies remained a man who had never been abroad, remained John Singleton Copley.

In the late 1750's, when hardly out of his teens, Copley had created pictures that surpassed all models available to him; he was forced to rely, for further development, on the personal experimentation which he carried out so brilliantly. Working in mercantile and middle-class Boston, where the Revolution was first to catch fire, he discarded the old Colonial interest in rank which Peale still reflected, and labored to depict character for its own sake. To him, a man's place in society was irrelevant; he wanted to know what kind of an individual each man was. In his efforts to record the truth of personality, he struggled with basic technical problems his American predecessors had usually ignored. He gave his figures weight as well as shape, placed them in a three-dimensional world. With his eyes as his guide and his native wits directing his painting hand, he began to achieve effects that had formerly been the monopoly of more sophisticated traditions, yet the foundation on which he built power and beauty remained the vernacular (Pl. 17). Copley's example marked a channel through which Colonial painting could, without any break in its flow, join the mighty river of world art.

Young men were coming up who seemed about to realize this consummation. The three ablest came from southern

New England: Ralph Earl, born 1751; Gilbert Stuart, born 1755; John Trumbull, born 1756.

Earl's *Roger Sherman* (Pl. 6) is wild, crude, and strange: one of the most exciting pictures of its time. The subject, a New Haven shoemaker who lifted himself by his own bootstraps to become a lawyer, a judge, and a Revolutionary leader, is revealed with so intense a vision that he seems less an individual than the ultimate distillation of strong and righteous New England. In painting the face, Earl used hard lines reinforced with overheavy shadows to lay bare the essentials of character. Square skull, down-turned mouth, sharp nose, burning eyes enclosed in tight lids: all were seen at white heat and fused by the imagination into a powerful image.

This fierce, distorted, yet manifestly truthful head tops an ungainly torso dressed sloppily in too tight a vest. The hands are blunt and strong, the veins studied naïvely from life. There is bulk in this part of the picture: then suddenly everything becomes spidery. Although Earl painted the upper half of his sitter as if from a point slightly above him, he became so fascinated with the deep space under the Windsor chair that he seems to have got down on the floor to peer through the long vista. The resulting contrast between mass above and depth below is odd and unnaturalistic, yet, because it was conceived in a powerful, artistic mind, it sets the imagination of the viewer spinning.

Earl completed his vision with very simple colors. Except for black stockings and shoes, and a few touches of white, the whole costume is russet brown, as is the curtain looped in the background, and even the seat of the chair. The orange-

6 RALPH EARL: Roger Sherman (*Courtesy Yale University Art Gallery*)

7 MATTHEW PRATT: Cadwallader Colden and Warren de Lancey (*Courtesy Peter de Lancey Swords*)

tan floor lightens but does not break the impression of mono-
tone which clothes well this stern and awe-inspiring likeness.

After firing had flared up at Lexington and Concord, Earl
joined the engraver Amos Doolittle on the deserted battle-
fields to depict the action in oil views, one of which survives
(Pl. 8). He painted an unbroken landscape and then super-
imposed houses and other man-made details. Finally, he
added the soldiers; Doolittle posed for each of the foreground
figures in turn. Attacking this home-grown historical com-
position without shyness, Earl indicated the trunks of distant
trees with two brush strokes, one for the lighted part, one for
the shadow. He did not hesitate to paint out or move grave-
stones until they made attractive frames for the men shown
standing in a cemetery. Often applied flatly over broad areas,
color was made to serve design. The painting is high-keyed
and full of a most unmilitary charm, much more impressive
than the better-known engraving made after it.

Where Earl came from prosperous yeoman stock in Worces-
ter County, Massachusetts, Stuart was the son of an im-
practical Scotch snuff grinder who lost his Rhode Island mill
when the painter was a child. Growing up in poverty on New-
port's water front, Stuart, a playmate tells us, was "a very
capable, self-willed boy . . . habituated at home to have his
own way in everything." When not endangering the com-
munity with his pranks, he drew childish pictures on fences
and the tailboards of wagons to the amazement of the local
patricians, who gave him paints and lent him spurious old
masters to copy. Then Cosmo Alexander, a Scotch artist of
weak and conventional powers, appeared in Newport. Stuart
was apprenticed to him, and, in 1771 or thereabouts, accom-
panied him to Scotland. Alexander promptly died. Stuart lived

in terrible poverty and finally, so his companions surmised, worked his way home before the mast. The trials he experienced were so horrible that he never would talk about them.

Because he could boast of foreign study, Stuart was enabled to sell many portraits, but they lacked the expected graces. Scorning the sugar-coated formulas that had enabled Alexander to approximate the surface appearances of nature, the self-willed youngster used the primitive expressionism of his Colonial predecessors as the starting point for violent personal experiments. Many attitudes that were to dominate his entire career were present. Already he loved color with a sensuous passion, and built his harmonies around the flesh tones of the face. Far from creating costume pieces as Alexander had done, Stuart, in his desire to express character, emphasized heads until bodies seem shrunken. He struggled to express weight, piling on his shadows until the modeling was so strong that the skin seemed too tight for the bones. The result is surprisingly powerful, for, even in its most extreme naïvetés, his technique served his unique method of seeing. And as time went on, he managed unconventional approximations of extremely knowing effect; in his *Francis and Saunders Malbone* (Pl. 10) the distorted figures have position in three-dimensional space.

Like almost every professional painter since the continent had been settled, Earl and Stuart were nurtured in a craftsman's world—but John Trumbull was the son of a merchant and future governor of Connecticut. Thus his career deviated at once from the Colonial norm. His first inspirations were the embroideries and water colors his elder sisters made at a Boston finishing school. When he decided to take up painting as a profession, he did not seek apprenticeship to a sign

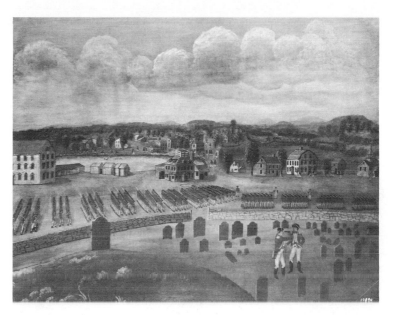

8 RALPH EARL: British Troops at Concord (*Courtesy Mrs. Stedman Buttrick, Sr.*)

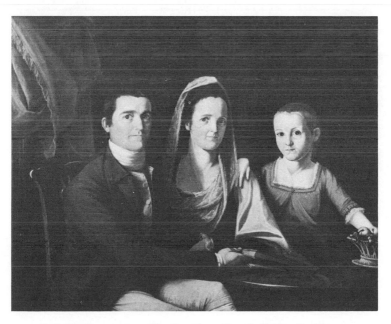

9 JOHN TRUMBULL: The Jonathan Trumbull Family (*Courtesy Yale University Art Gallery*)

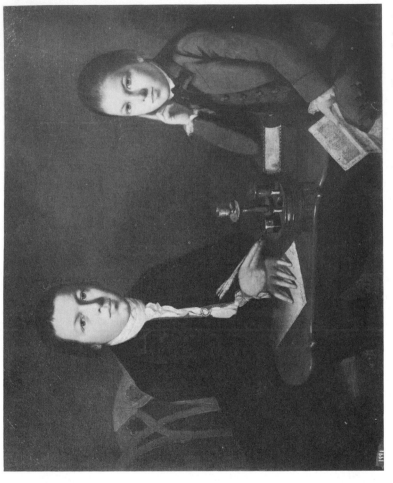

10 GILBERT STUART: Francis and Saunders Malbone (*Courtesy Francis Malbone Blodget*)

painter; he asked his father to pay Copley for lessons. But the father considered painting a menial trade beneath the family social station. He bundled John off to Harvard, where the sickly boy, who had spent most of his childhood in study, joined the junior class at the age of fifteen. Calling on Copley, he was reassured to discover that the artist had the appearance of a gentleman.

Trumbull studied painting in his spare time. Since no economic necessity drove him into the market place with the best wares he could manufacture at the moment, he limited himself to making copies of such pictures as a Copley portrait, an Italian oil of Mount Vesuvius, and a Biblical print after Antoine Coypel. Not until he had graduated from Harvard did he finally venture on an original composition, *The Death of Paulus Aemilius at the Battle of Cannae*, and even then he selected "from various engravings such figures as suited my purpose, combining them into groups, and coloring them from my own imagination." Full of scampering, insect-like figures, the picture has no composition and the color is applied in irrelevant spots. Trumbull was not moved; he was showing off his book learning.

Only when he turned to painting what he himself saw did his ability become manifest. As he re-created reality, form and color flooded his eyes. In the triple portrait of his brother Jonathan's family (Pl. 9) he tried to achieve all the effects he had read about: likeness, anatomical detail, chiaroscuro, shape, depth, texture, consistent color. These objectives, as is not surprising, often got in each other's way, yet the picture had a crude strength that boded well for the future.

There was great vitality in the old American traditions during the last years of the Colonial period. Copley, the self-

taught, and Peale, the returned traveler, were enriching the old canons, while the rising generation showed both the desire and the ability to solve deep problems of expression by testing new sources of inspiration with personal experiments. Then the Revolution stormed across the path of American art.

Himself from the artisan class which sparked the conflict, Copley had married the daughter of a Tory merchant; he felt there was right on both sides and tried by mediation to stop the Boston Tea Party. Failing, he fled mounting riots to the Old World in 1774. Stuart, who had no interest in politics and found that all business for artists was coming to an end, followed a year later. The one convinced Tory among the important painters, Earl undertook secret missions for the British, and in 1778 found it wise to retire across the ocean. Benbridge languished in a British prison ship; Delanoy was by 1780 "consumptive, poor, and his only employment sign painting." Pratt was also reduced to making his living from signs.

Appointed aide-de-camp to his father's friend George Washington, Trumbull was promoted rapidly, but in 1777 resigned from the army because he believed that the commission which made him a colonel at the age of twenty-three was dated some three months too late. "A soldier's honor," he explained, "forbids the idea of giving up the least pretension of rank." He tried to return to his painting, but "a deep settled regret for the military career from which I had been driven, and to which there appeared no possibility of an honorable return, preyed upon my spirits." In 1780, he sailed to France as a merchant. Then he moved on to England.

As a militia officer, Peale occupied himself not with putting lead into the enemy but food into his soldiers; most lovingly

he cooked for them himself. When not too busy campaigning, he painted full-length portraits of Washington for state legislatures, miniatures for officers to send home to their wives, and posters when some propaganda point needed putting over. Having, as he put it, "now unfortunately become popular," he found himself a leader of the political left wing. Once, his pleading with the unpaid militia helped keep them from attacking the rich merchants of Philadelphia, from starting a war within the war. About 1781, the hatred and turmoil became more than the artist's nerves could stand. Peale slid into a nervous breakdown.

Like snow falling on a great city, the Revolution first slowed and then stalled the arts of peace. Painting became almost extinct on the North American continent. What its nature would be when it started again the future alone would tell. One thing was certain: the headquarters of American art had followed Copley and Stuart and Trumbull and Earl to England. Even as the Americans and British fired at each other across rocky fields, American painters were working out a new artistic dispensation for their embattled land in Benjamin West's London studio.

CHAPTER THREE

The Torch of History

LONG before the Royal Academy exhibition of 1771 opens, lines form on the street, impeding London traffic. When the doors swing back, the crowd moves in a cramped mass until they are all gathered before a single picture. Men stare reverently, women weep into frilled handkerchiefs, or, past the aid of smelling salts, faint into their escorts' arms. All day long, until the doors close again at evening, emotion surges and breaks in the gallery where hangs West's *Death of Wolfe* (Pl. 11).

This depiction of the triumphant general dying at the very moment when Quebec—and with it French Canada—fell to British arms is thus described by a modern scholar, Charles Mitchell: "The awful contrast of dark and light in the sky, the great folds of the flag above Wolfe's head, the men-of-war lying at anchor, and the lamenting officers grouped in a circle —all told the solemn importance of the occasion. The various expressions on the faces of Wolfe's attendants gave depth and variety to the emotion of a hero's death in his moment of victory, and served to draw the spectator by sympathy into the company. Each character makes his own contribution: the impersonal grief of the grenadier standing on the right with

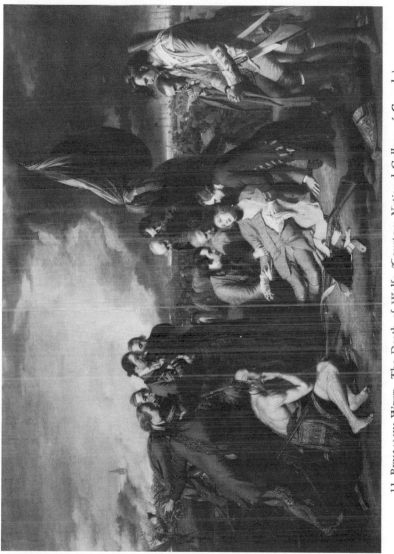

11 BENJAMIN WEST: The Death of Wolfe (*Courtesy National Gallery of Canada*)

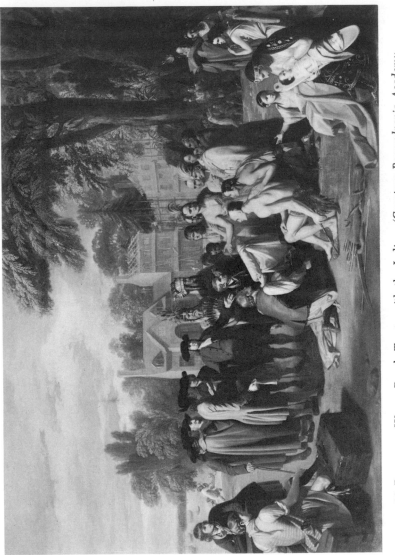

12 BENJAMIN WEST: Penn's Treaty with the Indians (*Courtesy Pennsylvania Academy of the Fine Arts*)

folded hands; the anxious solicitude of the surgeon wiping Wolfe's brow; the mixed emotions of Sir William Howe stretching out his hand to welcome the victory and regretting that Wolfe will not live to enjoy it; the unwitting eagerness of the soldier running up with the news; and the aloof calm of the Cherokee Indian, indifferent to victory and lost in contemplation of mortality."

This was a very strange picture for the artist whose fame was based on sober renderings of Greeks and Romans. Did not West realize that, according to the gospel of which he himself was the leading preacher, nobility was a characteristic of men long dead? If you wished to compliment a contemporary by raising him to the level of ancient heroes—a difficult feat at best—you made a learned allusion by painting him in a toga, attended by antique gods. The realistic costumes in which West painted Wolfe and his companions were supposed to impede imagination; boots, for instance, connoted not romance but London mud.

Reynolds and the King had tried to dissuade West from his radical undertaking. Although Reynolds, remaining unconvinced, continued to thunder in his *Discourses* against yoking high art to contemporary times, George III ordered a replica of West's picture, while the majority of the connoisseurs agreed with the commonalty that *The Death of Wolfe* rivaled the greatest old masters. The American's was the first picture ever painted in England that united King and merchant, artisan and peer—all the elements of the modern state—into voicing a single paean of praise. West's already tremendous fame mounted into the stratosphere.

His illustrations of classical times had been for painter and admirer alike an affectation. They belonged to the old Eng-

lish tradition of connoisseurship, which regarded art not as a plant rooted in local soil, but a spray of cut flowers brought home by the privileged from the grand tour of Europe. A generation before, Hogarth had attacked this point of view in the most brutal way imaginable. He raised the realistic depictions of English life, which had long flourished in popular woodcuts, into an art form that was as radical as it was great. Avoiding the sublime, which was universally considered an essential of beauty, he concentrated on the sordid. Arguing for virtue, he drew vice, which he found in the mansions of the rich as well as on *Gin Lane*. The road to happiness was that trod by *The Industrious Apprentice* who through sobriety and unremitting labor became lord mayor of London.

Hogarth's rendering of places and people everyone knew appealed to the British love of a portrait. Delighted to see evil punished and lords drawn as fools, the middle classes bought quantities of engravings after his paintings, but the original canvases stayed on his hands. The connoisseurs with the price, as shocked with his art as with his social philosophy, regarded him as no more than an illustrator. After his death, his approach sank back into the realm of popular woodcuts from which it had risen.

It remained for West to mix Hogarth's method with older conceptions into an amalgam that pleased prince and commoner alike. To make moralizing acceptable, he delineated not the ugliness of evil but the sublimity of virtue. And for *The Death of Wolfe* he selected the most modern of virtues, patriotism. In truly autocratic times, noblemen had felt more kinship with their peers in other lands than with the commoners at their feet; but the bourgeois economy required that a nation coalesce into a team that battled for trade. Although

the nationalism that typifies modern states had been augmenting in England for several centuries, art, under the patronage of the most conservative classes, had adhered to the old-fashioned ways of thought. Greatly overdue and thus received with double enthusiasm, *The Death of Wolfe* was the first important historical picture to give full rein to British patriotism.

An essential corollary of the nationalist approach, the use of British costume, chimed with the most up-to-date aspect of neoclassical theory, the emphasis on scientific accuracy. Arguing against Reynolds's suggestion that he dress his characters in togas, West explained, "I want to mark the date, the place, and the parties engaged in the event. . . . If instead of the facts of the transaction, I represent classical fictions how shall I be understood by posterity?" But it did not pay to be too accurate. A *Death of Wolfe* in contemporary costume had been exhibited seven years before West's at the Royal Academy by a minor English artist, Edward Penny. More matter-of-fact, containing many fewer figures, it was more historically correct, yet it created little excitement. Penny had merely carried the manner of the popular woodcut into paint. His canvas gave no hint that it was celebrating an event suitable for Homer's lyre.

Many years later West explained in connection with his *The Death of Nelson* that the admiral could not be shown "dying in the gloomy hold of a ship, like a sick man in a prison hole. . . . No boy would be animated by a representation of Nelson dying like an ordinary man. His feelings must be aroused and his mind inflamed by a scene great and extraordinary. A mere matter of fact will never produce this effect."

In *The Death of Wolfe* West labored "to dispose of the circumstances in a picturesque manner." Not only did he group

figures, many of whom had not actually been present, like a stage director, but he told his modern tale in an artistic language which had for generations connoted major events. As Mitchell points out, Wolfe lies in the arms of his lieutenants in the traditional pose for Christ in *The Lamentation,* while the tall grenadier to the right owes his figure to Rembrandt and his facial expression to Le Brun's depiction of "compassion." The ordinary eighteenth-century viewer did not recognize these quotations, yet he felt that something in the way the picture was painted communicated high tragedy. To the traditional allusions, West added an exotic symbol unknown in the iconography of art: the brooding Indian. Here was just the mixture of the familiar with the novel that carries over best to large audiences.

West violated strict historical accuracy, but stayed close enough to reality to enable a spectator to imagine he was actually present at the tragedy. Since neoclassical theory considered that "perfect truth" was a combination of the factual and the ideal, West had theoretical sanction for marrying the middle-class realism of Hogarth to the traditional conceptions of the connoisseurs. The child of this union inherited from both its parents not only artistic vitality, but also gold. Unlike Hogarth, who had been unable to sell his paintings, West was munificently paid for several versions of *The Death of Wolfe.* He also invaded Hogarth's source of income, since engravings after the picture were the most popular prints of their time.

West's formula was so potent that it excited individuals who found no patriotic pleasure in the event depicted. A print of this French defeat made its engraver between six and seven thousand pounds from sales on the Continent, and

pirated engravings appeared in Paris and Vienna. By clothing the realism of his American youth in the sophistication of his European training, West opened to artists everywhere a new source of inspiration and income. No longer shackled to the past, painters could now compete with broadsides and newspapers in the glorification of news. The French, once more following West's lead, used his methods to depict Napoleon's campaigns.

Having reached the depiction of his own times, West now felt free to range all through history. The Middle Ages had long been considered crude and unworthy of artistic attention—the word "Gothic" originally meant "barbarous"—but West painted, as companions for *The Death of Wolfe*, not only a classical subject, *The Death of Epaminondas*, but also *The Death of Chevalier Bayard*. Turning to his own wild homeland, he depicted, as an allegory preaching the virtues of peace, *Penn's Treaty with the Indians* (Pl. 12). The composition, with its wings of figures leading the eye back to the central friezelike group, reflects neoclassical canons, yet the total effect is not suave. The shapes are hard and tense, the emphasis on outline, the color not part of the forms but applied to them. No continuity of space unites the different planes, and each group of figures seems carved from a single piece of wood. For all his world-wide renown, West had not traveled very far from the techniques of his Pennsylvania years.

Although the picture lacks sensuous charm, if we examine it the way we should, reading it as if it were a book, it comes gradually to very active life. We see the eagerness on the face of the squaw as she fingers a fabric being offered her, while the brave standing to her right ponders dubiously, in typical

masculine preoccupation with price, his hand over his mouth. The papoose at its mother's breast is tied down so hard it is completely rigid, the flesh rising red between the bands. Realizing the importance of the situation, the Quakers are grave and thoughtful. Penn's swelling belly—hardly a heroic note—and his outstretched hands dominate.

The American Revolution now intervened in West's career. The officially appointed "historical painter to His Majesty" made no secret of his sympathy with the rebels. Amazingly enough, the King regarded this as proof of his sincerity, and rebuffed the Loyalist refugees who tried to drive him from court. But painting pictures for public exhibition was another matter; West never again showed an American scene. All of contemporary history became too dangerous for the radical artist who was to admire the French Revolution as much as the American, Napoleon as much as Washington. Except for a brief return to commemorate the death of Nelson, West virtually abandoned, a few years after he had invented it, the neoclassical news picture.

Leadership in the mode, far from falling into English hands, was assumed by another American, John Singleton Copley. After leaving Boston, Copley had visited London briefly, and then set out for Italy. West gave him an itinerary, telling him exactly what qualities to look for in the work of each artist, but Copley's reactions were less orderly than West's. Keeping his eyes on the compass of Winckelmann's doctrines, West had marched in a straight line, making sure that every step carried him in the direction he wanted to go. Copley did not know where he wanted to go; he wanted to clasp everything to his bosom. Beauty was to him a sensation to be expressed, not a conception to be formulated. West's

career reveals the impact of European art on the intellect of an American painter, Copley's on the sensitive nerves.

For twenty American years, Copley had struggled to invent for himself techniques that would enable his hand to express what his eyes saw; it had been like chopping through granite. Now the rock gave way and he ran with unimpeded feet through flowering fields. Although he made his own selection among the old masters, condemning some that custom admired, his letters home were filled with ecstatic praise. There seemed danger that he would be overwhelmed, so many were the impressions and so fine.

But always the strong artisan habits of his American years reminded him that these things were for use. There was no point in admiring flesh tones unless you could duplicate them, composition was meaningless unless it enabled you to give order to your personal vision. And, as he studied, he discovered that the old masters were after all not a different order of being; they had done a little more suavely what he had always done. Raphael, he observed, had painted his *Transfiguration* "with the same attention that I painted Mr. Mifflin's portrait and his lady's. In that determined manner he has painted all the heads, hands, feet, draperies and background, with a plain simple body of colors and great precision in his outline, and all parts of it from nature." Analyzed from the point of view of method, the glories of the old masters did not seem too difficult to duplicate. "I shall always enjoy a satisfaction from this tour. . . . I know the extent of the arts, to what lengths they have been carried, and I feel more confidence in what I do myself than I did before I came. I hope I will be enabled to make such use of my tour as will better my fortune."

During his childhood on the rowdy Boston water front, Copley had imbibed a profound horror of the sea. This horror had coalesced into a visible symbol when he had met a man whose leg had been chewed off by a shark. Now his Continental tour had taught him how to compose a complicated picture. These elements combined naturally, after he had returned to London late in 1775, into his first major English picture, *Watson and the Shark* (Pl. 14). He did not know or care that he was carrying West's practice a long step toward Romanticism.

The Romantic movement was the full-blown expression of middle-class thought. Aristocratic behavior had been supposed to follow a traditionally preordained pattern, but the bourgeoisie had risen by fighting this pattern. Having built their temporal eminence with their own hands, they believed in the value of ordinary experience; speaking to God in their own souls, they accepted as valid their emotions and inspirations. The two major directions thus encouraged in Romantic art were exemplified by the two poets who were, twenty-one years later, to publish *The Lyrical Ballads*. Wordsworth was primarily concerned with finding beauty in inconspicuous lives and the landscape through which ordinary men walked; Coleridge hymned those extreme visions which, according to Romantic doctrines, must be beautiful because the human mind that gave them birth was naturally good.

Coleridge had a precursor in the Anglo-Swiss painter, Henry Fuseli, who, four years after Copley painted his shark, exhibited *The Nightmare*. A woman lies on a divan in a pose that could only be achieved by a brilliant contortionist. On her chest sits a vicious imp from the realm of mythology, while the focus of the picture is the head of a luminous and

other-worldly horse. Such a scene would be encountered only in dream; Fuseli had distorted natural forms into a vision of horror.

Horror, too, is the subject of Copley's picture, but there is no dreaming here, no exaggerated vision. We are shown a real harbor—identified as Havana—floating an actual boat in which ordinary people behave as ordinary people would when attempting to avert tragedy. In the foreground, a naked boy is being attacked by a very material shark. Far from being asked to accompany the artist down the ghost-haunted corridors of his own mind, we are made spectators at a frightening accident.

This concentration on verisimilitude was fundamental to the American school in London. Denizens of the imagination were allowed to enter Copley's or West's pictures only if they walked rationally in a rational world. West, for instance, argued that a Cyclops's single eye must be placed "in the center under the eyebrows," since, if it "is placed in the forehead, the brain has an encroachment upon it which cannot be admitted without the loss of reason." A portrait approach to even the most exotic and insubstantial themes came naturally to men who had started life as Colonial limners. Struggling for generations against very practical hazards, the American mind had learned to apply itself to the real and immediate.

Although Horace Walpole had in his *Castle of Otranto* gone in heavily for supernatural horrors, he preferred Copley's Romantic realism to Fuseli's imaginative symbols. He considered *The Nightmare* "shocking," *Watson and the Shark* "good, and the whole a good picture." Copley sold several replicas and was encouraged to have the painting engraved.

Indeed, he had proved himself as important an innovator

as West. By depicting emotion for its own sake, he had brought into historical art a whole new world of subject matter. No uplifting moral tempers the pure sensationalism, and the event has no historical significance: the protagonist was not even identified when the picture was shown. Far from sitting down with Shakespeare to "tell sad stories of the death of kings," we are asked to sympathize with an unfortunate only because he is a human being like ourselves.

France is commonly regarded as the innovator of Romantic painting, but decades were to pass before the artists there worked in the manner of *Watson and the Shark*. Gericault's *The Raft of the Medusa*, which seemed so revolutionary when exhibited at the Salon in 1819, may well have been inspired by an engraving after the American's picture.

Copley, however, did not continue down the path he had blazed. No sooner had he finished *Watson and the Shark* than that popular idol and friend of America, William Pitt, Earl of Chatham, collapsed while speaking in the House of Lords and was carried out to die. Here was a news event that cried for the painter's brush. West started a picture but, probably because Pitt was a political enemy of George III, abandoned the subject to Copley.

When, adhering still to the psychological approach of American portraitists, Copley made *The Death of Chatham* (Pl. 13) into a vast conversation piece, a group likeness of the House of Lords in a moment of emotion, he moved once more in a new direction. For his depictions of contemporary events, West had chosen distant and exotic places, but Copley demonstrated that in a man's own city life could blossom into tragedy suitable for high art. That heroes, far from breathing a special air, walked the streets beside us, implied that a man

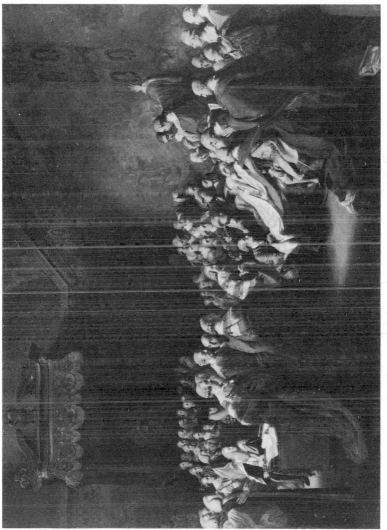

13 John Singleton Copley: The Death of Chatham (*Courtesy Trustees of the Tate Gallery*)

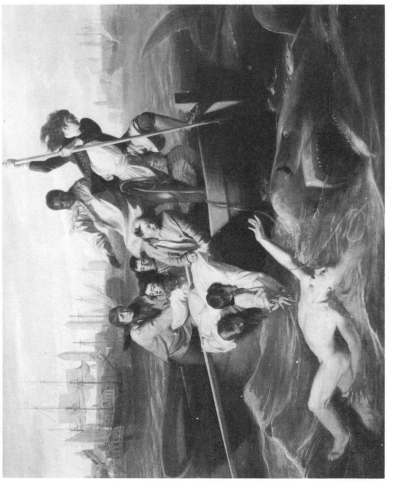

14 John Singleton Copley: Watson and the Shark (*Courtesy Museum of Fine Arts, Boston*)

who was ordinary today could be great tomorrow. This conception was revolutionary, but so much in accordance with the movement of the times that the picture was a great success, both critically and financially.

Instead of sending *The Death of Chatham* to the Royal Academy exhibition, Copley hired a hall and charged admission, receiving roughly £5,000 from some 20,000 citizens. Thus he pioneered in a method that combined with the publication of engravings to rescue artists from dependence on rich patrons. When, in 1799, David exhibited in the same manner his *Battle of the Sabine Women* and, in the name of a people's art freed from the domination of the few, called on his French colleagues to do likewise, he cited Copley's experiment as a precedent.

Now on the highroad of fame and prosperity, Copley became a news reporter. "No artist," wrote the chronicler Cunningham, "was ever more ready . . . to lend his pencil to celebrate passing events." His tremendous canvases, *The Death of Major Pierson* and *The Repulse of the Floating Batteries at Gibraltar* illustrated British victories during the Napoleonic wars and delighted the populace.

Justified by neoclassical theory, West had adhered to the uncomplicated colors and sharp outlines of Colonial practice, but Copley, who found "a luxury in seeing as in eating and drinking," loved the brilliant tints and sensuous effects of Reynolds and Gainsborough. His pictures glow with richly painted hues, sparkle with emotion and excitement. Yet his fundamental psychological approach grew from his earlier years. As long as he expressed American thought with European skill he remained a great painter, creating some of the

finest historical paintings ever produced in England. Nation-alistic-minded Englishmen could not help being irritated because the leadership in this most admired form of art should have fallen into the hands of Americans. In 1810, *The Morning Herald* imagined that at a banquet of the Royal Academy the following number was produced to the tune of "Yankee Doodle":

West sings:
From Philadelphia's broad-brimmed race
Who vanity have undone,
I took my easel on my back
And crossed the seas to London!

Lord, how I marvelled as I passed
The streets with Uncle Goodin,
For here we saw the men and girls
As thick as hasty pudding.

Chorus of R[oyal] A[cademician]s, dancing:
Yankee doodle, doodle do
Yankee double dandy.
A perpendicular line is straight,
But beauty's line is bandy.

Copley sings:
From Massachusetts, rebel state,
When loyalty was crying
I ran on shipboard here to paint
Lord Chatham who was dying.

Then I hung up the House of Peers
(Though some were quite unwilling)
And gave the group to public view
And showed them for—a shilling.

West and Copley sing together, hand in hand:
Let David paint for hungry fame,
And Wilkie subjects funny;
Let Turner sit and study storms,
But we will paint for money.

After George III had officially announced American independence, Copley gleefully added the stars and stripes to his portrait of an American envoy; and West wrote Charles Willson Peale that he planned a series of pictures based on the Revolution: "the cause of the quarrel, the commencement of it: the carrying it on; the battles, alliances, etc." Prudence intervening, the King's painter turned the project over to Trumbull.

Shortly after Trumbull had reached France in 1780, his mercantile speculations had collapsed. "The study of art remained as a last resort," he wrote, "and I resolved to go to London." No sooner had he begun his labors in West's studio than the execution of Major André as a spy so excited public opinion against the rebels that Trumbull, as a former American officer, was visited by "a very respectable looking middle-aged man" who carried him off to the jail. West and Copley came to his assistance; eight months later he was released on condition that he leave the country. Back in New England, he returned to trade, but January, 1784, found him once more in West's studio.

After the pupil had copied a composition by West and painted, as student exercises, several classical pictures, he was considered ready to begin his series on the Revolution. Trumbull had almost blinded one eye in a childhood accident, and West considered that his damaged vision might re-

sult in the distortion of large pictures. Furthermore, such pictures would probably be unsalable, since the major interest in their American subject matter would be in the United States, where fortunes were still meager. He advised Trumbull to make his compositions the size of engravings and paint them for the purpose of having them engraved. He would then receive "in small sums from many purchasers . . . adequate compensation." Trumbull, indeed, was never to offer the original paintings for sale; he kept them as capital assets.

With West overseeing him at every turn, Trumbull followed an already solidified tradition by focusing his military scenes on expiring commanders. *The Battle of Bunker Hill* features Dr. Warren, mortally wounded and about to be stabbed again by a bayonet. The figure is pitifully enough conceived—too weak to lift his head, he follows with his eyes the descending blade—yet no deep emotion is communicated. Although we are shown two dead men and many who are dying, blood appears only in chromatically valuable places. More spirited in action, brighter in color than West's neoclassical compositions, this remains a heroic vision of warfare, formal and full of glorious banners.

In his next composition, *The Death of General Montgomery at Quebec* (Pl. 15), Trumbull escaped into ardors more suited to his own temperament and his younger, more romantic generation. A cloud of sulphurous smoke closes in on a group of writhing figures. The eye is led by the extended body of a dead man up to the twisted form of Montgomery, dying on his knees. Huddled around him, holding above them tangled banners that have become gray and inglorious, his partisans are about to be engulfed by the horror of the onsweeping

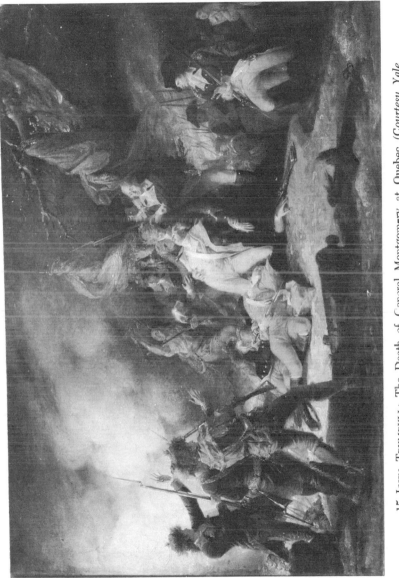

15 JOHN TRUMBULL: The Death of General Montgomery at Quebec (*Courtesy Yale University of Art Gallery*)

smoke. Their rigid fear contrasts with the violent motion of the Indian running in from the left, tomahawk upraised.

Outside the central group, Trumbull painted ordinary persons being confronted with this seemingly preternatural apparition of pain. Three militiamen throw up their hands as if to blot out the sight, while Colonel Thompson, coming in from the right, looks on with unblinking courage. Details are treated not for literal accuracy, but impressionistically to contribute their part to the total emotion. The thirty-year-old painter had produced a masterpiece that promised a brilliant future both for his own art and for the historical inventions of West.

In 1789, Thomas Jefferson, then American ambassador to France, tried to further this consummation by offering to make Trumbull his private secretary, a job that paid £300 a year and that, he assured the painter, "will not take a moment of your time from your present pursuit." The reply he received makes amazing reading to modern eyes. Trumbull stated that he realized painting "as it is generally practiced is frivolous, little useful to society, and unworthy of a man who has talents for more serious pursuits." Although he had resigned from the army at the beginning of the Revolution, he went on to say that he alone was capable of depicting its events, since he was the only painter who had taken an important part in the battles and had known, as a social equal, the principal actors. This gave a "dignity" to his own painting, "peculiar to my situation. . . . Vanity was thus on the side of duty, and I flattered myself that by devoting a few years of life to this object, I did not make an absolute waste of time, or squander uselessly talents from which my country might justly expect more valuable services."

Trumbull, so he continued to Jefferson, intended to go to America and offer a subscription for the series of engravings he planned. He hoped that Congress would buy a hundred copies of each print to give to distinguished persons in place of medals. If the subscription succeeded, he would continue with art and look favorably on Jefferson's proposition. Otherwise— "You see, sir, that my future movements depend entirely on my reception in America, and as that shall be cordial or cold, I am to decide whether to abandon my country or profession."

Although the first American patrician to become an artist had shouted down his father's objections to so menial a trade, clearly he had not completely succeeded in convincing himself. The fact that Trumbull had great natural ability as a painter, the joy he must have felt in the manipulation of pigments, did not compensate for a fall in social eminence. Knowing that he condescended, he wished instant reward. It was too much to expect that such a man as he should wait patiently for fame, or live on the adequate but not munificent salary Jefferson offered him.

In the autumn of 1789, Trumbull carried to the United States the historical inventions that had been made by American artists in London and had electrified Europe. He offered to apply this distillation of Old World art to depicting the history of the new. He was, he believed, putting his homeland to the test. Either there was taste in the new nation, or there was none. The next few years would tell.

Theories and English Faces

A S WEST went on from triumph to triumph, he came to feel that "when my pictures come into an exhibition, every other painter takes his place as if a sovereign had come in." Seeing a "necessary union between morals and good taste," he believed that his position as the greatest artist required him to be the most generous of men. He opened his purse, his store of knowledge, and his studio to every aspiring beginner.

Since no public institution gave practical instruction in painting—the Royal Academy School taught only drawing—the wooden benches in the anteroom of West's studio were crowded every morning with nervous young men, each carrying a canvas to be criticized. In 1829, the keeper of prints and drawings at the British Museum stated that in his opinion almost every successful contemporary English artist had benefited from West's "able and generous communications." The same may be said of almost every American painter who rose to prominence during West's London years.

His great efficacy as an instructor was based on the cerebral approach that made him a cold painter. The English artist, James Northcote, who is considered to have been Reynolds's

only important pupil, considered West "the best possible teacher," because West "did everything by rule, and could give you chapter and verse for every touch he put on the canvas." The American did not try to impose any particular point of view. "Try it," he would say when he made a suggestion, "and if it is not good you can alter it." That Constable and Lawrence were both grateful to him for advice that helped them travel their diverse roads, that he was one of the few recognized artists who admired Blake's wild drawings, show that West possessed one of the most flexible minds of his generation.

Although the outstanding practitioner of a high aesthetic style, West drew no line between beauty and use. Art, he told the rising business class, paid off in pounds and shillings. The Royal Academy, of which he was one of the four founders, was to England "of more real and solid advantage than would be the discovery of gold and silver mines within her earth; as it taught delineation to her ingenious men, by which they were instructed to give taste to every species of manufactories, . . . which raised the demand for them to an eminence unknown before in all the markets of civilized nations throughout the world."

The broadness of West's approach to contemporary art— and also his friendship with the King—made him the natural leader of the English profession. After Reynolds's death in 1792, he succeeded to the presidency of the Royal Academy, and he was re-elected annually, except for a break of one year, until his own death in 1820.

Like Reynolds, he delivered Discourses, but his tone was much more liberal. Painting, the older artist had stated, "being intrinsically imitative, rejects this idea of inspiration more

perhaps than any other"; each beginner should try to "unite in himself the excellencies of various great masters." West denied that originality was a monopoly of men long dead; it was the duty of living artists. Study was only useful when it released inspiration from the shackles and aberrations of ignorance.

West ignored Reynolds's preference for the "grand style" of the Roman and Florentine painters over the "ornamental style" of the Venetians. In a letter he had written to give Copley short cuts toward a knowing technique, West epitomized the advice he continued to promulgate. "Every perfection in the art of painting" could be learned from five sources: (1) classical statues, "the great original wherein the various characters of nature are represented from the soundest principles of philosophy," (2) Raphael, who employed "fine fancy in the arrangement of his figures into groups, and those groups into a whole, with that propriety and fitness to his subject, joined to truth of character and expression, that was never surpassed before or since," (3) Michelangelo, for the "knowledge and grandeur" of his human figures, which "have the appearance of a new creation, formed by the strength of his great imagination," and which contain "all that is great in design," (4) Correggio, for chiaroscuro, "the foreshortening of figures seen in air, . . . the magical uniting of his tints, the insensible blending of his lights into shades, and the beautiful effect over the whole arising from those pieces of management," (5) Titian, who "gave the human figure that truth of color which surpassed all other painters. His portraits have a particular air of grandeur and a solidity of coloring in them that makes all other portraits appear trifling."

Submitting thus far to convention, West dwelt on the art of Italy, and failed to communicate his own interest in the achievements of the Low Countries, in Rubens and Rembrandt. This was an unfortunate omission, since much in that earlier wave of bourgeois painting suited contemporary English and American needs. To bring his ideas up to date, West used his own experiences as a primitive painter in the New World. He considered his years as a self-taught professional "the most fortunate circumstance that could have happened to me. My having no other assistance but what I drew from nature . . . grounded me in the knowledge of nature, while had I come to Europe sooner in life, I should have known nothing but the recipes of masters."

When he had first arrived in Rome, the connoisseurs had said of him, "He is an artist that comes we do not know from where, and he paints as we do not know how." They were puzzled because he did not make line drawings but laid out his pictures with paintbrush in hand. Although he was to become convinced of the utility of drawings, he remained opposed to the academic practice of forcing the young to delineate endlessly from the antique before they were permitted to touch pigment. Many old masters, he pointed out, had painted "fine pictures . . . before they obtained the age of fifteen." Like West and his American colleagues, they had suffered through no long period of rudimentary instruction. An artist should "early in life be acquainted with the making of pictures, and qualify himself for a painter, and not a drawing master."

While his reputation as a historical painter was still in the making, West had created many landscapes. He had rejected the generalizing style of Claude, so suited to neoclassical theory, for concern, in the manner of Rubens, with what Reyn-

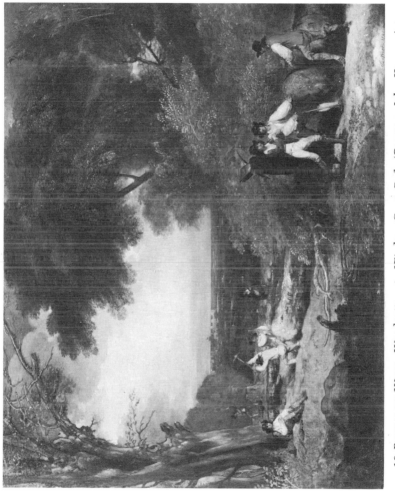

16 BENJAMIN WEST: Woodcutters in Windsor Great Park (*Courtesy John Herron Art Institute*)

olds denounced as "the accidents of nature." Fascinated with
effects of light at sunrise and sunset, West painted pastorals
of the English countryside with purity and simplicity if with
no particular poetic fire. Greater success gave him less time
for this "humble" mode, yet he sold George III such land-
scapes of royal interest as *Woodcutters in Windsor Great Park*
(Pl. 16), in which well-scrubbed workmen contributed to the
casualness of a scene more ordinary than ideal. His practice
enabled him to appreciate Constable's revolutionary paintings
when they were still banned by his colleagues in the Royal
Academy, and to give that young man what he considered the
best lessons he had ever received. Constable praised West's
"ability in the composition of landscape," but not his color,
which followed the old formulas.

West painted at least one genre scene in Hogarth's ribald
style, *The Bathing Place at Ramsgate*, which seems, most sur-
prisingly, a satirical comment on modesty. Beside horse-
drawn huts that enabled ladies to enter the water without any
male glimpsing them in bathing attire, other ladies lounge
contentedly in their skins. A group of naked boys dash for the
surf, the most conspicuous striking a macabre note by dan-
gling a stump where he should have had a leg. It would be fun
to argue that the president of the Royal Academy was a pre-
cursor of Surrealism.

Although he had learned in Italy to despise the practice of
portraiture, West had expected, when he arrived in England,
that he would have to make his living from painting like-
nesses. Lacking the virtuosity of brush stroke, the glitter of
color that made so attractive the work of rivals like Reynolds
and Gainsborough, he tried to heighten his portraits with ele-
ments borrowed from historical paintings. The quality of the

result depended on his own belief in the symbols he introduced. He failed to view social elegance with a properly appreciative eye, and could think of no better way to make glamorous the double portrait of the newly married Mr. and Mrs. John Custance than to introduce a smirking Hymen, clad only in his wings, who leans chummily against the groom, while the bride, her hair-do endangered by a low-flying cupid, chastely ignores the immodest god. It is hard to believe that this picture is by the same hand as his powerfully conceived likeness of the New York partisan fighter, Colonel Guy Johnson, who is shown with an Indian encampment in the background and one of the braves he led standing behind him (Frontispiece).

When safely on the King's payroll, West announced, "I seldom paint portraits, and when I do, I neither please myself nor my employers." Likenesses continued to figure in his tremendous output, but now he created them according to his own taste; he returned, with new technical sophistication, to the directness that had characterized his boyhood work. He showed the Queen in her jewels as matter-of-factly as he had depicted Colonial maidens in their laces, and his self-portraits, where he had to please no one but himself, seem less in the tradition of Van Dyck than of Rembrandt. They are completely grave, entirely unadorned, the body and its costume subordinated by shadow to the quietly painted face.

Warmer in temperament, less concerned with neoclassical theory, Copley gloried in the sensuous achievements of the leading British portraitists. He alternated likenesses with historical paintings, and substituted for the hard drawing, labored brushwork, and sober coloring of his American years a lightly tripping brush, dashing forms, and chromatic show-

ers of bright tints. In competition with painters who were creating some of the most decorative portraits the world has known, he approached or rivaled all but the two leaders of the school, Reynolds and Gainsborough.

Certainly, he had not failed to achieve technical virtuosity. In the background of *John Quincy Adams,* Copley sketched in, very rapidly, a little landscape about a foot square. Sky, hill, and meadow are not drawn but indicated with sweeps of color. The autumn tree is a squiggle of green on top of a squiggle of orange, the meadow a plain of luminous greens darkening as they approach the spectator until they are almost black. Should we frame this landscape for itself, it would seem to be a mid-nineteenth-century work, so completely is form subordinated to color. Other passages of paint are almost equally impressive, yet the likeness is disappointing to admirers of Copley's American work. Adams was a Bostonian of the deepest dye; a few years before, Copley would have shown him as being full of idiosyncrasies, of character. But we see a young man more handsome than interesting.

In 1771, while visiting New York, Copley had painted a little girl, Mary Elizabeth Martin, romping with a dog; now he painted three daughters of George III romping with a multitude of pets (Pls. 17 and 18). That he remembered the earlier picture is shown by the reappearance of the American child's spaniel in the very center of the royal group; the dog is realized with more sophistication, more accuracy of detail, but a diminution of strength. Further comparison between the canvases reveals with what a lavish hand Copley made use of his newly found abilities to compose complicatedly, to express his sensuous pleasure in the seduction of fine stuffs. *The Three Princesses* is brilliant, instinct with charm and

gaiety, yet that starker image, *Mary Elizabeth Martin,* communicates deeper emotion.

Copley's Boston portraits had been strong in content and weak in technique; now the opposite was the case. This transformation might have been prophesied when he stepped into a ship whose sails swelled with an eastward wind. In America he had regretted that he could not show his sitters dressed in foreign fashions. He had borrowed fancy poses from transatlantic prints, and only abandoned them when he could no longer make them accord with the literal painting style that, for lack of further information, he had been forced to work out for himself. Not grounded on any thought-out theories of politics or art, the downright, earthy directness of his American likenesses had been an unconscious outgrowth of his environment and personality.

Now he attempted to accept a new environment, but it is easier to move a body through space than a mind. Fundamentally, his personality remained the same; necessarily, the result was conflict. Yet England was not Africa or even France; many aspects of his new habitat were quite familiar, and this undoubtedly helped him succeed as well as he did. When in Boston Copley had broken with the aristocratic stereotypes that had dominated Colonial portraiture, he had paralleled the experience of English artists who had broken with a more sophisticated version of the same tradition. Rising individualism on both sides of the Atlantic had banished the depiction of people primarily as representatives of class or occupational types. But Copley, following his own inspiration, had walked further down the new path than the leading painters of England. With only a little heightening, he had shown Boston businessmen as ordinary people engaged in

ordinary tasks, while Reynolds, whose paymasters were the most elegant citizens of London, regarded personality not as an end in itself, but as the foundation on which to build a socially acceptable image. Although the English artists never lost sight of individuality, they emphasized the most admired aspects of a sitter's character and features. Like Copley, Reynolds looked at reality, but he wore much rosier glasses.

Reynolds was a man of the world with a noble, graceful air. In a drawing room, Copley was uneasy and shy; when he spoke, he was likely to be blunt. The subtle type of flattery demanded by his London clients was outside his natural range. Not realizing this, he attempted to vie with great portraitists on ground not of his own but of their choosing. His conscious mind little understood his own gifts and strengths and inspirations.

The difficulties Copley faced also affected the other American painters who reached London. Most had been professional portraitists in the New World. If they wished to continue their trade without fleeing to some back province, they had to compete with brilliant practitioners, who served a very popular blend of old-fashioned elegance and up-to-date directness. But the Americans had been conditioned to a brew that contained less elegance and more literalness, even as American society was less aristocratic and more middle class. What seemed to the Londoners natural grace, seemed to them flattery. How were they to achieve fame and fortune, and still paint the truth as they saw it?

West had encouraged his earlier American pupils—they intended to return home immediately—to ignore the more flamboyant aspects of British portraiture. However, the artists

who fled a revolution that might burn endlessly had to pre-
pare to make their living in England.

When Stuart arrived in 1775, he saw no reason why Lon-
doners should not admire and buy the type of portrait that
had made him a sensation in Newport. He tried to set up as a
professional. At first, his failure was due to lack of contacts
in the foreign city, but soon an American friend secured him
commissions. He even started a full length of the celebrated
Dr. John Coakley Lettsom for exhibition at the Royal Acad-
emy, but this picture, like most of his others, remained un-
completed. A burning of liquor in his throat took the place of
artistic creation. He became more familiar with the interiors
of debtors' prisons than the chaste halls of the Royal Academy.

Stuart had visited English collections, allowed his eyes to
rest on old masters and modern English portraits. In his loy-
alty to American primitivism, he sneered in his conscious mind
at such fancy concoctions, but he could not help being moved
by color and texture and virtuosity. Stubbornly he refused to
give in to sophistication, yet the knowledge that it existed
stayed his painting hand. The man who in America had been
so self-confident could no longer finish a picture.

After a year of frustration he admitted that he would have
to learn all over again how to paint. He had shunned that
mecca of American art students, West's studio; now he sent
West a letter that could only have been torn from his proud
spirit by desperation. "My poverty and ignorance are my only
excuse" for "taking this liberty . . . Pity me, good sir. I've
just arrived at the age of twenty-one, an age when most young
men have done something worthy of notice, and find myself
ignorant, without business or friends, without the necessities
of life, so far that for some time I have been reduced to one

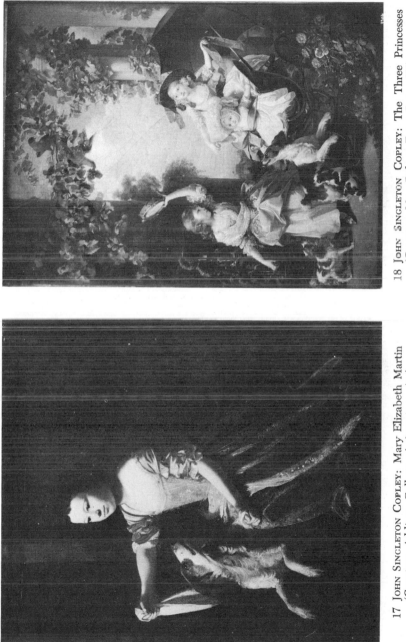

17 John Singleton Copley: Mary Elizabeth Martin
(Courtesy Addison Gallery of American Art)

18 John Singleton Copley: The Three Princesses
(Courtesy Mrs. Robert Treat Paine III)

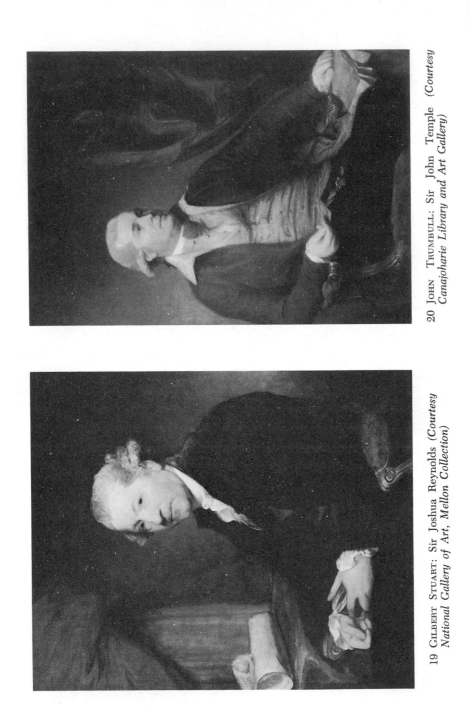

19 GILBERT STUART: Sir Joshua Reynolds (*Courtesy National Gallery of Art, Mellon Collection*)

20 JOHN TRUMBULL: Sir John Temple (*Courtesy Canajoharie Library and Art Gallery*)

miserable meal a day, and frequently not even that. Destitute of the means of acquiring knowledge, my hopes from home blasted, and incapable of returning thither, pitching headlong into misery, I have only this hope—I pray that it may not be too great—to live and learn without being a burden."

A much less anguished appeal would have brought tears into the calm gray eyes of West. He took Stuart into his house, and, recognizing that this wild creature had talent, put up with his drunkenness and pranks, made him his first assistant. Although Stuart laid in backgrounds on West's "ten acre canvases," he was not tempted to try similar pictures. When he stated "no man ever painted history if he could obtain employment in portraits," he was probably teasing his good master, yet he was serious too. His interest was in likenesses.

Stuart refused to abandon himself to any elegances he did not feel. Resentful of social fashion and only secondarily concerned with beauty, he never wavered in his desire to put on canvas "the animal" he saw before him. A man did not seem to him an opportunity for a picture; a picture was an opportunity to show a man. Like a spy searching out the secret weapons of his enemies, he would learn British skills, but only to turn them to his own ends. He used his studies to escape from the technical naïveté that had in Newport prevented him from giving complete expression to the basic realism of his vision.

Such early English portraits as *Dr. John Fothergill* possess a naturalism unknown in Stuart's American work, but are, according to London standards, hard, dry, and labored. With each succeeding year, he became more fluent, particularly in the parts of his pictures that interested him least. He came

to sketch in costumes and settings with a brilliant rapidity based on what he called Gainsborough's "dragging method of tinting." But the depiction of faces, those windows to the soul, he had to work out for himself. All through his English career he drew features with such passionate attention that they remained, in contrast with the work of his London rivals, firm, tight, uncompromising in their terrible sincerity. His technique was deeply influenced by his study of European art but his point of view remained the point of view of America.

English critics soon accorded him pre-eminence in one particular, the achievement, "without any attempt to dignify or elevate the character," of a true and accurate likeness. They ranked his work high in exact proportion to their belief that to "nail the face on the canvas" was the object of portraiture. Although he was attacked because "he never deviates into grace," connoisseurs had to admit that he was a major artist. His partisans even argued that on the death of Reynolds and Gainsborough he would become the leader of the British portrait school.

Stuart lifted his price for a head from five to fifty guineas, and still could hardly keep up with his commitments. Yet very few ladies entered his studio, and those who did were often guilty of wearing last month's fashions. The men were likely to be deficient in grace; they strode up his steps with an ungainly energy. Although Stuart's clients occasionally sported high civil or military titles, they tended to be members of the upper middle class. Whigs in sympathy with the American patriots, many were the English equivalents of the leaders of the United States.

Professional men were Stuart's specialty. When Alderman Boydell, the publisher who had made the engraving of paint-

ings into a mass industry, wanted to hang in his salesrooms portraits of England's leading artists, he turned naturally to Stuart. In one of the resulting pictures, Stuart showed William Wollett at work on the most famous print of all: West's *Death of Wolfe*. The portrait is graceful in color, suave in composition, and sure in execution, but the fat, nervous, and unlovely face is in no way prettified. Stuart's likeness of Reynolds (Pl. 19) annoyed that aging tamer of the rainbow, who remarked that if it resembled him, he did not know his own appearance.

Despite such dissent, Stuart demonstrated in portraiture what West had demonstrated in historical painting: that an American, working according to his own ideas, created pictures satisfactory to a large segment of English society. This was shown even more markedly by the career of Mather Brown, a Boston boy who, inspired by Stuart's youthful pictures, followed him to London where he became West's pupil in 1781. Boasting none of Stuart's transcendent ability, he nonetheless made a great hit with such unflattering likenesses as his *John Adams*. In 1788, so a contemporary letter stated, Brown rented "a house at £120 a year, keeps a servant in livery, and is appointed portrait painter to the Duke of York. He has a great run of business, and has not only painted many of our nobility, but also the Prince of Wales." Even the aristocracy, it seems, were on occasion willing to be depicted with pedestrian accuracy.

Trumbull, though specializing in historical painting, showed, by his likeness of his friend, Sir John Temple (Pl. 20), that, had he wished, he might have cut a mighty swath as a portraitist. His monocular vision in no way damaged this life-size three-quarter length, which is dominated by the painting of the hands. The right is relaxed on the arm of a

chair, while the left, resting at arm's length on a table, is clenched into a fist. These contrasting tensions vitalize the entire picture. The body in an electric pose, both negligent and tense, is placed to one side of the canvas, while the strong thrust of the outstretched arm balances. Behind the arm, space is stopped by a maroon curtain, but the figure rises against a tan background that gives a sense of undefined depth. Inherent movement, expressed in monumental forms, has been synthesized into aesthetic calm.

Although equally naturalistic, this picture differs from Stuart's output in not being primarily a character study. The organization, the lighting, the color scheme of reds contrasting with yellows, combine to show Temple as a physical human form clothed in texture and placed in space. We feel a vital sense of active manhood, but the sitter is not particularized. Even in such brilliant portraits as this, Trumbull remained a figure painter.

The third of the able artists who was born in America during the 1750's reached England in 1778. Unlike Stuart and Trumbull, Ralph Earl practiced at first in the provinces, where he could sell pictures that would have been laughed at in London. His *William Carpenter*, painted in Norfolk, has many resemblances to his *Roger Sherman* (Pl. 6), painted in New Haven. We find the same legginess, the same startling contrast between weight above and tenuousness below, but there is a new unity of point of view: light is more consistently studied and the artist looks down on all details from a single elevated spot. The bright colors are naïve, the red coat and trousers standing out like a bugle call. Earl is interested as before in depth, and amazingly successful in achieving it despite errors of perspective. The vision is less stark and un-

21 RALPH EARL: Lady Williams and Child *(Courtesy Metropolitan Museum of Art)*

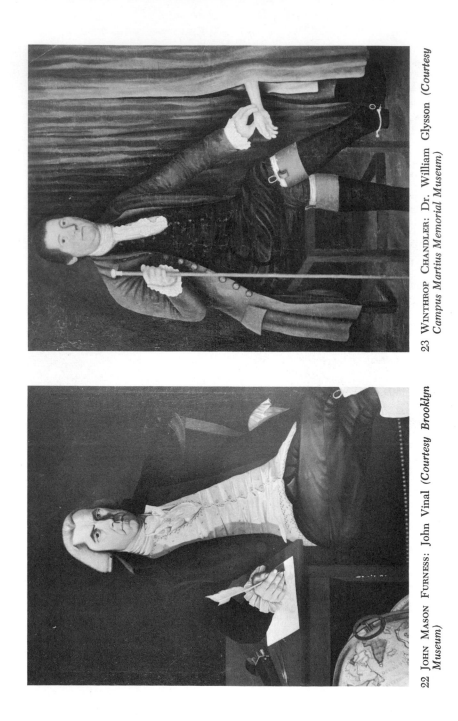

22 John Mason Furness: John Vinal (Courtesy Brooklyn Museum)

23 Winthrop Chandler: Dr. William Glysson (Courtesy Campus Martius Memorial Museum)

compromising, the surfaces more smoothly painted, and the character gone from the hands. That such a portrait could be sold reveals that, even as in America, primitivism was alive in back-country England.

But the urge to escape from it was greater. Earl was drawn to West's studio, and by 1783 he was exhibiting at the Royal Academy. His *Lady Williams and Child* (Pl. 21) is cold and stark according to British standards, but reveals a great smoothing out of style. Shape, lighting, and color are planned as a unified whole to produce a picture that imitates, although not subtly, forms as they might have been in life.

Although the American painters who became London professionals often adhered to the philosophy of life they had brought with them from the New World, they abandoned, to the best of their ability, the primitivism of their painting techniques. For this there was the best of reasons. By applying American ideas, they became in England the most successful type of prophets: men who were only slightly ahead of the dead center of the times. Had they defended the primitive aspects of their painting styles, they would have been arguing for innovations that were not to reach maturity anywhere until a full century had passed.

Today critics wish artists to break visual reality into its elements, to heighten by a selection and arrangement so rigorous that it often shatters the objective continuity of nature to form a subjective image. In particular they are interested in plasticity, a formal organization of weight and space. According to such twentieth-century ideas, Earl's *Lady Williams and Child* is a very dull picture compared to *Roger Sherman;* West's *Death of Socrates* (Pl. 1) has many virtues absent from his *Death of Wolfe* (Pl. 11); Copley and Stuart

lost much when they abandoned, in favor of a naturalistic
rendering of texture and color, their overemphatic statements
of the third dimension.

Such regrets would have seemed pure idiocy in the
eighteenth century. The classical and Renaissance canons then
dominant demanded that artists reproduce the surface ap-
pearances of nature as seen by the ordinary, unanalytical
eye. Again and again a portrait was given the final compli-
ment by the statement that the subject's dog wagged his tail
and tried to jump into the simulated lap. (The Greek sculptor
Myron was celebrated for having carved a cow that fooled
several bulls.)

Despite the primitivism of their own background, the
Colonial artists who went to Italy made no exciting discov-
eries there of primitives. West had some familiarity with
Cimabue and Giotto, but he considered that they had pre-
ceded the dawn of art. Painting in the true sense, he told
the Royal Academy, began on a humble scale with the found-
ing of St. Luke's Academy in 1350, and mounted rapidly for
one hundred fifty years "to bring forth a Michelangelo, a
Raphael, a Bramante." Although shocked by the subject
matter of the *cinquecento*, he joined his European contempo-
raries in worshiping the technique.

The American artists had evolved their primitive deviations
without conscious intent, as a result of experimentation forced
on them by ignorance. That they enjoyed what they were
doing is shown by Stuart's struggle to adhere in London to
his own style. However, Stuart was completely converted,
while men like Peale, whose techniques were not made over
by their European studies, brought home with them the belief
that they were minor workmen who would never create great

art. No deep intellectual conviction lay behind the American vernacular tradition. The conceptions that would have made such a conviction possible had no basic relationship to eighteenth-century life and thought.

During long years of isolation, American painting had clumsily, instinctively, out of chronological sequence, pushed toward the taste of modern times. Powerful workmen had produced powerful pictures, but always they had been made uneasy by a sense of ignorance. After the triumphant conclusion of the Revolution, the need for that ignorance was slowly brought to an end. Although West and Copley remained abroad, the three younger masters found their way home: Earl in 1785, Trumbull in 1789, Stuart in the winter of 1792-93. The first well-trained American painters to walk American soil, they brought with them great but dangerous gifts.

CHAPTER FIVE

Habitats and Heads

THE old American tradition of portrait painting had withered down to the roots during the winter of war but when peace returned green shoots sprang upward. The greatest activity was in New England, where there existed a large class of artisans from which painters could be recruited, where the distances between communities were not great, where widespread prosperity created a wide market, and where the influence of Copley's Boston pictures shed a quickening light.

The most interesting of Copley's close followers was John Mason Furness, whose *John Vinal* (Pl. 22) is a powerful translation of the master's manner into a harder, more linear style. The disappearance of almost all Furness's other pictures is a great loss.

Winthrop Chandler, a Connecticut house and sign painter who emerged as a portraitist shortly before the Revolution, shared Copley's realistic attitude but lacked the means to achieve a realistic image. He recorded that an ornamental tack was missing from a sitter's chair, but the sitter's figure remained weightless, hardly more than a complicated silhouette. Naïveté carried Chandler into the most unconven-

24 WINTHROP CHANDLER: Overmantel, View of a City (Courtesy Mr. and Mrs. John Robert Moore)

25 RALPH EARL: Daniel Boardman *(Courtesy National Gallery of Art, gift of Mrs. W. Murray Cane)*

tional compositions. Thus, Dr. William Glysson (Pl. 23) is
shown feeling the pulse of a withered female hand that pro-
trudes from the curtains which hide the sufferer's nightclothes
from physician and painter. With complete matter-of-fact-
ness, the doctor is revealed as a self-assured country bumpkin.
His mulberry-red coat is painted as flatly as if it were a barn
door, and what unity the picture has is imposed from the out-
side in linear design. Chandler's life-size three-quarter lengths,
which sometimes include several figures, are pastiches of exact
details arranged in an arbitrary manner.

When, as a sign painter, Chandler executed views to be set
into the paneling over fireplaces (Pl. 24), he put in some
homely particulars—a colored peddler, for instance, is shown
walking down a road—but accepted the fundamentally orna-
mental role his output was to play. His houses vary in color
with the needs of composition, but all have white window
frames and black doors. His wall decorations were considered
neither valuable nor art: a 1779 inventory lists one at thirty-
three cents.

A Connecticut dry-goods merchant, Richard Jennys,
doubled from the 1760's to the 1790's as an itinerant por-
traitist: he painted as differently from Chandler as was pos-
sible within the naturalistic, primitive style. His small pictures
are devoted to bust portraits in which accessories are kept to
a minimum. As Stuart had done in his naïve period, Jennys
envisioned shapes so tightly that the surface seems to be
shrinking into the mass.

The indigenous tradition was being practiced variously and
with considerable power when Earl returned to his native
New England. Several times he invaded New York City, but
he made no impression on the metropolis. He became an

itinerant in rural Connecticut, and, despite his seven English years, his work blended so well with the output of his primitive neighbors that he became invisible to critics and connoisseurs. When, in 1834, William Dunlap, who had studied with West as a young man, published his invaluable chronicle of American art, he devoted seventy-three pages to Trumbull and seventy to Stuart, but gave Earl one paragraph, which concluded, "He had considerable merit—a breadth of light and shadow, facility in handling, and truth in likeness—but he prevented improvement and destroyed himself by habitual intemperance." Earl seems to have committed bigamy and to have deserted both his wives. For some fifteen years his feet wandered, often unsteadily, down elm-shaded streets; he drank and dreamed and despaired; his hand created, very unevenly, scores of portraits. One month he would paint with startling exactitude, the next, as if he wielded a shoebrush. Although Stuart, as he careened down the years, had also moved recklessly, he had escaped serious accident; Earl had crack-up after crack-up. A church record at Bolton, Connecticut, ascribed his death in 1801 to "intemperance."

Earl's English experience had, of course, marked his style. On the debit side, it had eradicated forever the efforts to express weight and position in space which had made *Roger Sherman* (Pl. 6) so exciting a picture. However, new skills in composing a complicated canvas and in duplicating surface reality enabled him to achieve fluently the effects he now desired. No longer wishing to record faces with impolite exactitude, he repeated stereotypes: high forehead, blunt nose, strong nostrils, archaic smile. His passion became to record, as Chandler had done more clumsily, the objects with

which his sitters surrounded themselves. This was an act of piety to the American way of life.

The French traveler, De Tocqueville, pointed out that hereditary aristocracies take luxuries for granted, but when, as in the United States, static hierarchies are shattered, "the desire of acquiring the comforts of life haunts the imagination of the poor and the dread of losing them the rich." Americans, who never procured possessions "without exertion" or indulged in them "without apprehension," were fascinated by "gratifications so delightful, so imperfect, so fugitive." In aristocratic portraits, settings were luxurious but not particularized; Earl painted each object he included lovingly for its own sake.

There was little self-consciousness in this as his *Elijah Boardman* shows. As we run our eyes up the elegantly elongated body, from the clocks on the stockings via the dangling gold ornaments and silk vest to the powdered hair, all is fine and shiny. Boardman stands nobly before a bookcase, full of leather volumes, each with its legible title: he owned Moore's *Travels,* Martin's *Grammar,* a *Dictionary of the Arts and Sciences,* the *London Magazine* for 1786, and others. So far, so fancy, but what do we see through the open door? We see shelves on which are piled bolts of cloth. This fine man is not a lord after all, but a draper. He is proud of his trade, and glad to have the painter record it.

When Earl departed from visual truth, he was not escaping from reality but trying to record it more completely. Thus, in *Mr. and Mrs. Oliver Ellsworth* he not only repeated carpet and costume, chair and books, but showed through the window the façade and the lawn of the house in which the Ellsworths were sitting.

Earl's few surviving easel landscapes date from his later years, when the deterioration of his personality had become manifest in his art. The landscape backgrounds of his portraits are more exciting. Often, as in *Daniel Boardman* (Pl. 25), his sitter's flatly painted form, jammed against the front of the picture space, stands to one side and serves as doorman for his environment. Behind Boardman stretches, in deep perspective, his home town, New Milford, revealed as a pastoral poem: these were the grassy slopes, those the spires, that the river the artist loved. A dim sunset lights the far hills, while evening sinks toward the spectator until the nearest bend of the river is gray with dusk.

Unconcerned with the picturesque formulas, which still dominated English landscape painting, Earl, at his best, recorded nature quite simply, as he saw it. Gershom Burr sits before a village scene so intimate, so informal that it might almost have been painted in the late nineteenth century. Houses straggle on a promontory under a gray winter sky enlivened by a flight of birds. A big square-rigger reposes stolidly at its wharf, while tiny men manipulate smaller boats along a sedgy shore. Earl became so fascinated with this scene, that he lost hold on the logic of his composition; the sitter in his coral-red chair is elevated most unnaturally over the water.

Earl achieved the effects that men like Chandler would have liked to have achieved, and thus in Connecticut he had disciples. Joseph Steward, a disappointed minister, who in 1797 turned museum keeper, exhibited at Hartford natural curiosities and art. "He has now 350 feet of painting," Steward advertised proudly, adding that a Biblical, classical, and genre subject each contained "about sixty feet of canvas."

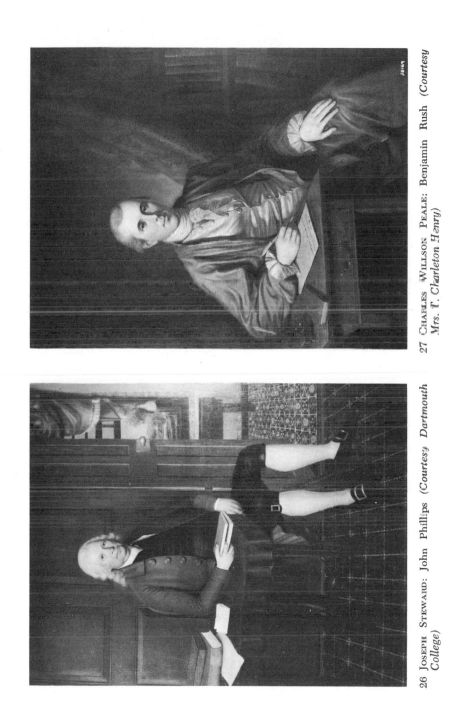

26 Joseph Steward: John Phillips (*Courtesy Dartmouth College*)

27 Charles Willson Peale: Benjamin Rush (*Courtesy Mrs. T. Charleton Henry*)

28 REUBEN MOULTHROP: Reverend Ammi Ruhamah Robbins *(Courtesy Yale University Art Gallery)*

Dunlap considered Steward's portraits "wretched," as many of them were, but in his full length of John Phillips (Pl. 26), this madly uneven painter followed the lead of Earl in revealing effectively, in his habitat, the New England merchant who founded Phillips Exeter and Phillips Andover academies.

A rival museum keeper, Reuben Moulthrop of New Haven, was best known as the sculptor in wax of such exhibition pieces as "David going forth against Goliath with sling and stone: the figure of the giant ten feet high, with his coat of mail and implements of war." He made portraits both in wax and on canvas. What must be his earlier pictures were marred by the utter naïveté of his attempts to achieve in paint the roundness that came easily in sculpture. Ignorant of how to use shadow, he laid forms side by side on a flat plane. Earl's influence unlocked him from his strait jacket, enabled him to produce in *Reverend Ammi Ruhamah Robbins* (Pl. 28), an intense image, powerful in its expression of physical detail and human character.

The role played in Connecticut by Earl was being played more effectively and on the larger stage of Philadelphia by that earlier London student Charles Willson Peale. Peale had recovered from the horrors that had stricken him during war time by discovering within himself deep stores of love and gentleness. He transmuted Dr. Benjamin Rush (Pl. 27)—that firebrand who hated his enemies with a rare passion and came to believe that the only way to cure the sick was to bleed them almost to death—into a smooth-faced, soft-smiling vision of relaxed ease. Still hidden away for the most part in private houses, the pictures Peale painted shortly after the Revolution have never been properly appreciated: they are among the most gracious portraits in our national heritage.

James Peale, Charles Willson's younger brother who was the first of the many relatives he taught to paint, was primarily a miniaturist. Even when he worked in oil, James thought in the small, and his canvases, although stylistically close to Charles's, are more delicate. In a conversation piece (Pl. 29), he shows the members of his own family, each only a few inches high, moving naturally through a gay landscape built on three planes like a stereopticon view: in the foreground, rank weeds; in the middle, people; farther back, trees opening into a vista. James Peale, too, has never received the admiration he deserves.

The only member of the next generation of Peale painters to develop a personal style in the years immediately following the Revolution was Charles's nephew, Charles Peale Polk. As his portrait of Mrs. Isaac Hite and her son (Pl. 30) shows, he carried his uncle's manner in the more literal directions that characterized his Connecticut contemporaries. That hoary convention, a looped curtain *cum* tassle has become an identifiable piece of drapery, and so compelling was Polk's interest in actual possessions that the book on the lady's lap contains page number, legible text, and a copy of the illustration.

Since slaves had not yet proved their great value to the rising cotton economy, talk of emancipation was in the air, and Maryland aristocrats sat to a colored artist. Probably a pupil of Polk's, Joshua Johnston, nevertheless, remained a true primitive. He broke completely with the continuity of nature, yet held on for dear life to specific detail. In his *Charles Herman Williams,* no eye can fathom how the ivied arch fits into the picture space—yet every stone is carefully delineated.

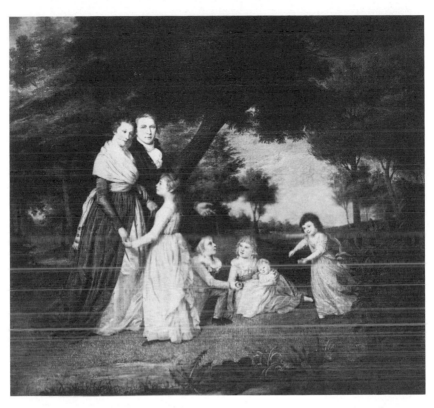

29 JAMES PEALE: James Peale and His Family (*Courtesy Pennsylvania Academy of the Fine Arts*)

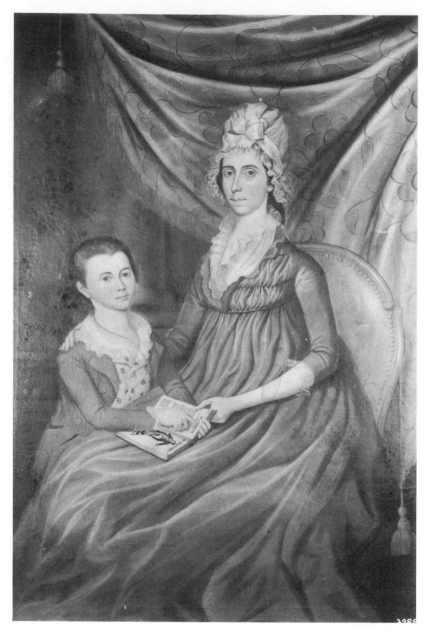

30 CHARLES PEALE POLK: Mrs. Isaac Hite and James Madison Hite, Jr.
(Courtesy Maryland Historical Society)

Signs by C. W. Peale's fellow student in West's studio, Matthew Pratt, creaked over Philadelphia's streets to the great admiration of sidewalk connoisseurs. In 1796, Pratt entered into a partnership with George Rutter and two talented young artists, William Clarke and Jeremiah Paul, "for the purpose of carrying on in the most extensive manner the different branches of portrait or other ornamental paintings: such as all kinds of emblematical, masonic, historical, and allegorical devices and designs for pictures; regimental colors and standards; ship's flags, drums, and every other decoration of that kind; . . . also fire buckets . . . coffin plates, japanned plates for merchants' counting houses."

When he undertook portrait work, Pratt painted, in the old Colonial manner, unadorned likenesses in which he probed for character with great seriousness, producing a homely, somewhat ugly prose. The much younger Clarke fell over himself to place on canvas details of environment. Behind Captain William Frazer, a window opens into a stable yard complete with horses, cows, grooms, hayricks. Governor Levin Winder is overwhelmed by lush landscape. There is much here of Earl's approach, but these portraits of Maryland worthies fly off into crotchets quite foreign to New England. From under a frilled cap three times the size of her head, Elizabeth Gibson languishes with a coyness quite frightening. Mrs. William Frazer sits, in her best clothes, on a rock. Behind her a headland frowns over a stormy sea, and in the foreground the artist has painted, with minute accuracy, a group of sea shells.

Risen from the ashes of the Revolution, the old portrait tradition was moving strongly in consistent directions, but there were harbingers of change. A new crop of artists was

seeking instruction abroad. To name four among many: Robert Fulton, the miniaturist who was to become a famous steamboat inventor, sailed in 1787; C. W. Peale's son Rembrandt Peale in 1802; the New York portraitist Samuel Lovett Waldo in 1806; the Philadelphia portraitist Thomas Sully in 1809. But more important than these departures was an arrival. Gilbert Stuart reached New York during the winter of 1792-93.

In London Stuart's substantial earnings and his mad extravagances had raced each other for years; then extravagance pulled so far ahead that he had found it convenient to disappear, leaving no address. During November, 1787, he turned up in Dublin, where he painted the wild Irish squires in the daytime and caroused with them at night. After about five years, his debts threatened again to overwhelm him. Since it was his habit to collect half his fee at the first sitting, he started a multitude of portraits, and then sailed for America. This, he told a friend, would make business for the Irish artists. "The likeness is there, and the finishing may be better than I should have made it."

When Stuart landed in New York, he brought to these shores for the first time a truly rich painting technique. Dunlap, who had also studied in England, felt as if he had "never seen portraits before, so decidedly was form and mind conveyed to the canvas"; naturally, men familiar only with the vernacular tradition were overwhelmed. Likenesses which Londoners would have considered unflattering and almost too exact seemed in America the height of elegance. Stuart became the favorite painter of the Federalist aristocracy who dominated the nation before the electoral revolution of 1799.

A comparison of Stuart's *Horatio Gates* (Pl. 32) with

31 ROBERT FEKE: William Bowdoin (*Courtesy Bowdoin College Museum of Fine Arts*)

32 GILBERT STUART: Horatio Gates *(Courtesy Mrs. Charles A. Pfeffer)*

William Bowdoin (Pl. 31), by the most accomplished painter of the Colonial aristocracy, Robert Feke, makes clear what had happened to American art and thought in half a century. Feke's shapes are stylized into a few simple, static forms, and his color, although charming, is inorganic, added to the surfaces; his technique is subjective while Stuart's is visual. In *Gates,* the shapes imply the complication of nature, and no sharp outlines separate them from the encasing air. Stuart's colors reproduce the effects of light striking texture and form. The flesh tones in particular are brilliant and naturalistic, recalling the artist's statement that flesh "is like no other substance under heaven. It has all the gaiety of a silk-mercer's shop without the gaudiness and gloss, and all the soberness of old mahogany without its deadness or sadness." Far from being a hard solid molded by a few variations of tone, Gates's face is soft and pliable, "the colors mottled and mingled, yet all is clear as silver."

In contrast to Feke's, Stuart's method was in the great European tradition, but when we turn from technique to content, we realize that the earlier artist was more traditional. Bowdoin is not shown as a specific person: face, pose, costume, setting, tell us only that he is rich and aristocratic and thus, so Feke implies, admirable. Although equally established traditions existed for showing famous generals, Stuart avoided them all. A British-trained soldier in the American Revolutionary army, the idol of New England radicals but hated by George Washington, the hero of Saratoga and the villain of Camden, Gates was an equivocal figure, and the strangeness of his personality is clearly marked, by feature and posture, in Stuart's portrait.

For roughly a decade after his arrival, Stuart created, in

New York, Philadelphia, and the new city of Washington, the type of likeness that had made his British reputation. A shrewd rendition of a face was embedded in a decorative setting. However, Stuart never particularized an environment in the manner of Earl: that would distract attention from what alone he considered important, the personality of the sitter. The costumes he painted did no more than imply elegance; chairs were swirls of pigment that became unrepresentational if studied closely; landscape backgrounds were chromatic suggestions of sky and tree and earth. Although ugly faces and ungainly poses were unsparingly reproduced, Stuart worked with such human understanding that the result was always dignified, never brutal.

Stuart now painted his most charming female portraits. His sophisticated eye was amused by girlish charm; he saved his admiration for maturity. *Mrs. George Plumstead* (Pl. 33) looks older than her twenty-four years. Her sharp eyes, staring from a cool and determined mind, warn the painter, the public, and the critic to attempt no undue familiarity. This is an image of pride, but Stuart did not react to social haughtiness with Feke's admiration and deference. Quite dispassionately, he studied Mrs. Plumstead as a particularly fine specimen of a sub-classification of Homo sapiens.

When, in 1795, Stuart finally got around to depicting President Washington, he did a strange thing. Now that America's most famous artist was painting the ruler of the new nation something noble seemed called for, a rhetorical portrait to outdo all the others, full of symbols indicating military might and temporal power. Instead, Stuart placed on a small canvas, against a background that was no more than an unrepresentational shading of colors, a soberly and quietly painted face

33 GILBERT STUART: Mrs. George Plumstead *(Courtesy Pennsylvania Academy of the Fine Arts)*

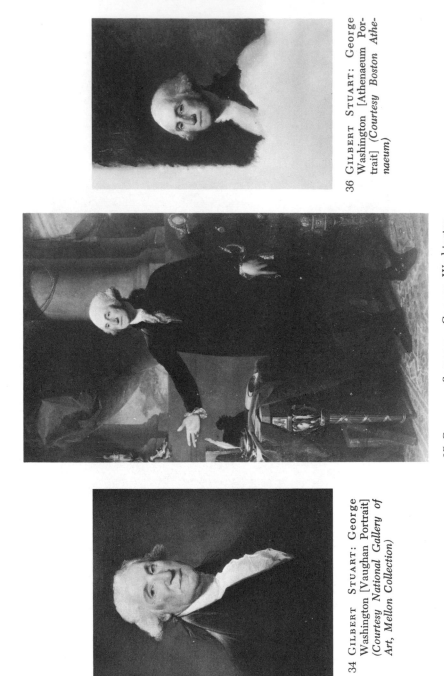

36 GILBERT STUART: George Washington [Athenaeum Portrait] (Courtesy Boston Athenaeum)

35 GILBERT STUART: George Washington [Lansdowne Portrait] (Courtesy Pennsylvania Academy of the Fine Arts)

34 GILBERT STUART: George Washington [Vaughan Portrait] (Courtesy National Gallery of Art, Mellon Collection)

(Pl. 34). He completed the composition—known as the *Vaughan Portrait*—with a plain lace ruffle and a dimly indicated torso that did no more than give the head position. Nothing exterior indicated that this was a great man; if we are impressed it is by the character shown.

No wonder the rich Federalists who were trying to reproduce in America the Court of St. James, with Washington substituting for the King, demanded a likeness more suitable to their aristocratic pretension. Always spending money faster than it came in, Stuart could not refuse so profitable a commission. He painted the so-called *Lansdowne Portrait* (Pl. 35) in which Washington, at full length, wades in an iridescent pool of noble symbols. Since Stuart had revolted against this kind of picture all his life, he became annoyed with his elaborate composition, and then tangled in it. Furthermore, his fundamental realism continually shattered the mood; he showed Washington's body as ungainly and his false teeth as disfiguring. Amazingly enough, the result pleased the Federalist tycoons and their ladies. But Stuart knew it was a failure.

Given a third chance, he created the *Athenaeum Portrait* (Pl. 36) which shows only Washington's features; Stuart never finished the body or the background. That this became the most admired representation of Washington and the most celebrated picture of its time gives us insight into American taste. Of course, much fancier likenesses continued to be painted, particularly when rich men wished to decorate a large room, or legislatures commissioned something grand to hang in a public building. At least since Feke and John Smibert had in the 1740's delineated the commanders of the siege of Louisburg, the historical role played by contempo-

rary heroes had been commemorated in full-length portraits with the scenes of their glories somewhat sketchily indicated in the background. Peale had kept this form alive during the Revolution with large canvases of Washington leaning on cannon while troops and bayonets emerged behind him from the smoke of battle; Trumbull, too, tried his hand at the mode. This idiom remained conventioned for official portraits throughout Stuart's lifetime, as is revealed by the number of such pictures, hanging in public buildings, that show heroes of the War of 1812. Yet these full lengths seem to have been favored for special occasions largely because they were unusual, apart from the ordinary fare of life and art. The people did not take them to their hearts the way they took Stuart's simple rendition of Washington's features. Concerned not with the hero's honors but with his character, they wanted to sit down in the same room with the father of their country, to meet him face to face.

Decorative arrangements of costume and setting had been forced on Stuart by the necessity to compete in London. In America, he feared no competition. He was, in the words of John Neal, the nation's most prolific early nineteenth-century art critic, "unquestionably at the head of American painters." A newspaper paragrapher, who wished to be listened to himself, complained that it would be "extraordinary . . . to hear an amateur decide on the merits of a picture before the opinion of Mr. Stuart should be known." One younger painter, Washington Allston, is reported by another, Thomas Sully, to have told a third, John Neagle, that Rembrandt, Rubens, and Van Dyck combined could not equal Stuart's likeness of *George Gibbs*.

Particularly after he settled in Boston in 1805, Stuart threw

37 Gilbert Stuart: Nathaniel Bowditch *(Courtesy Heirs of William I. Bowditch)*

overboard all his great skill at depicting textures and building decorative compositions. It is hard to imagine more brilliant renditions of features, but his pictures contain little else. Hands, which Stuart often painted with criminal carelessness, are omitted. He did not use pose or bodily shape as part of the characterization: torsos are mere notations showing there is something under the head. Unrepresentational surfaces of flat color, backgrounds are designed only to bring out the flesh tones of the face. Since so often Stuart's interest in a picture died once he had finished the head, some of his most exciting canvases are those in which he never went any further. His portrait of the geographer Nathaniel Bowditch (Pl. 37), which he abandoned at the instant his inspiration ran out, shows that in his fifties Stuart could paint like a youthful lyricist.

He had, indeed, never settled down into the golden calm of well-adjusted maturity; his nerves remained at hair-spring tenseness. Wine flowed unendingly down his throat and snuff rose in his nostrils; his tantrums terrified his wife and children; he sprang to heights of boasting and fell into pits of despair. Only too often it was impatience that forced him to finish his pictures crudely, any old way. Yet this carelessness had a rational base. In extreme revolution against aristocratic conceptions, he wished to isolate a personality from all considerations of class and property; this went for American merchants as well as British lords. Paring away extraneous factors he exposed what he considered the visual essence of a man: character as revealed by features.

In this sacred labor, the artist would admit no interference from the sitter or anyone else. If a subject dared make a criticism of an unflattering stroke, Stuart would slap down his

brushes and refuse to finish the portrait. Sully once stepped accidentally on an uncompleted canvas of Napoleon's brother, Jerome Bonaparte, as it lay on the floor of Stuart's attic. "You needn't mind," Stuart commented. "It's only a damned French barber." Far from kowtowing to the temporal great, Stuart insisted that genius outranked birth and that the great should kowtow to him. He had no respect for the ordinary business of life; no admiration for noblemen or generals or merchants with heavy moneybags. He admired only "commanding talents in literature or art."

Since the successful alone could pay his prices, he automatically ignored the mass of the population. When a vulgar citizen did penetrate into his studio, the contrast was startling. Dunlap tells us that a mantua maker, having won a lottery, "decorated herself with all the choice trumpery of her own shop," and "presented herself to the great portrait painter for immortalization. There were times and humors in which he would have refused the task, but he consented to share the prize, and painted the accumulation of trinket and trifle." The picture finished, Stuart exclaimed, "There is what I have all my painting life been endeavoring to avoid: vanity and bad taste."

A citizen of the eighteenth century, Stuart was concerned with a public rather than a private image. He saw women not as mothers but as poised inhabitants of drawing rooms. Far from being relaxed on vacation, his statesmen are about to address the nation. In the classical manner, he sought not extremes of movement or emotion, but the one facial expression that included all the others, that was the final summation of character. There was no place in his method for caricature or flattery, attack or adulation. As Neal wrote, "whatever he

puts down on canvas is like a record on oath: plain, unequivocal, and solid."

Stuart went beyond his own master, West, in his objection to the traditional pedagogic emphasis on draftmanship. "Drawing outlines without the brush," he pontificated, "[is] like a man learning the notes without a fiddle." He preferred the old Colonial method of making sketch and painting a single process. First he put on canvas a dim image, such as might be seen through a badly adjusted lens, and then in successive repaintings sharpened the focus. Thus he escaped completely from the strong outlines typical of neoclassicism and the school of West. If a painting attributed to his late years is even in the smallest degree liny, it is probably by another hand.

Stuart created primarily in color. He did not lay on his pigments in streaks as did his contemporaries, but placed little dots closely side by side. He told his pupils, "Preserve as far as practicable the round, blunt stroke in preference to the winding, flirting, whisping manner. . . . Never be sparing of color: load your pictures, but keep your colors as separate as you can. No blending. 'Tis destructive to clear and beautiful effect." As he grew older, his nerves made his hand increasingly unsteady, but this served to give a vibrancy to his surfaces that is far from unpleasant. Until his death at the age of seventy-three, he painted impressive portraits.

He pointed out that his practice was different from that of his European contemporaries, and he was proud of it. English taste he considered inferior to American because in London pictures were compared to other works of art while in the United States they were compared to nature: "Nature is the first and last school. . . . As your object is to copy

nature, 'twere the height of folly to look at anything else to produce that copy." Dependence on traditional formulas had brought all European art to "a standstill," since even the greatest master "hides nature instead of displaying it." Stuart expressed thus his attitude toward recipes learned from the great departed: "Does Rubens paint on a blue or yellow ground? Answer: He paints on just what ground he pleases."

A few residuary ties remained, but fundamentally Stuart had broken with the neoclassicism that dominated European aesthetic thought. He had no interest in the glories of the past. Arguments that art should concern itself with the general and the ideal struck him as comic. He was concerned with recording on canvas, as directly as he knew how, the real and the individual. When he told a fellow portrait painter, "You cannot be too particular in what you do to see what animal you are putting down," he anticipated the extreme naturalism of the much younger English landscapist, Constable, who was himself so far ahead of his time in Europe that his merits were only recognized by the most advanced spirits at the very end of his career. Indeed, in some particulars Stuart foreshadowed the point of view and the technique of Impressionism.

With great brilliance and exactitude, Stuart's portraits summarized the attitude of the emerging United States. Painter to the Federalist aristocracy, he created dignified likenesses of leading citizens, yet he was unswayed by rank or wealth. In this new world portrait gallery, each man's personality, viewed with the level gaze of a scientist, was recorded without fear of favor. Stuart was not a philosopher or a poet or any kind of a dreamer; the word "beauty" was not in his

vocabulary. He was a practical man creating objects as closely allied to social needs as were medieval cathedrals.

The religion of America's early national years was the religion of man. Its ethic was based on human rights. In the Declaration of Independence, in the Constitution, the phrases ring out like strokes of a carillon over a Sabbath city. No artist was ever more absorbed than Stuart in the cult of the individual man. He admired not people but person; not convention but human truth; not class and rank but character. Like any fanatic, he threw over all aspects of life that were not part of his faith. Even the cataloguing of a bourgeois' possessions was banned and Americans, who so loved their possessions, accepted this with the rest of his persuasive style.

CHAPTER SIX

Historical Painting in America

THE knowledge that in Europe only historical painting was considered the grand style had long troubled American painters and patrons. Most artists had made some gesture toward the mode, even if it did not go beyond copying on canvas a foreign engraving. In 1768, John Durand bought space in the *New-York Gazette* to read the public a lecture, abridged from Jonathan Richardson's *Essay on the Theory of Painting*, concerning the respect which had been accorded the grand style "by the people of the most improved minds and best taste and judgement in all polite nations in every age." Though Durand realized that "this branch of painting especially required a more ample fund of universal and accurate knowledge," than he could pretend to, he hoped that "the good nature and indulgence" of his compatriots would make acceptable his "humble efforts," and he offered "to work at as cheap rates as any person in America." The portraits Durand painted at the time of the advertisement show that he worked in a homely prose, the clumsy shapes given charm by sincerity.

Although a few altarpieces were commissioned, American churches commonly opposed religious art; and the relation-

ship of classical times to American life was small. Local his-
torical happenings seemed to most Colonials footnotes to
greater events taking place abroad. Up to the Revolution, the
grand style had usually been practiced as an affectation. But
now Americans had defeated an empire, and they intended,
by reforming the evil institutions that had corrupted all hu-
manity, to demonstrate to the whole world the perfectibility
of man. Even Europeans were impressed. No sooner had the
war been won than an Englishman rushed across the Atlantic
to record the victory.

A disciple of Reynolds, Robert Edge Pine, amazed every-
one with color harmonies unknown, since Stuart had not yet
returned, in the United States. However, Pine underestimated
American interest in realism. He painted on little oblongs of
canvas the faces of Revolutionary heroes, but failed to take
adequate notes on bodies. "When he began to put his figures
together," so wrote Rembrandt Peale, "remarkable effects
were produced, the head of a large man, for instance, being
put on a small body. The result was the total failure of the
historical painting."

In 1789, Trumbull arrived to pursue an objective similar to
Pine's. A brilliant and well-trained artist, with topflight Amer-
ican connections, he was offering to depict subject matter that
interested every patriot according to a novel style that had
been invented by a fellow American and was sweeping
Europe. Historical painting seemed about to begin a trium-
phal course in the United States.

Trumbull's *Bunker Hill* and *Death of Montgomery* were
being engraved in Europe, but he brought with him detailed
sketches for four additional pictures: *The Declaration of In-
dependence, The Capture of the Hessians at Trenton, The*

Death of General Mercer at the Battle of Princeton, and *The Surrender of Lord Cornwallis.* Traveling from Maine to South Carolina, he drew the actual topography of backgrounds and collected, as pencil drawings or oil miniatures, the heads of participants. The little oil likenesses are expert renditions of physical appearance, but not remarkably revealing of character. This suited well the historical paintings into which the portraits were placed. If individual peculiarities were greatly emphasized, the group emotion would be shattered. Each person should be recognizable as an individual, yet general enough to stand for all humanity.

In the historical paintings with which Copley and West had electrified London, a single character had occupied the spotlight; the others were supporting players. Except when Washington walked the boards, the American Revolution was unresponsive to such treatment; achievement was likely to reflect communal effort. In his battle scenes Trumbull conscientiously placed a dying commander in the center of each picture, but he was less concerned with an individual than with the engagement as a whole. And *The Declaration of Independence* (Pl. 38) has no hero; the eye is drawn to a central group which itself merges with the surrounding figures. This representation of legislative government was in opposition to the aristocratic conception of history as a succession of powerful individuals dragging mankind along in the wake of their imperious wills and majestic destinies. Trumbull foreshadowed the technique of such modern novelists as Dos Passos, who elucidate a period not by the experiences of a single character but by interweaving the lives of many men.

The lack of a single human focus was only one of the many

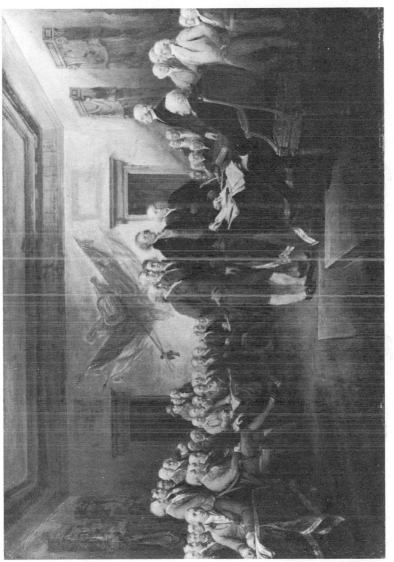

38 JOHN TRUMBULL: The Declaration of Independence (*Courtesy Yale University Art Gallery*)

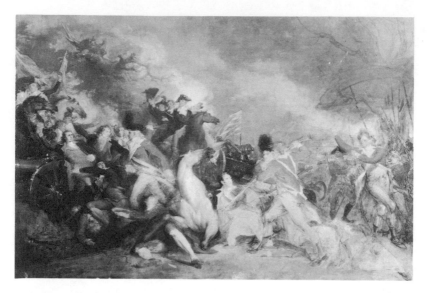

39 JOHN TRUMBULL: The Battle of Princeton [preliminary composition] (*Courtesy Yale University Art Gallery*)

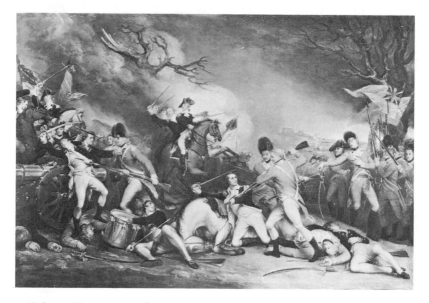

40 JOHN TRUMBULL: The Battle of Princeton (*Courtesy Yale University Art Gallery*)

problems that Trumbull solved in *The Declaration of Independence*. There is no real action, no unifying sweep of melodrama as in Copley's legislative scene, *The Death of Chatham* (Pl. 13). Nor did Trumbull, as West had done in *Penn's Treaty with the Indians* (Pl. 12), present a variegated series of gestures and expressions that could be read like a book. The canvas is small—twenty inches by thirty—and the forty-eight portraits are tiny. We take in at a glance the high-ceilinged room, the impressive grouping of many figures all moved by the same sense of the gravity of the occasion. A profound effect is achieved by expert composition, sophisticated chiaroscuro, and unifying color as solemn as the occasion depicted.

This quiet scene was the most successful of the pictures Trumbull completed in America. Now in his mid-thirties, he had left behind the rush of inspiration that a few years before had carried him to romantic heights. In the sketch for *The Battle of Princeton* (Pl. 39) he had made in West's studio, a mass of writhing men and horses are being piled up on the left of the canvas as if by an apocalyptic gale. The picture he completed in the early 1790's and repainted some years later (Pl. 40) shows only carefully drawn figures posing as if in a waxworks. The descent in quality is, indeed, frightening.

Things were not going well for the proud and gifted artist who had written Jefferson that he would continue as a painter only if the Americans subscribed enthusiastically for his engravings. In 1790, he had prepared an elaborate prospectus arguing that "no period of the history of man is more interesting than that in which we have lived. . . . If national pride be in any case justifiable, Americans have a right to glory in having given to the world an example, whose influence is

rapidly spreading the love of freedom through other nations, and everywhere ameliorating the condition of mankind." His entire series illustrating the Revolution would include fourteen pictures, but for the moment he only asked subscriptions at three guineas apiece for the two engravings being made in Europe.

Conditions in America were by no means altogether favorable to his project. There was not a national metropolis which, like London, brought to one place the leading citizens of the entire nation. Since distances were great and communications poor, no product—not shoes or clocks or prints—had yet been sold successfully on a national scale. Currency was so scarce in those post-Revolutionary years that few people could part easily with six guineas for two engravings, much less forty-two for fourteen. Nor could the government, hardly able to pay for practical necessities, appropriate money for art.

Equally serious was the inability of American engravers to do anything more complicated than execute simple line cuts and scratch emblems on gunstocks. Mezzotints of paintings had to be made abroad. The most expert printmakers were Englishmen who shunned scenes from the American Revolution. Although Trumbull placed his one depiction of an English triumph, *The Sortie from Gibraltar,* with the famous William Sharp, he was forced to carry his American subjects to continental mezzotinters, who proved slow and incompetent. The original canvases were abroad, being copied, when he circulated his prospectus; and he had no proofs to show.

However, Trumbull's Revolutionary scenes appealed naturally to many facets of American taste: to the universal delight in portraits, to a mingling of the new patriotism with the old yearning for high art. "His pieces," Washington wrote,

"so far as they are executed, meet the applause of all who have seen them. The greatness of the design and the masterly execution of the work, equally interest the man of capacious mind, as the approving eye of the connoisseur. He has spared no pains in obtaining from the life the likenesses of those characters, French as well as American, who bore a conspicuous part in our Revolution; and the success with which his efforts have been crowned, will form no small part of the value of his pieces."

How widespread was the agreement with such sentiments is shown by Trumbull's early subscription list. When Congress convened in New York, "I obtained the names of the President, Vice-President, ministers, seventeen senators, twenty-seven representatives, and a number of citizens." Leaders of every branch of thought supported his project: Jefferson and Hamilton, Madison and John Adams, Robert R. Livingston and Richard Henry Lee. The names of merchants, bankers, lawyers, scientists, and plantation owners jostle together to form a Who's Who of Federal America.

But about 1793 there came a great change. "Wherever I went, I offered my subscription book, but wretched was now the success, and rapidly decreasing the enthusiasm for my national work. The progress of the French Revolution was blasting to my hopes."

The Federalists were terrified by the increasing radicalism of the governments that succeeded each other in France, but not the Jeffersonians. "The whole country," Trumbull complained, "seemed to be changed into one vast arena on which the two parties, forgetting their national character, were wasting their times, their thoughts, their energy on this foreign

quarrel." He himself was far from remaining calm: "My whole soul," he stated, "revolted from the atrocities of France."

Calling on a young girl with many "personal charms," he found that extreme radical, Senator William Giles, already in possession of the drawing room. The two men squabbled about the writings of John Adams, until the lady, "with one of her sweetest smiles," squelched the Senator. A few days later, Trumbull went to dinner with Jefferson; who should be there but the miscreant Giles? This time they bickered about Christianity. Finally, Giles asserted that he regarded as "miserable delusion and priestcraft" the conception of "a Supreme Being" and "a future state of existence."

Trumbull rose from his seat and shouted invectives which he later summarized in sonorous periods: "Sir, in my opinion, the man who can with sincerity make the declaration which you have just made is perfectly prepared for the commission of every atrocious action, by which he can promise himself . . . the gratification of his impure passions. . . . Sir, I would not trust such a man with the honor of a wife, a sister, or a daughter. . . . Our acquaintance, sir, is at an end." He stamped out of Jefferson's house. When telling the story around Philadelphia, Trumbull felt it his duty to "elucidate the character of Mr. Jefferson" by stating that "in nodding and smiling assent to all the virulence of his friend, Mr. Giles, he appeared to me to avow most distinctly his entire approbation." The future president was not pleased to have a story told which represented him as what he was not, an atheist. "From this time," Trumbull remembered, "my acquaintance with Mr. Jefferson became cold and distant."

Trumbull liked to call his paintings "my national work," but he had mortally offended the section of the population

most likely to support his efforts. Not only were the Jeffer-
sonians rising to power, but they became the only group that
wished to remember the birth pains of the nation. Trumbull
himself stated the Tory point of view: "The calm splendor of
our Revolution, comparatively rational and beneficial as it
has been, was eclipsed in the meteoric glare and horrible blaze
of glory of Republican France." Conservative thinkers de-
cided that it would be better not to encourage the publication
of engravings that glorified civil conflict. Trumbull's orders,
which had reached 344 copies, stopped short. In indignation,
the artist threw down his brushes, crying that in America no
hope remained for the arts.

His Federalist friends came to his rescue. In 1794, Trum-
bull sailed for London as secretary to John Jay, the American
commissioner to settle differences that had arisen with Eng-
land. When the negotiations were completed, he did not re-
turn to painting, but became a picture dealer, buying old
masters which, because of the civil unrest, were available in
Paris. Next, he made use of his American citizenship to run
brandy across closed frontiers from France to England. But
the old masters were soaked in unloading, and the brandy
boat sank. So Trumbull returned to politics, serving as the
nonpartisan member of an Anglo-American commission to
oversee the execution of the Jay Treaty.

When this task was finished, it was 1804. Trumbull had
proved himself a useful negotiator, but, since Jefferson was
now president, he could expect no further governmental jobs.
"My political glory as well as my military," he mourned, "has
departed, to rise no more." His business ventures had without
exception failed. At the age of forty-eight, after neglecting

his brushes for ten years, he returned to America and "began my course as a portrait painter."

He had set his sights on Boston, but, when informed that Stuart was expected there, he settled in New York where there was an artistic vacuum. He was swamped with business. Working rapidly—five sittings to a head—he finished twenty-four likenesses in five months for top prices: $100 for a bust and $150 if he included hands. The best of his portraits are well composed and suavely colored. Reflecting the most up-to-date English styles, he often showed faces not at rest in classical calm but moving with romantic fire. Since he had no deep insight into character, his likenesses seem most particularized when he emphasized salient features in a manner that borders on caricature. In *The Rev. William Cochran* he pointed up the ruggedness of the face by executing the entire picture in a choppy manner; while to express the more subtle features of *Robert Benson* (Pl. 41) he painted quietly throughout, subordinating all detail to the appraising glance of the eyes and the quizzical curve of the lips. Even in these powerful likenesses there is a touch of formula—the eyelids for instance have a prefabricated almond shape—and in the majority of his portraits formula dominates. Such women as Mrs. Stephen Minot are given an empty beauty of broad brows, fine nose, and chiseled lips. Upon occasion admirable, none of Trumbull's new portraits could compare in quality with his earlier *Sir John Temple* (Pl. 20).

After the pictures by great names he had bought in Paris were water damaged, Trumbull had repainted them and sold all he could to English collectors. Now he exhibited the residue in New York. Dunlap was deeply impressed by what he considered the first exhibition "of original pictures by old

41 JOHN TRUMBULL: Robert Benson *(Courtesy New-York Historical Society)*

masters" ever held in America, but the public was not moved by what must have been a very pale reflection of European art. Admission fees did not pay expenses.

Trumbull spent his happiest hours denouncing Jefferson's administration. An extremist by nature, he might, had he been born into a liberal environment, have become an arch radical like his enemy Senator Giles. As it was, he marched so steadily to the right that every year his point of view was further separated from the productive evolution of American thought and society. The man who believed, upon occasion, that he "devoted his life to recording the great events of the Revolution," so hated and distrusted the forces it had unleashed that he eventually characterized republics as "that favorite phantom of the age." His interest in the stirring events he had pre-empted shrank into an empty idolatry for the reputation of Washington, seen from its most conservative angle.

After he had spent four years as a New York portraitist, the embargo was enacted. Convinced that Jefferson's policy "threatened the entire destruction of commerce and the prosperity of those friends from whom I derived my subsistence," Trumbull sailed back to England. Art, he shouted, was stifled by the taste, manners, and institutions of America.

The Londoners, with whose political principles he so heartily agreed, would certainly be eager to have him paint their faces! But, alas, he was no longer expert enough to compete in the British capital. He had engaged his passage back to the United States when the War of 1812 trapped him abroad. He was eventually to return, and to play a major role in art politics, but his period of aesthetic achievement had come to an end. Although that dubious honor is usually reserved for

Washington Allston, Trumbull was the first monumental example of aesthetic frustration in American annals.

His masterpieces were painted, either entirely or in part, when he was working in West's studio. The teacher may have helped him lay out his compositions, but this does not explain the quality of Trumbull's achievement, which depended on warmer color, more dashing execution than West ever achieved. Probably the major contribution of the dedicated older man was to overcome, during their period of close association, Trumbull's greatest weakness: his inability to devote himself wholeheartedly to art.

From the moment when, as a little boy, Trumbull had copied his sister's needlework patterns, he had been told that painting was an unsuitable profession for the well bred. His Harvard tutor had written his father that his "natural genius and disposition for limning . . . will probably be of no use to him." The father replied that he had "frequently" pointed this out. After his first trip to Europe, Trumbull had declaimed to his father that art had been the principal glory of ancient Greece. "You appear to forget, sir," replied the Governor of Connecticut, "that Connecticut is not Athens."

During the 1780's, no American familiar with the careers of Copley and West could maintain that art did not offer a good income to its most eminent practitioners—but so did saddle making and silversmithing. To make your living with your hands, be it at painting a house or a picture, was considered unworthy of a gentleman. True, art was an amusing diversion, but a "man who has talents for more serious pursuits" would no more want to be a professional artist than a professional fisherman. So deep-seated was the prejudice which had in 1735 made the Governor of Virginia feel sheepish at having

lent his carriage to a painter that Trumbull was the first truly well-born American to dare go against it. This far his courage went, but he did not have the further courage to be proud of his unconventionality.

In his marriage, Trumbull followed the same pattern. During 1800, he invited a few friends to an obscure church in London. A coach drove up, Trumbull helped a handsome, much younger woman to alight, and, without pausing to make introductions, married her. When one of his friends asked who she was, the groom replied, "Mrs. Trumbull, sir."

Although the painter loved his wife—he was to be heartbroken when she died—he continued to be ashamed of her. Perhaps in revenge, she gave him reason. Usually he kept her in retirement, but once, when they were traveling together, he "hesitatingly" asked some friends to invite her to dinner. "Mrs. Trumbull's appearance accounted for her husband's hesitation," a fellow guest remembered. "Her coarse and imperious expression reflected her low habits of mind, and her exaggerated dress and gesture betrayed lack of education. At dinner, Mrs. Trumbull drank glass after glass of wine and became abusive. Colonel Trumbull asked his host to forgive him. He had married, he explained, 'to atone for sin.'"

Mrs. Trumbull may have found some compensation for maltreatment in being linked to so splendid a man; the muses were not equally complacent. Certainly one of the indispensable qualities of great art is belief. As soon as an artist begins to doubt the importance of what he is doing, his hand cannot help wavering, his emotion must break. During those few years in West's studio, Trumbull seems to have believed.

When doubt crept in, he tried to buy it off with the promise of worldly success. If the government would establish a na-

tional policy of rewarding heroes with copies of his engravings, certainly no one could say he had wasted his time. And a large sale that lined his pocketbook would at least make him the equivalent of merchants who made killings in brandy. Like a rickety barn hastily patched with baling wire, his belief in art toppled under the first adverse wind.

It is impossible to know whether a man more like West—resolute, discreet, democratic in outlook, and profoundly convinced of the importance of art—could have used the admiration for his method and the popularity of his subject matter to overcome the many practical pitfalls that menaced a historical painter in the United States. Yet it is clear that Trumbull's debacle did much to determine future American directions. Young men who yearned toward high art were profoundly depressed by the fact that a painter with so many advantages, who had worked so brilliantly but had achieved so little, loudly blamed his frustration on his countrymen's lack of taste. And as the self-styled friend of Washington, the possessor of an archive of life portraits no beginner could duplicate, Trumbull stood for a half-century between his colleagues and the historical events that remained the great American legend.

The Thing Itself

CHARLES WILLSON PEALE, who gloried in the results of the Revolution as Trumbull was unable to do, celebrated the victory by building across Market Street in Philadelphia an arch, forty feet high. It was embellished with allegorical statues and with transparent paintings, designed to be lighted from behind, of such subjects as *Washington in the Character of Cincinnatus Returning to the Plough*. A gigantic figure of *Peace* was to appear unexpectedly on a neighboring housetop. Illuminated by lamps in the clouds on which she trod, the goddess was to slide slowly down a rope to the dark arch below, which, at her touch, would blaze into light as hundreds of rockets roared into the air. Unfortunately, while Peale was making final adjustments on the summit of the arch, a drunken reveler ignited the rockets, several of which exploded inside the painter's coat, or so he thought. Thus peace was ushered in not by a descending goddess, but by an incandescent painter. However, it took more than powder burns and a forty-foot fall to discourage Peale for long. He rebuilt his arch.

When the celebration was over, Peale did not consider the historical paintings he had so lovingly painted and repainted

worth preserving; his two years in West's studio had convinced him that the grand style demanded more training, different skills than he possessed. To commemorate the Revolution in a permanent form he turned to the art with which he felt at home. He importuned the heroes of the conflict to let him paint their heads and shoulders; soon he had a gallery of historical likenesses which he showed in his studio for a fee.

Peale was urged to this move by the unwillingness of prosperous Philadelphians to give portrait commissions to a man who regarded as social-revolutionary a conflict that they had decided to interpret as a quarrel between aristocrats. Since the artist, for his part, did not wish to cater to the luxury and self-esteem of the rich, he was not sorry to make his living from exhibitions that attracted the citizens who were eventually to put in power his dear friend Jefferson.

When he thought of himself as a showman, he escaped from self-consciousness. Mounting the wild horses of his inspiration, he galloped off in new directions. His first experiment would still be advanced today. On learning that Philip de Loutherbourg, Garrick's scene painter in London, had created miniature stage sets that moved to tell a story, Peale recognized "a new kind of painting." He created six "pictures" which he advertised in 1785 as "perspective views, with changeable effects, of nature delineated in motion."

Peale showed dawn rising over a rural landscape; night sinking on Philadelphia's Market Street; a Roman temple battered by a thunderstorm that ended in a rainbow; and a view, exploding with fire and brimstone, of Satan's palace as described by Milton. There was also a historical painting of a Revolutionary sea battle which he described in these words: "*The Bonhomme Richard* and *The Serapis* was represented

at the extreme and opposite ends of the picture in full sail with a fine breeze, as represented by the waves in pleasing motion, a fleet in the distance going into Scarborough. The two ships, approaching each other, begin to fire: the flash and distant reports imitated. They are now closely engaged and the sails are torn in holes. The sea gradually becomes calm, and, midnight coming on, the moon rises. The fight continues and the *Serapis* is on fire and afterwards extinguished. Her main mast falls and then [she] strikes her colors. The firing ceases. Afterwards, the day breaks, and the sea becomes agitated. The American colors are hoisted on board the *Serapis*. *The Bonhomme Richard,* being greatly shattered, begins to sink from the sight of the spectators in a slow manner until she gets so low as to pitch her head down and quickly passes out of sight. And then the *Serapis,* brassing [bracing] about her yards, pursues her course, which ends the scene."

In his moving pictures Peale blended with controlled lights painting, sculpture, and natural objects. Carved waves were agitated by cranks, while real spray spurted upward from concealed pipes. Painted transparencies, passed one over the other before candles, created airy effects. Foreground objects were either flat cut-outs or three-dimensional properties. Not to be outdone by any Hollywoods of the future, Peale sustained mood with the music of a specially built organ. At first his mobile montages were a great success, but he discovered that interest could only be kept alive by a perpetual succession of new features that cost too much in money and time.

Turning to what he considered still another kind of painting, he determined to reconstruct "the world in miniature." In 1787, a visitor to Peale's studio noted that "natural curiosities were arranged in a most romantic and amusing man-

ner." The artist had built a landscape out of a mound of turf, trees, a thicket, and a pond. On the mound were "those birds that commonly walk the ground," and also a stuffed "bear, deer, leopard, tiger, wild-cat, fox, racoon, rabbit, squirrel, etc." The boughs of the trees were loaded with birds and the thicket was full of snakes. On the banks of the pond were shells, turtles, frogs, lizards, watersnakes, while in the water stuffed fishes swam between the legs of stuffed waterfowl. A hole in the mound displayed minerals and rare earths. "What heightened the view of this singular collection," the traveler concluded, "was that they were all real, either their substance or their skins finely preserved."

"Peale's Museum" now became the artist's principal interest. It grew until it filled most of Independence Hall, and became one of the major cultural institutions in the United States. Since the theater was often considered immoral, so-called "museums" which specialized in odd mechanical devices and waxworks of heroes and horrors had a long history in America as centers of amusement. But Peale's institution, although baited with frivolous attractions, was basically serious. It was one of the first important efforts in the entire Western world to bring natural history to the people.

His fellow members of the American Philosophical Society influenced Peale to classify his specimens scientifically and show the development of nature from "the lowest orders" to "natural man." Carefully written labels carried the message to the public. The painter even delivered lectures on botany, though his personal motivation remained primarily artistic.

All his aesthetic skills were brought into play. To show animals in their natural habitats, he constructed grottoes out of imitation rocks, built trees, and painted as backdrops land-

scapes that showed everything from the aerie of the eagle to the burrow of the prairie dog. Finding that ordinary taxidermy did not produce a lifelike effect, he stretched skins over cores which he had carved in wood with all the muscles indicated. Arrangement was a perpetual task. His rooms were a kaleidoscope in which there formed and dissolved pictures of the entire world and all its inhabitants: minerals and plants, insects, birds, and quadrupeds joined at his command into vast compositions. Man was represented by Peale's gallery of portraits and by a collection of artifacts, Roman and American Indian gods standing quietly side by side. But humans did not have that starring role in which they had for so many centuries cast themselves. "Science," Peale wrote, "would be considerably benefited by ascertaining the real difference that exists in nature" between men and monkeys.

Peale's display techniques, which were so far ahead of their time that many were rediscovered during the twentieth century, were a logical though startling reinterpretation of West's neoclassicism in the light of science and the bourgeois interest in things. The historical painter, West believed, should reconstruct accurately all the physical aspects of his scene—setting, pose, costume—and then use imagination in their arrangement. Peale capped this formula by substituting for painted effigies the objects themselves. His purpose was also moralistic, but he stepped into the future by emphasizing, instead of the deeds and dreams of men, nature and natural law.

West's paintings had reflected the philosophy of low-church Protestantism; Peale's museum was a hymn to deism, the faith of Franklin and Jefferson. The belief that natural goodness had been corrupted by evil institutions led such

thinkers to conclude that God resided not in churches built by the clerics of any sect, but in His own cathedral, under the arches of the trees, lighted by His lamps: the sun and the moon and the stars. If you wish to know the Divine Word, listen to the singing of the birds, read the calligraphy of shadows on the grass!

Peale wrote, "Was our ministers of the Gospel more frequently to illustrate the goodness of the Almighty in the provisions He has made for the happiness of all His creatures, that excellent code of Christianity would produce more votaries of charity, love, and forebearance." Peale saw no conflict between God and science, religion and utility. "As this is an age of discovery, every experiment that brings to light the properties of any natural substances helps to expand the mind, and make man better, more virtuous, and liberal. And what is of infinite importance in our country, creates a fondness for finding the treasures contained in the bowels of the earth, that might otherwise be lost."

Peale loved to tell how two hostile Indian tribes, who had never met except on the warpath, looked up from his exhibits to find themselves side by side. Reminded by their surroundings that all men are brothers, they agreed to bury the hatchet. The doctrine that nature and virtue are one was to inspire the landscape painters of the early nineteenth century. As Jefferson was to Washington, as Wordsworth was to Gray, as Constable was to Richard Wilson, so were Peale's natural history constructions to the historical paintings of West.

As an attraction for the public—and to delight himself—Peale created what he called "deceptions." He continued a stairway up a blank wall with paint and depicted two of his sons climbing the illusion. What was his delight when Wash-

ington, fooled by a dim light, gravely bowed to the imaginary gentlemen! Alone among his deceptions, this *Staircase Group* has survived. When their usefulness had passed, he tended to throw them away, along with all the other art work he created for his museum.

Every few years he publicly renounced easel painting. Like Trumbull, Peale was unable to stick to art, yet his reasons were very different. Trumbull felt painting was unworthy of so great a man; Peale felt himself unworthy of so great an art. Furthermore, innumerable things fascinated him. Not a gentleman ashamed of a manual trade, he was an artisan whose hands itched to have a go at everything. Even some of his own children complained because his activities and enthusiasms carried him perpetually beyond genteel bounds.

His museum was only one of his many activities. He invented bridges and stoves and windmills and vapor baths; he promulgated medical doctrines, some remarkably advanced; he experimented with false teeth, artificial limbs, eyeglasses, aids for the deaf, and methods of embalming. In his spare time, he just tinkered. He wrote of himself, "Peale's active mind kept his hands constantly employed, and at his leisure moments here he made a fan to keep off flies, and to fan the air for the refreshment of sitters at their meals; and his watch did not please him." He made it over. "This sort of work gave him amusement, yet," he added piously, "it was always misspent time."

Even on the road he had to keep himself amused. Too humane to use whip and spur, when his horse got balky, he would pull a book out of his pocket and read until the animal got so bored he started again by himself; "this mode of treatment completely broke him of such tricks." Traveling through

Maryland in a carriage, he harnessed with the horses a stuffed fawn and several other specimens, which, he reports, "excited much curiosity along the road."

Peale's greatest triumph as a museum curator led him indirectly back to painting. He dug up, near Newburgh, New York, two almost complete mastodon skeletons, and, when the bones were put together, human eyes saw, for the first time in many millenniums, the semblance of a prehistoric monster. The excitement was international and, in 1802, he sent his favorite son, Rembrandt, to London with one set of bones.

Like other members of the family, Rembrandt had learned painting at his father's knee; as *Hugh McCurdy* shows, by the time he was twenty he was painting charmingly in Charles's graceful, old-fashioned manner. Between exhibiting the bones and lecturing on them, Rembrandt studied briefly at the Royal Academy and with West. Abandoning his father's archaisms, he moved in the directions pioneered by Stuart, toward an interest not in grace but in exact representation of features. When, after his return to Philadelphia in 1803, he painted Mrs. William Finney, he depicted the contours of her not-too-attractive face with still-life accuracy, as if she were an apple.

Charles had sworn off painting six years before, but he could not resist trying out his son's new tricks. Impressed by Rembrandt's improvement in coloring, he begged for lessons. The brush felt agreeable in his hand, and, Baron Humboldt being in the city, he diffidently asked the famous naturalist to pose, giving him in return "a presevered allegator." The picture he created delighted him.

A doting father learning from his son, the sixty-five-year-

42 CHARLES WILLSON PEALE: James Peale (*Courtesy Detroit Institute of Arts*)

43 CHARLES WILLSON PEALE: The Exhuming of the Mastodon (*Courtesy Municipal Museum, Baltimore*)

old artist felt he was beginning all over again, and with startling suddenness his style moved into line with that of the younger American painters. He abandoned the charming generalizations of his earlier work; he reproduced faces exactly. The moles and disfiguring wrinkles he once suppressed became important parts of the characterization, and often he reproduced his sitter's possessions with all the passion of an Earl or a Moulthrop. His portrait of his brother James (Pl. 42), painted when he was eighty-one, gives us an affectionate yet unflattering view of the miniaturist engaged in his trade under the light of his favorite lamp.

That an elderly painter could practice a new style so powerfully reveals how profoundly suited it was to his temperament. Indeed, Peale's earlier work had been increasingly inconsistent for a man who was building the universe over again out of actual specimens, a fact which may well have caused the dissatisfaction that had made him, in middle life, abandon his art. Now he was happy with his art, and, since his likenesses suited the more advanced thought of his time, his friends assured him he was painting better than he had ever done.

The success of his *Baron Humboldt* encouraged Peale to undertake in 1806 a historical painting of sorts, to depict that great moment of his own life, the exhuming of the mastodon. However, he so "doubted my abilities to make a tolerable picture" that he did not purchase a suitable easel. "As I advanced in the work," he continued in a letter to West, "it seemed to engross my whole attention, and I really took pleasure in painting from morn till night, and even to use lamp light. I then ordered the cabinet maker to make me a commodious mahogany easel, etc., so instead of burning my pen-

cils and totally quitting the art, as I thought very probably would be the case, I found it much less difficult than I imagined, and have ever since regretted that I had not taken a larger canvas and devoted more time to give a higher finish to the piece."

The Exhuming of the Mastodon (Pl. 43) makes us realize how much American art lost through Peale's lack of self-confidence in aesthetic matters, for the picture exemplifies an approach well suited to American conditions. It is a historical painting without artificiality, a conversation piece of more than private interest, a genre scene rooted in local soil. We see men working as all Americans worked, using, as was universal, an ingenious and jerry-built device to increase the effectiveness of their hands. Their objective was not military glory or political action, but the exploration of their continent; and to achieve so glorious an end they did not hesitate to wade in mud like European laborers. Science and wonder inspired them; the endless chain of buckets, hitched to a crude wheel, lifted away the mire that obscured the skeleton of dream.

True, the picture is not a masterpiece, but the naïve composition and the childish drawing only half obscure that exuberance of life, that unfeigned and unposing passion that is the breath of art. The artist makes us feel the enthusiasm he himself felt when guided to the marl pit where fossils had been found: "Behold," Peale wrote in the third person, "it was a spacious hole now filled with water. The pleasure he felt at seeing the place where he supposed his great treasure lay, almost tempted him to strip off his clothes and dive to the bottom to feel for bones."

Here was a type of picture that an American could paint

out of his own experience, in deep belief and with no affectation. However, Peale would never have dared consider *The Exhuming of the Mastodon* as more than a family memento. Even his new enthusiasm could not make him forget what he had been taught: that out of such elements great art had never been made.

CHAPTER EIGHT

The Scope of Art

CHARLES WILLSON PEALE'S experiences in teaching his relatives to paint made him wish for a school of the fine arts which would "supersede the necessity and save the expense of a foreign education." As was done by the Royal Academy, the school could be supported by entrance fees to an annual exhibition which would, in its turn, bring contemporary American art before the public. With Peale, to think was to act. On December 29, 1794, he called a convention of artists at his museum. It was a large and polyglot group, for the national capital of the new nation had figured as a happy hunting ground in the minds of mediocre workmen from all over Europe. Newspaper advertisements reveal the presence of artists from London, Edinburgh, Dublin, Stockholm, Copenhagen, Berlin, Paris, Bordeaux, Geneva, Rome, Venice, and Santo Domingo. With these foreigners, there mingled a goodly number of native-born painters, sculptors, and architects.

Some Englishmen, who could never have squeezed into the Royal Academy at home, saw Peale's scheme as a delightful opportunity for glory. The miniaturist Robert Field, confided to a friend his expectation of "making a figure in an

Academy of Arts and Sciences now establishing here, the plans for which are the most enlarged, liberal, and grand of any in the world. The President is much delighted with it, and will, when it is in a riper state, become the principal patron." This point of view touched off a controversy reflecting the war between England and France in Europe, and the political enmity between Federalists and Jeffersonians at home. The Britons wished to set up an authoritarian institution, patronized by the President as if he were a king, which would dictate the development of art throughout the United States. "Visitors" would travel from Philadelphia to other cities, and judge which of the local practitioners were worthy to become academicians in the national capital. The faction led by Peale and the figurehead carver William Rush was horrified by such notions. They thought of themselves as a group of workmen banded together for mutual advantage; workmen in other cities might do the same. No one was better than anyone else. The Corsican sculptor Guiseppi Ceracchi, who was to die in an attempt to assassinate Napoleon as a betrayer of republicanism, attacked the authoritarian faction with such vehemence that eight English artists resigned and tried to set up a rival institution.

A spirited engagement was fought in the press. The seceders charged Peale's group with "preventing and cramping the original idea of a National College into a contracted plan for an academical drawing school." Peale's faction replied, "Although many of us are not foreigners, but citizens of the United States, we would not presume to establish a national institution which would place similar institutions in other states in a subordinate position. Some gentlemen, who fancy themselves a better order of beings, imagine themselves equal

to the most stupendous projects . . . but America is not the soil to foster seeds of such vanity and arrogance. . . . We will leave conceptions so profound as a national college . . . to those who started up from the hot-beds of monarchy, and think themselves lords of the human kind. . . . We are not in monarchical subordination here."

Both sides called for recruits. As a group, the Philadelphia artists were Jeffersonians; they flocked to the liberal banner, while the English faction secured only one additional member. The secessionists thereupon left the field to Peale's "Columbianum, or American Academy of Painting, Sculpture, Architecture, etc." Its published constitution added engravings, models, enamels, and drawings to the specialties of the organization; provided that not more than half the members could be amateurs; called for an annual exhibition limited to works of modern artists never before shown in America; provided for lectures on relevant subjects from perspective to chemistry, for a gallery of old masters—as soon as the society secured some—a library, and classes in drawing from casts and from life.

A baker was persuaded to pose naked, but no sooner had he emerged into the stare of many eyes than he fled back to cover. Although Peale stripped off his own clothes, it was an inauspicious beginning. The life class soon petered out, and the Columbianum itself, weakened by its internecine quarrels, collapsed within the year.

But first the academy held, in 1795, a group exhibition. The catalogue, which gives the earliest cross-section view of the work being produced in an American center, underlines the fact that portraiture was not, as is usually stated, the artists' exclusive interest. Thirty-seven painters exhibited;

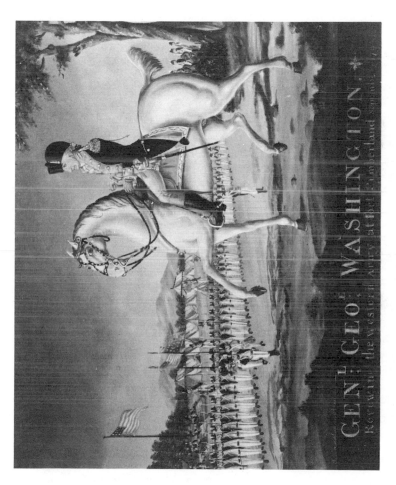

44 Frederick Kemmelmeyer: General George Washington Reviewing the Western Army at Fort Cumberland (*Courtesy Hall Park McCullough*)

45 Jeremiah Paul: Children at Play (*Courtesy Arthur J. Sussel*)

nineteen, or almost exactly half, showed likenesses, and many of these also submitted pictures in other modes. Almost as popular as likenesses were landscapes and still lifes, each exhibited by eleven painters. Three artists showed historical paintings, three showed maps, and there was one example of genre. These figures are not proved false by the fact that the majority of the canvases surviving from this period in Philadelphia are portraits. When nineteenth-century taste came to regard all American art as crude, only likenesses that appealed to dynastic pride seemed worth preserving. The ash can yawned for every other type of picture.

Two of West's pupils who were active in Philadelphia painted, upon occasion, the subject matter of the grand style —C. W. Peale in transparencies, Pratt in signs—but neither had the courage to exhibit any efforts in this manner. The three historical paintings were by the deceased Englishman, Pine, and by amateurs identified as "a gentleman" and "a lady of Philadelphia." The grand style was practiced without shame only at the extremes of technical competence: by those who dreamed of being great artists and by those who did not care. Frederick Kemmelmeyer and William Mercer, who failed to exhibit at the Columbianum, may be taken as typical of the second group.

A sign painter and drawing teacher, Kemmelmeyer did not hesitate to paint Washington as he had seen the hero, on his last military mission, reviewing the troops gathered at Fort Cumberland to put down the Whisky Rebellion (Pl. 44). Although stiff and crude, his several versions of the subject are charming in color and delightful in design. Almost as primitive is *The Battle of Princeton*, by Mercer, which shows the death of the painter's father, General Hugh Mercer. The

artist was a deaf-mute whom Peale, inspired by a warm heart and experimental curiosity, taught to paint after a fashion. It is typical that the half-educated pupil dared what his foreign-trained master would not have attempted.

The one genre painting at the Columbianum, *A Boy Holding a Cat to a Mouse,* was by Pratt's partner Jeremiah Paul. "This," Dunlap wrote, "is one of the unfortunate individuals who, showing what is called genius in early life . . . are induced to devote themselves to the fine arts, without the means of improvement or the education necessary to fit them for a liberal profession. . . . He was a man of vulgar appearance and awkward manners." Dunlap disdained Paul for daring hugely; he mocked this sign painter who exhibited in an engraver's window during 1811 *"Venus and Cupid,* nine feet by seven, taken from living models." Paul's career was, indeed, not glorious. A drunkard, like so many of his colleagues, he drifted unsuccessfully from city to city, seeking business at last in the new settlements of the Ohio Valley, where he painted "phantasmagorias" and theatrical scenery.

A surviving composition by Paul (Pl. 45) shows a small girl sketching on the pavement a portrait of a boy who stands with amusing self-consciousness. Two other children play with a tub of water. Extremely interesting is the organization of space, the stark background with its deep perspective. The picture may well be based on an engraving, yet it has a vitality of its own.

No one needed to be shy about attempting still life. Fruit and flower pieces were a standard exercise for beginners, and documents reveal that such representations of actual objects had been prized by American collectors since the first years of settlement. At the Columbianum, the usual decorative sub-

46 RAPHAELLE PEALE: Still Life *(Courtesy Detroit Institute of Arts)*

47 JAMES PEALE: Still Life *(Courtesy Worcester Art Museum)*

48 JARED JESSUP: Overmantel, Burk Tavern, Bernardston, Mass. (*Courtesy Pocumtuck Valley Memorial Association*)

jects were supplemented with representations of game, fish, and raw meat. "Deceptions" fooled the eye into accepting the actual presence of a painted image.

Although all the still lifes shown at the Columbianum have vanished, we have many examples painted after 1815 by two of the exhibitors, C. W. Peale's brother James and his son Raphaelle. Their closely related little canvases (Pls. 47 and 46) reflect Dutch models of the seventeenth century. Edges of tables make horizontal lines at the bottoms of most of the pictures, while bowls, with the fruit that fills and surrounds them, stand out before plain walls. The lighting is arranged unnaturalistically to present sharp contrasts: where the foregrounds are most brightly illumined the backgrounds are in shadow, and on the rear walls light and shade break in sharp diagonals. James's pictures display abundant leafage and ribbon-like tendrils; Raphaelle's are more simply composed. James made his highlights self-contained spots of color, while Raphaelle blended them into the mass with halftones, thus giving his forms more solidity. Both men handled their colors agreeably to achieve the greatest possible verisimilitude. Organization of weight and space, so important to modern still-life painters does not seem to have consciously concerned the Peales; their objective was decoration grounded in literalness.

Like most of Charles's sons, Raphaelle fiddled with museums. He amused customers by making them grope on walls for objects that were not really there. A surviving "deception," *After the Bath*, was painted to tease his termagant wife, who, according to the Peale biographer, Charles Coleman Sellers, "comes storming into his painting room—what is he about now? A large canvas rests upon the easel. Something indecent, as far as she can judge, by the bare feet at the bottom, and

the undressed hair held up on a slim woman's hand, at the top. But the man has concealed the rest, fastened a tape across it and to this has pinned one of her best linen napkins. She goes instantly to retrieve the cloth and learn what lies behind it—only to find, with her fingers against the canvas and the laugh upon her, that linen and canvas are one, a painted picture only." Conceived as a joke, the canvas forced Raphaelle to concern himself with the almost abstract design caused by light striking the folds of a white napkin.

At the Columbianum, landscape vied for popularity with still life. Again the actual paintings shown have vanished, but many landscapes created in that period remain. They range from purely decorative combinations of natural elements and factual portraits of places to reflections of academic British landscape art.

The decorative combinations were painted directly on walls, or on boards that were built into paneling. As was the case in earlier generations, such pictures are increasingly effective the further they break with reality, the more they are in a wallpaper not an easel-painting tradition. Attributed to Jared Jessup, who seems to have worked exclusively as an interior decorator, an overmantel (Pl. 48)from the Burk Tavern, Bernardston, Massachusetts, weaves a harbor town, complete with shipping, a horseman, and a prominent tavern, into a formal pattern beautiful to modern eyes. How it appeared to nineteenth-century eyes is revealed by the hole mercilessly cut into it for a stovepipe.

At the time of the Columbianum, as in earlier generations, artists tramped the American countryside making in water color what were advertised as "perspective views of gentlemen's estates." When they sketched cities or natural wonders

that would interest many people, their drawings were sometimes engraved. In England, such activity was to flower in the work of Girtin and Cotman into authentic landscape art, but these men were yet young, and the leading foreign water colorists did not come to the United States. There arrived, instead, a perpetual succession of minor Europeans, both amateur and professional, who joined with native artists to create a steady stream of topographical views.

Among the most prominent practitioners of this art form was the Scotchman Archibald Robertson. His presence reflected an effort to found an art school aimed, not at professionals like Peale's, but at amateurs. When Robert R. Livingston and other New York patricians wished their children to learn the polite accomplishment of drawing, they decided that a suitable teacher could not be found in America. A professor at King's College, Old Aberdeen, recommended Robertson, who with his brother, Alexander Robertson, in the early 1790's set up the Columbian Academy at New York. They did not bother to teach ladies and gentlemen how to paint in oil—water color was a more suitable medium. Although in a book of art instruction he published, Archibald paid lip service to historical painting as the highest mode, he stated that landscape was the form which "every man may have occasion for. . . . Rocks, mountains, fields, woods, rivers, cataracts, cities, towns, castles, houses, fortifications, ruins, or whatsoever may present itself to view . . . may thus be brought home and preserved for future use, both in business and conversation."

The method the Robertsons taught had been evolved for the production of aquatint engravings, in which the plate printed a graduation of values from gray to black that gave

contour and shape to transparent water-color washes later applied flatly by hand. Drawing in "the light and shade" before adding colors, Archibald wrote, enabled beginners to achieve "with very little labor . . . a considerable effect." *The Collect or Fresh Water Pond* (Pl. 49) by Archibald or one of his pupils reveals both the charms and the weaknesses of the result. The composition has grace, but the even washes give neither strength nor vibrancy. Most serious and typical of all is the lack of any real feeling for nature. There is no air in the spaces, no mood in the sky, no growth in the trees, no dirt in the ground that has been tinted according to an artificial and elegant formula.

That drawings by the Robertsons and others were sent abroad for reproduction (the art of aquatint engraving was unknown in the United States) reveals a real interest in American scenes. Beginning in 1787, various American magazines published local landscapes engraved in line on copper. The exact spots depicted are identified in the titles, yet the accompanying texts often generalize, trying to catch in words wide implications which the uninspired renderings of physical topography miss. Thus *A View at Minisink, New Jersey,* drawn by Jacob Hoffman, is described as "an elegant rural prospect from a part of our country which affords as many novel and romantic scenes as a lover of the charms of nature can anywhere meet with, or as the most enthusiastic artist could desire." *View on Mushanon River,* also engraved after Hoffman, is said to demonstrate that "no quarter of the world, however celebrated, affords more novel and sublime scenes than are to be met with among the romantic wilds of America." The desire to show nature luxuriating in all the glories of her local raiment, which was to inspire the Hudson River

NEW YORK.

49 ARCHIBALD ROBERTSON (?): The Collect or Fresh Water Pond (Courtesy Edward W. C. Arnold Collection)

50 WILLIAM GROOMBRIDGE: English Landscape (*Courtesy Maryland Historical Society*)

School, was already present, although the skill to give it visual form was not.

Among the English workmen who flooded into the new nation after the Revolution, there were many who painted landscapes in oil: a richer tradition than that of the water colorists, if a more conventional one. Roots went back to the classical serenity of Claude Lorrain, the tempests of Salvator Rosa, and the modified realism of the Dutch. Through the years these influences had interwoven into formulas, more direct when the Dutch element was more predominant, but always applicable by rote.

The most distinguished of the immigrants was Charles Catton, Jr., who spent the last fifteen years of his life on the banks of the Hudson. "During his residence in the United States," his obituary tells us, he "devoted attention principally to agricultural pursuits, and seldom exercised his pencil, except to gratify personal friendship, or enliven the dull monotony of rural winter life." Yet in his last years many of his pictures—they are all lost—were exhibited at the American Academy in New York. If in his English manner, they were impressive farm scenes, half landscape and half genre, done in a style basically derivative but lightened with personal vision. The British historian Grant considered him "a strong and able painter" who combined Morland's choice of subject with the "virile land" of James Ward and the "finished draughtsmanship" of John Herring. C. W. Peale was so impressed with Catton's rendition of *Noah's Ark* that he copied it for his museum.

During the 1790's, four British-born landscapists made their headquarters in that secondary art center, Baltimore. Three were conventionally trained: George Beck, William

Winstanley, and William Groombridge, the last a seceder from Peale's Columbianum. Failing to look at nature with their own eyes, they painted America as if it were England, vended sterile recipes. George Washington bought two landscapes by Beck and four by Winstanley, and several of Beck's American views were handsomely engraved in England. Yet all three painters failed to make good livings from their art. Groombridge and Beck turned to schoolteaching, while Winstanley's greater enterprise carried him into painting panoramas and forging Stuart *Washingtons.*

The fourth Baltimore landscapist, however, sold his paintings by the hundreds. While his rivals had been studying art, Francis Guy had been apprenticed to a tailor in Westmorelandshire. Groombridge and Beck had exhibited at the Royal Academy; Guy had invented machines for glazing silk and had become—or so he claimed—"calender and dyer to Her Majesty." Failing to keep ahead of his creditors, he had fled to America, where, first in New York and then in Philadelphia, he had set up factories to apply his new methods. When success still evaded him, in the words of Rembrandt Peale, he "boldly undertook to be an artist, although he did not know how to draw." This was about 1797.

Applying his inventive mind to his new pursuit, Guy built a portable tent with a single window across which he stretched a piece of black gauze. Then he "drew with chalk all the objects seen through the medium, with perfect perspective accuracy. This drawing," Peale continues, "being conveyed to his canvas by simple pressure from the back of his hand, he painted the scene from Nature, with a rapidly improving eye, so that in a few days his landscape was finished, and his tent conveyed in a cart to some other inviting locality. . . . He

produced four pictures of extraordinary merit as rough transcripts from Nature. They were exhibited in the ballroom of Bryden's Hotel, and soon found purchasers at twenty-five dollars each. Whilst he continued this mode of study, his pictures were really good—but excited by the reputation he was gaining, he afterwards *manufactured* landscapes with such vigor that I have known him to display in the *sunshine,* on a lot contiguous to his residence near the city, forty large landscapes, which were promptly disposed of by raffle. He painted standing, stepping frequently back to study the general effect, and taking a *huge* pinch of snuff from a large open jar—perhaps in emulation of Mr. Stuart—then advancing with dramatic energy to his picture, first flourishing his pencil in the air, executed the leaves of his trees, with flat brushes and cut quill feathers, as he imagined no one had ever done before."

Guy was eccentric. Typical of his frequent notices in the newspapers is his "Communication to the Friends of Literature," in which he characterized himself, without any sense of incongruity, as both a landscape painter and a dyer. He was projecting a book to teach these twin arts. In painting he would "pitch the key to young beginners, that natural taste and genius, if they have any, may play the tune." Dyeing and scouring, he added, "will give the American families a pleasant and profitable amusement." The book would also contain his autobiography, an attack on deism, a satirical ballad called "The Devil and Tom Paine," and a humorous article recommending the substitution of "Scotch snuff" for the atomic bomb of those days, the Congreve rocket, "that the enemy might be blinded . . . and taken all alive." It is melancholy to report that this volume was never published.

In 1807, Guy and Groombridge held a communal exhibition at Baltimore. Citizens clamored to buy pictures by the self-taught artist and shunned those of the educated British landscapist, which enraged a female editor, Eliza Anderson. Daughter of a distinguished Irish physician and fiancée of the French architect, Maximilian Godefroy, who himself drew some chaste views, she styled Baltimore "the Siberia of the arts," and admonished those Americans who had not acquired "the knowledge necessary to constitute a judge of painting" to accept the dicta of experts who "have an acknowledged and established right to pronounce on these points. . . . They say that the genius of Mr. Guy is a wild plant; that nature had intended him for a landscape painter . . . but they will also say that he has not studied . . . nor has he made a single striking step in the art. . . . In a word, that if Mr. Guy is a diamond, it is without polish." On the other hand, "real connoisseurs will say that, as for Mr. Groombridge, he views nature with an artist's eye; that he is familiar with good schools; that he has a great deal of felicity; and that to produce paintings really fine" he needs only encouragement.

In another article, Mrs. Anderson reported with horror that in America such uneducated creatures as bricklayers and carpenters pretended to a taste in painting. She denounced the national tendency to make no sharp distinction between artisans and fine artists. While "duly appreciating the utility of those who profess the useful arts, we must, nevertheless, observe that Apollo is somewhat aristocratic and does not permit of perfect equality in his court. . . . The Muses are rather saucy, and do not admit *workmen* to their levees." She held it against Guy that he had been a tailor and advised him

51 FRANCIS GUY: Bolton (*Courtesy Clapham Murray, Jr. and William H. Murray*)

52 Francis Guy: Winter Scene in Brooklyn (*Courtesy Brooklyn Museum*)

to return to his "soul-inspiring avocation of making panta-loons." Guy replied that Groombridge was a good painter who deserved more support than he received, but added, "The connoisseurs of Baltimore will not be dictated to by insolence and abuse."

Today, the artistic taste of the public seems far superior to that of the refined lady and her well-educated French fiancé. Proper, conventional, and insipid, Groombridge's landscapes (Pl. 50) are based not on nature or any belief, but on other pictures. With conviction and a wild joy, the tailor painted images his own eyes had seen, his own mind conceived. He organized naturalistic details into unnaturalistic designs, fusing all over the flame of imagination. So strong was his creative will that, despite their underlying literalness, his pictures carry us into his personal fairyland. No one could be lonely in this ecstatic world; figures walk in twos; even the cows and dogs have mates. Before the Maryland mansion, Bolton (Pl. 51), stroll a pair of elegantly attired ladies painted completely in dead white; their gay and ghostlike forms sweep this carefully drawn "perspective view" into some other-worldly stratosphere. Guy's pictures are dreams, not fantastic, but dreams of reality.

About 1817, Guy moved to Brooklyn. Ailing, rotted with drink, he painted over and over again the semislum he saw out of his window. There are melancholy, peopleless pictures, which seem to brood on the shabby pointlessness of man's earthly habitat; and also his chef d'oeuvre, the same scene, but gay now, crowded humorously with neighbors (Pl. 52). The artist, we are told, "would sometimes call out of the window to his subjects, as he caught sight of them on their cus-

tomary ground, to stand still, while he put in the characteristic strokes. . . . Jacob Hicks, whose house is just visible on the corner of Main Street, was brought to a halt, goose in hand; and after he had been sketched, politely sent the goose as a present to the painter, that he might 'sketch the fowl more deliberately, and eat him afterwards.' "

Guy's vigorous *Winter Scene in Brooklyn* typified the vernacular tradition which, despite the contrary influence of Stuart, was still active in America. Detail, accurate and voluminous, selected and organized into design; a mingling of knowing and crude techniques; color applied superficially yet often harmonious; literalness tempered by ebullient imagination: these characteristics appeared everywhere. Although the sublime was talked about and admired, it was left to European masters, who would by definition be more competent to achieve it. Americans practiced a local and human art, loving neighbors and their possessions. Episodic in approach and eccentric in execution, it was more likely to be charming than deep. Yet it grew naturally from the painters' environment and revealed the ungainly vitality of young and growing things.

The tradition promised much for the future, but only if the artists could find the courage to work profoundly, could escape from ignorance, self-abasement, and sheepish fear. When high art beckoned to them, it seemed to call them to leave their American roots, to leave themselves. Conning elegant ideas from books, they were far from sure that beauty could be unearthed by using greater knowledge to dig more deeply in the soil they had always known. Certainly the Elysian Fields were made of more exotic stuff.

Such was the situation when the end of the War of 1812 permitted a group of able American artists, who had been trapped in Europe, to return to the United States, bringing with them skills their home-grown brethren lacked and longed for.

CHAPTER NINE

The Wild and the Holy

THE sunlight of reason in which American art had grown for so long was now obscured by the tempestuous clouds of romantic vision. A weird darkness fell over the land, and rivers ran strangely, as if with blood. Cutting across the sky, a flash of lightning illumined an odd tableau.

In a cabin on a South Carolina rice plantation a richly dressed white child was listening to an old Negress, while shadows thrown by the fire formed into the supernatural beings who had loyally accompanied their people on slave ships to the New World. "I delighted," wrote Washington Allston, "in being terrified by the tales of witches and hags which the Negroes used to tell me." Returning home years later, he made a pilgrimage "to a gigantic wild grape vine in the woods which had been the favorite swing of one of these witches."

Seeking as adults for the strange and marvelous, such French Romantic painters as Descamps and Delacroix were to journey self-consciously across the Mediterranean to North Africa; as a child, Allston had merely to toddle across the stable yard. The slave trade had curious effects, and this was one of the strangest. Allston's nephew and biographer, Jared

53 WASHINGTON ALLSTON: The Buck's Progress, No. III — Midnight Fray with a Watchman (*Courtesy Mrs. Frank M. Clark*)

B. Flagg, attributed the whole bent of the artist's career to the "novitiate in barbaric magic and superstition" the child experienced in the family slave quarters. Clearly this is an exaggeration, for the Romantic movement grew in other soil than the American South; yet the arrow was from the first aimed at the target.

At the age of ten, Allston was sent to school in Newport, Rhode Island, and in 1796 he entered Harvard. One morning as pupils and professors flocked to chapel, they were stopped in the doorway by posters, "ornamented with altars, daggers, swords, chalices, death's heads, and cross bones," announcing the meeting of a secret society clearly dedicated, like those recently exposed by Professor Robinson, to overthrowing all governments and perhaps Christianity as well. Allston was amusing himself with an elaborate and high-spirited hoax. A new kind of man had entered American art.

Since the first years of settlement, painters had usually been self-elevated artisans who, like Copley, never forgot the value of time, money, sobriety. The typical variants, as exemplified by Stuart, had reacted violently against the virtues of their artisan backgrounds. Different from these, Allston also was different from the only important college-educated artist who had preceded him. Attending Harvard a quarter-century before, Trumbull played the eighteenth-century gentleman: full of windy honor, he tried to overawe his fellow students with his birth and importance.

Allston amused his friends with a series of drawings in imitation of Hogarth entitled *The Buck's Progress* (Pl. 53), and gleefully shocked the lower classes with such pictures as the one his janitor described: "a woman, stark naked, going into the water to wash herself." When C. W. Peale had worked on

an ephemeral display, it had been to assist in the public cele-
bration of a national event; Allston spent weeks carving masks
for a private ball. He danced and drank, but combined with
gaiety an elegance, probity, and refinement that impressed
even his classmates.

Quite matter-of-factly he wrote his mother that he intended
to be at very least the greatest painter in America. "I am in-
clined to think from my own experience that the difficulty to
eminence lies not in the road, but in the timidity of the trav-
eler." Perhaps this was a comment on the hesitation of the
older American painters to attempt high art.

Allston's generation had been born into a new world. When
he was three, America had become independent, and since
then the nation had coalesced and augmented as if inhabited
by a chosen people. Whatever they said with their mouths,
the younger citizens knew that the acrimonious debates that
preceded the election of Jefferson were ripples on an irresist-
ible wave of strength and prosperity. Allston's reaction to
threats of revolution was to burlesque them. As for the his-
tory of modern Europe, even his classmates criticized his lack
of interest in it. They tried to stump him by asking, "What can
you say of the Treaty of Westphalia?"

"What can I say? I can say it was a very pretty treaty."

The national basis for Allston's sense of security was a local
manifestation of profounder currents. For generations, the
bourgeoisie had preached that man had been corrupted by
evil institutions. Now that the reins of state seemed about to
fall into their hands all over Europe, they intended to take a
few correct turns and draw up triumphantly at the gate of
that Eden which their aristocratic predecessors had wrongly
believed had been lost forever by our ancestress Eve. Seen

through the golden glasses of those days, man was a marvelous creature every one of whose emotions was precious: his generous tears and his psychological gloom. For the moment these discoveries were altogether joyous, not darkened by the disillusionment that gripped Europe after the Napoleonic wars.

Allston's first original composition, done while he was at school in Newport, showed "the storming of Count Roderick's castle, from a poor (though to me delightful) romance of those days." At Harvard, so a friend remembered, "his favorite reading were plays and romances, particularly romances of the German schools, and he would sup on horrors until he would be almost afraid to go to bed until he had made sure that no goblin was under it or in the closet." A similar taste was sweeping America. Charles Brockton Brown published his Gothic novels, and on the stage "all must be 'wrapt in clouds, in tempest tossed,' alternately chilling with horror or dazzling with astonishment."

Bandits misbehaving in castled landscapes were a favorite theme of early Romantic painters in Europe, for they combined defiance of aristocratic authority with picturesque nature and the macabre. Although America was discouragingly devoid of castles, autocrats, or outlaws, Allston materialized them from books. He painted "robbers fighting with each other for the spoils, over the body of a murdered traveler. And clever ruffians I thought them. . . . I thought I had happily succeeded in cutting a throat." Youth, he explained, is so perpetually assailed with new impressions that it needs "something fierce, terrible, or unusual to force it above its wonted tone." Indeed, earlier American artists probably found in

their renditions of battles the same excitement and sadism Allston now sought.

With such minor exceptions as Pine's historical paintings, Allston's pictorial sources were those that had inspired his American predecessors: Colonial portraits, imported engravings, a Smibert copy of Van Dyck which had moved Copley. It was his printed sources that were new. Not seeking, as his elders had done, recipes in treatises on paintings, he sought excitement in plays and novels. This union of literature and art was typical of the Romantic movement. Allston wrote a poem on the death of Washington, which he recited to a memorial meeting at Harvard: "The audience had been cautioned, on account of the solemnity of the occasion, to abstain from the usual tokens of applause, but at several passages they could not be restrained."

In 1801, he sailed for England, a rich young man who had turned his patrimony into cash. Basing his opinion on prints after such compositions as *The Death of Wolfe,* he had looked on West's "understanding with indifference and his imagination with contempt," but now he wrote home that "among the many painters in London, I should rank Mr. West as first . . . one of the greatest men in the world." He was amazed to discover that West's pictures were "sublime and awful."

Unlike most official leaders of art, the president of the Royal Academy had moved with the times. One day, so his biographer tells us, as West was chatting with George III he "happened to remark that he had been much disgusted in Italy at seeing the base use to which the talents of the painters in that country had been too often employed; many of their noblest efforts being devoted to illustrate monkish legends, in which no one took any interest, while the great events in

the history of their country were but seldom touched." The King thereupon decided that since Windsor Castle had been built by Edward III it should be ornamented with depictions of his "splendid reign." For £6,930 West produced eight large paintings of those medieval times which, although considered unbearably crude by classicists, appealed to romantic imagination. He was led naturally to use more violent action and less formal composition than when he painted the antique, but he adhered to his moral point of view. A writer in *Public Characters* for 1805 tells us that his *Battle of Poitiers* shows Edward "with manly demeanor receiving the vanquished king, expressing an air of welcome, treating him more as a visitor than a captive." Neither the vainglory of the conqueror nor the submission of the vanquished is shown. "All is Gothic," the writer concludes, "and all is British."

Next West used his friendship with the King to break down the ban on religious painting which the Church of England had established centuries before in order to neutralize one of the great attractions of Catholicism. At his urging, George III asked a committee of prelates to approve the erection at Windsor Castle of a chapel which would house thirty-five pictures, to be painted by West, depicting the development of *Revealed Religion*. The artist drew up "a list of subjects from the Bible, susceptible of pictorial representation, which Christians of all denominations might contemplate without offense," and the King explained to the churchmen that he saw no reason why his private chapel might not be adorned with illustrative pictures, even as the Bible itself often was with engravings. Although one of them showed his irritation with West by making a derogatory remark about Quakers, the prelates bowed to the royal will. Soon the King was giving

altarpieces by West to public churches. Thus, through the influence of the American, the dominant subject matter of Renaissance art was opened, for the first time in modern history, to Englishmen.

During his Pennsylvania childhood, the battle between God and the devil in every Quaker soul had seemed more immediate even than the battle with the forest. West seemed about to mine a rich vein in his spirit, yet there were difficulties. He had to concern himself with visionary things, but he never saw visions. Far from attempting to carry imagination into the supernatural, he wished to make the supernatural rational, even as Protestant parsons often defend miracles by showing that they could be explained according to scientific law. West combed the Jewish quarter for patriarchs to pose as prophets, and enlarged a macaw's wing into the wings of angels.

Yet his subject matter forced him upon occasion to push naturalism beyond natural limits. The picture that had so excited Allston, a small oil of *Death on a Pale Horse* (Pl. 54) from Revelation, shows the apocalyptic destruction of mankind by three terrible riders. The central horseman sits his saddle naturally, yet his crowned head is a skull. "It is impossible to conceive anything more terrible," Allston wrote. "I am certain no painter has exceeded Mr. West in the fury, horror, and despair with which he has represented the surrounding figures."

For some years, all contact between England and France had been at the cannon's mouth. When, in 1802, the Peace of Amiens cleared the Channel of warships, West hurried to France and showed his *Death on a Pale Horse* at the Salon. A reviewer in the *Journal des arts* acknowledged his "genius

54 BENJAMIN WEST: Death on a Pale Horse (Courtesy Pennsylvania Museum of Art)

55 WASHINGTON ALLSTON: The Poor Author and the Rich Bookseller
(Courtesy Museum of Fine Arts, Boston)

and enthusiasm," but was too familiar with Rubens not to think West's colors chilly for so baroque a subject. The picture, the reviewer felt, was modeled on Poussin: some of the figures were imitative of that master's and others were worthy of him.

On his return to London, West stated that the French had benefited greatly from their revolution. Previously there had been ostentatious wealth and "religious processions moving in every direction, but the mass of the people abject and ragged. Now there appears to be but one order of people, a middle class." His friends deplored "the excessive indiscretion of West, situated as he is with the King, in speaking in the manner he does of the state of Europe and his partiality for Bonaparte." Englishmen agreed that West did not have "an English mind." George III, tottering on the brink of madness, was deeply offended; a bitter battle was fought in the Royal Academy and in 1805 West resigned the presidency.

Unconcerned with politics, Allston stuck to his art. He came to admire the romantic Fuseli as much as West, but he wrote concerning the British portrait painters, "even Lawrence cannot paint so well as Stuart; and as for the rest, they are the damndest stupid wretches that ever disgraced a profession." He drew at the Royal Academy school, exhibited some romantic genre pictures that created no sensation, and soon accompanied another young American painter, John Vanderlyn, to Paris. Ignoring contemporary French art, Allston haunted the Louvre.

The works of Titian, Tintoretto, and Veronese swept him into an aesthetic world he had not known existed; standing before them, he could think of "nothing but the gorgeous concert of color." He was amazed to discover that the great

Venetians had given "little heed to the ostensible stories of their compositions," but were content to let "the poetry of color" give birth "to a thousand things which the eye cannot see." The pictures left "the subject to be made by the spectator, provided he has the imaginative faculty—otherwise they will have little more meaning to him than a calico counterpane."

Allston had moved far from the school of West. West admitted that in poetry "effect is produced by a few abrupt and rapid gleams of description, touching as it were with fire the features and edges of a general mass of awful obscurity; but in painting such indistinctness would be a defect, and imply that the artist wanted the power to portray the conceptions of his fancy."

Neoclassicism had regarded color as Puritans regarded feminine charm, as something that was there, that could upon occasion be useful, but that was not quite respectable and should be kept subordinate to more intellectual things. Even Allston felt it necessary to defend the Venetians from the charge of sensuality. They used color, he argued, not to titillate the senses but to pass beyond them to that region "of the imagination which is supposed to be under the exclusive domain of music, and which, by similar excitement, they cause to teem with visions that 'lap the soul in Elysium.'"

He exemplified his views in a series of amazing landscapes. His *Rising Thunderstorm at Sea* seems influenced by Vernet, but where the rococo Frenchman would have made his composition a stage set, peopled it with gesticulating actors, and colored it according to academic recipes, Allston relied for his effect almost entirely on poetic but naturalistic hues: the

menace of dark clouds gradually throttling blue skies, the fearful black of angry water.

When he proceeded to Rome, Allston met Washington Irving. At twenty-two a fledgling lawyer who nurtured vague artistic ambitions, Irving was delighted to discover that a gentlemanly compatriot of "good education" had "adopted the profession of painting through inclination." He found Allston "inexpressibly engaging . . . of a light, graceful form, with large blue eyes, and black, silken hair waving and curling round a pale, expressive countenance. Everything about him spoke the man of intellect and refinement. . . . Indeed, the sentiment of veneration so characteristic of the elevated and poetic mind was continually manifested by him. His eyes would dilate; his pale countenance would flush; he would breathe quick and almost gasp in expressing his feelings when excited by any object of grandeur and sublimity." Irving was so charmed that he almost resolved to become a painter like Allston.

Samuel Taylor Coleridge was equally impressed. "Had I not known the Wordsworths," he wrote Allston, "[I] should have esteemed and loved you first and most; and, as it is, next to them I love and honor you. . . . To you alone of all contemporary artists does it seem to have been given to know what nature is: not the dead shapes, the outward letter, but the life of nature revealing itself in the phenomenon." Allston, for his part, wrote, "To no other man whom I have known do I owe so much intellectually as to Mr. Coleridge. . . . When I recall some of our walks under the pines of the Villa Borghese, I am almost tempted to dream that I had once listened to Plato in the groves of the Academy." But on one point at least the poet and the painter argued. Coleridge

loved Gothic architecture, while Allston had fallen under the pure and simple spell of Greece.

In such landscapes as *Diana in the Chase* he abandoned horror for serenity. Believing that every individual aspect of nature is one note in a celestial chord, he sought to express this harmony. Beauty came to him in color, in mood, in sentiment. Soft blue water, bright blue sky, gleaming gray and pink of rock, gentle green of foliage, all join in paeons of praise to the ecstasy and quietude of nature. Human beings in the foregrounds are kept small, yet they are the emotional centers of the pictures, for we are not shown nature pure, but nature as felt by the sensibility of man.

Concerning this picture, Allston's biographer, Edgar Preston Richardson, wrote: "There is the rich, subtle sweep of tone, the severely limited range of hue, the subtle contrasts of warm and cool, which were to characterize his style from this time on. . . . In the painting of the distant mountain, Allston introduced his first coloristic innovation, his own variety of 'broken color' to create atmosphere and luminosity. He did not lay on the pigments side by side but one over the other, so that the pigment below shows through that above (more like the style of Feininger or the late Kokoschka than the broken color of the French Impressionists). Sometimes, as he himself said . . . it required twenty such tints, one above the other, to create the delicate veil of light and air he threw over such distant mountain peaks." Although the picture was based on drawings of actual Swiss scenery, Allston freely combined and fused the natural elements to "represent his whole imaginative experience of the Alps."

Allston never undertook commercial portraiture, yet he

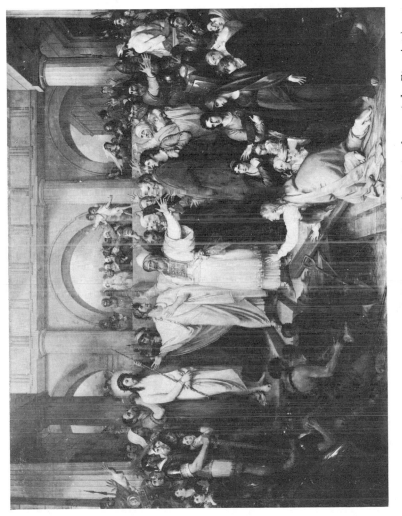

56 BENJAMIN WEST: Christ Rejected (Courtesy Pennsylvania Academy of the Fine Arts)

sometimes enjoyed rendering the faces of his friends, and for such pictures he turned to the example of Titian, seeking the same unity of hue achieved by glazes, the same monumentality. His self-portrait (Pl. 67), created in Rome, seems the epitome of all the likenesses he painted, for he was too introverted to recognize in others characteristics not his own. Although he did not make every sitter as handsome as he himself was, he saw in every face an oversensitivity that might have been morbid were it not so romantically rendered.

The Napoleonic wars flamed up again, and in 1808 Allston became convinced that the United States would be embroiled. Quickly he sailed for Boston, where a blue-blooded girl had been waiting patiently for him to complete his travels. He married, lived like a gentleman, and published some amateurish poems. He returned to polite genre: in *The Poor Author and the Rich Bookseller* (Pl. 55) an emaciated man of letters, who has just delivered his manuscript to a fat, brutish publisher, is being swept out with the rest of the trash. Ignoring the Massachusetts hills and fields around him, Allston reconstructed from memory a *Coast Scene on the Mediterranean.*

In 1811, he guessed wrong about a possible war with England, and sailed for London, accompanied by a pupil, the future inventor, Samuel F. B. Morse. There, Allston found his own teacher, Benjamin West, swimming in a sea of difficulties. Although West had been reinstated as president of the Royal Academy when, after a single year, the artists found they needed his leadership, his radicalism continued to shock the royal family. Despite everything, the King had persevered in his admiration for his friend's pictures, but in 1811 George was officially declared insane. The Regent instantly canceled West's commissions, cutting off the patronage that had for

some forty years enabled him to pursue his art only secondarily concerned with popular taste. The American was stunned. "If you expect either honor or profit by spending your days and nights in endless labor that you may excel in the department of historical painting," he told the students at the Royal Academy, "you will be miserably deceived as I have been. Who purchases historical specimens of the art now?" he asked, and answered that no one did.

Almost instantly he was disabused. As a contribution to the Pennsylvania Hospital in Philadelphia, he composed a huge canvas of *Christ Healing the Sick*. Before it was finished, members of the newly organized British Institution, wishing to keep it in the country as "the commencement of a national gallery," bought it for £3,000, said to be the largest price ever paid in England for a contemporary picture. Crowds that stormed to see the completed painting paid £2,500 in entrance fees, and £2,200 was subscribed for an engraving. A replica sent to the Pennsylvania Hospital created a sensation in America.

West's next picture, *Christ Rejected* (Pl. 56), was even more remunerative. Forced when over seventy to turn to the public for support, he became in the words of Sir Thomas Lawrence, England's "one popular painter." The many-figured canvases which earned him such fame were composed with great clarity, but possessed no other qualities that appeal to an artistically sensitive eye; they were, indeed, largely executed by his assistants. Yet once again West proved his genius for giving expression to a commonly held attitude. He did much to define the idiom that still dominates Protestant religious art.

A pamphlet distributed at exhibitions of *Christ Rejected*

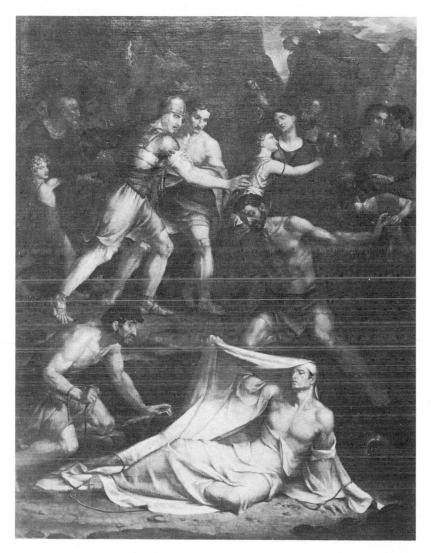

57 WASHINGTON ALLSTON: The Dead Man Revived by Touching the Bones of the Prophet Elisha (*Courtesy Pennsylvania Academy of the Fine Arts*)

58 WASHINGTON ALLSTON: Elijah in the Desert (*Courtesy Museum of Fine Arts, Boston*)

quoted relevant Biblical passages and stated that the artist intended "to excite feelings in the spectator similar to those produced by a perusal of the sacred texts." The role of each figure in the composition is copiously described: the Savior stands "with a divine composure, while, with a dignified and pensive resignation, He is absorbed in the grandeur of the end for which 'He has come into the world'—evincing this tranquility amidst the savage and thoughtless tumult of men." If this were the first historical painting a man had ever looked at, he would be able to understand all of it; and if, like almost everyone in those days, he were a Bible reader, he would see familiar happenings, depicted life size, just as he himself might have imagined them. Since no mysticism was indicated, no sensuousness, nothing except what was obviously recorded in the Good Book, no Protestant needed fear that he was being lured by some artistic black magic toward the "idolatry" of Rome. As West himself wrote concerning his homilies, "The most scrupulous amongst the various religious sects in this country about admitting pictures into churches, must acknowledge them as truths, or the Scriptures fabulous."

West's success exerted an amazing pull on the other American artists in London. The aging Copley tried to follow him into religious art, but it was too late. For some fifteen years after he had arrived in England, Copley had created brilliant paintings. However, as he grew older, his health gave way, and in his pictures rhetoric took the place of belief.

It is a temptation for American critics to attribute his growing deterioration to his abandonment of the Massachusetts environment that had shaped his talent, and certainly there was much in London to urge him toward artificial effects that were foreign to his nature. Yet while he kept his health he had

painted well, and perhaps the premature senility that over-whelmed him would have done so anywhere. In 1811, Morse wrote, "I visited Mr. Copley a few days since. . . . His pow-ers of mind have almost entirely left him; his late paintings are miserable. It is really a lamentable thing that a man should out-live his faculties." The tremendous *Resurrection* Copley painted in that year was a failure. Copley's important role in art had come to an end about 1800 although he lived until 1815. His death interested only his relatives, while, in 1820, West, hardly past the peak of his fame, was buried with great pomp in Westminster Abbey.

Trapped in England by the War of 1812, having difficulty selling portraits, Trumbull had also followed West into the religious arena. His tangled psychology impelled him into painting the wife whom he had married "to atone for a sin" as the woman taken in adultery. Since the Scriptures did not state that the lady in question was actually guilty, he had chosen, he explained publicly, to represent her "as a lovely woman." Whatever emotion there was behind this strange picture fails to communicate itself from the vast and dull canvas which connoisseurs showed no inclination to buy. Like Copley, Trumbull had left far behind him his best years.

Allston was in his middle thirties and painting brilliantly, yet he too followed West into vast Biblical canvases. *The Dead Man Revived by Touching the Bones of the Prophet Elisha* (Pl. 57),which he completed in 1813, measured thir-teen by eleven feet. A few years before, he had written that color should so overwhelm the emotions that it would be un-necessary to tell a story. How far he had backtracked is shown by his long, literary explanation of the picture. He pointed out that Elijah's skull was "particularized by a preternatural

light," and that the two slaves who had just lowered the corpse exemplified respectively "astonishment and fear modified by doubt" and "unqualified, immovable terror." Since the "habitual firmness" of "the military character" could be upset by "no mortal cause," the soldier in full flight indicates that a miracle is taking place.

Marrying West's approach to sensationalism, *The Dead Man Revived* had many similarities to Copley's *Watson and the Shark* (Pl. 14) of thirty-eight years before. Based not on a contemporary accident but on a Bible story, the scene, nevertheless, had no moral significance. Depicting the effect on a group of people of a single terrifying event, Allston achieved a unity not logical as in West's pictures but emotional as in Copley's. Allston was a more subtle colorist than the other Anglo-American painters, yet in this picture his method was similar to theirs: the hues in the costumes of the principal characters were reflected on a diminishing scale throughout the composition. Although he was concerned, in the Romantic manner, with a weird supernatural happening, Allston's objective remained that of the school of West: to show with great clarity a dramatic event as it might actually have taken place. His friend Coleridge had expressed a similar objective in his preface to *The Lyrical Ballads:* the poet wished to give verisimilitude to the unearthly by expressing "the dramatic truth of such emotions as would naturally accompany such situations, supposing them real."

Allston was rewarded for his submission to the grand style by such national celebrity as had never been accorded to his more original achievements in the less admired art of landscape. His historical picture received a premium of 200 guineas from the British Institution, and he joined West and

Copley in the Royal Academy, where his election meant the defeat of the pioneer landscapist Constable.

However, Allston suffered a nervous disorder of the stomach, and then the death of his wife catapulted him into a nervous breakdown. "He was haunted," a pupil wrote, "during sleepless nights by horrid thoughts; and diabolical imprecations forced themselves into his mind. The distress of this to a man as sincerely religious as Allston may be imagined." He sent for Coleridge, who assured him that only thoughts he wished to think were truly his; he was not responsible for visions that welled up despite his will. By enabling him to disown the instinctive part of his nature, this doctrine helped him resume his daily tasks, but Allston tells us that he never again experienced "an hour of buoyant health." He destroyed a picture he had created during his troubles lest it drive others mad.

Under Coleridge's influence Allston, whose piety had not been connected with any specific sect, joined the Church of England. As a first result, he abandoned a painting containing the figure of Christ—he considered the Savior "too holy and sacred to be attempted by the pencil"—and changed the title of a *Virgin and Child* to *Mother and Child*. He limited himself to scenes from the Old Testament, which he did not have to take too seriously.

During a brief visit to Paris, he restudied the Venetians and refined his technique. As Richardson explains, he used "a combination of underpainting and glazing to produce warm, rich, resonant tones that are not any one color but contain all colors floating in suspension. Local colors disappeared except as accents in the glow of his chiaroscuro." Thus Allston

anticipated Delacroix's practice of the 1860's, and even the early stages of Impressionism.

The first picture to which he applied this subtle method seemed particularly unsuited to it. His vast canvas of *Uriel in the Sun* is crowded to the frame by a single seated figure shown at between two and three times life size. This rendition of the guardian of Paradise won a premium at the British Institution, for it suited the fad for gigantic religiously inspired figure pieces, but it is difficult to defend. So monumental a composition called for an aggressive, robust talent like Michelangelo's; Allston's was a delicate, lyrical gift.

The relatively small *Elijah in the Desert* (Pl. 58), although less admired, seems more successful to modern eyes. It was in the artist's old vein: what Richardson calls an "inhabited landscape." Making color slave to "that inner eye that is the bliss of solitude," Allston expressed desolation through a polyphony of browns. A pool of water is brown, and what little green there is merges into the dun tonality. These warm colors contrast with patches of cool blue sky seen through brown clouds. A dead tree in the foreground dominates the gnarled forms, and at first we hardly notice at one side the blue-coated Elijah praying. Yet once seen, this figure controls the mood: Allston had again revealed nature not for its own sake in the manner of Constable, but through the mind of a protagonist.

Americans were watching Allston's career with pride that culminated in the purchase by the newly founded Pennsylvania Academy of his *Dead Man Revived* for $3,500. Although the English had been amazingly friendly during the War of 1812, even such intimate friends as Coleridge had upbraided him for not admitting the United States was in the

wrong; his patriotism had been kindled. When in 1818 his patrimony gave out, forcing him for the first time in his career to make his own living, he resolved to return to the homeland that seemed so eager to give him support. As he sailed into Boston Harbor he meditated "that I had returned to a mighty empire, that I was in the very waters which the gallant *Constitution* had first broken; whose building I saw when at college; and whose 'slaughter-breathing brass,' to use a quotation from worthy Cotton Mather's *Magnalia,* but now 'grew hot and spoke' her name among the nations."

Thus in a glow of patriotism there returned a native-born artist, already famous abroad, who was determined to acclimate the grand style of historical painting to America. Twenty-nine years before, Trumbull had landed shortly after another war and on a similar mission which had failed. But Trumbull had been an isolated figure; Allston had allies, both men and institutions.

CHAPTER TEN

Students

J OHN VANDERLYN was two years Allston's senior. Grandson of Pieter Vanderlyn, who had in the 1720's painted crude but exciting portraits in the Hudson River Valley, son of a sign painter at Kingston, New York, he was born into the old artisan tradition; he was apprenticed to a Manhattan print and paint seller. A merchant threw him into another world by sending him to the Columbian Academy where the children of the rich learned to make agreeable water-color views. For the future professional, the Robertsons gave a special course in the alphabet of historical painting: he copied engravings after Le Brun of the facial expressions that connoted different human passions.

Making Vanderlyn his protégé, Aaron Burr placed him with Stuart, and, in 1796, started a new current in American art by sending him not to England but to France. Vanderlyn was at first uneasy in wicked Paris; he studied with François-André Vincent, who, he explained, had a better moral character than David. However, he soon expressed amusement that "an untutored American" might be shocked at the nakedness of the French dancers: all his working hours were spent with naked marble or naked flesh. "By next summer," he

wrote home, "I think I will be fully acquainted with the human figure, which seems to be the only thing they draw in the school." The red-headed son of artisans, who rarely joked or smiled, drew conscientiously, for this, he was told, was the necessary preparation for painting great historical pictures. When Vincent pulled him away to study landscape he complained—"I do not intend to adopt this branch of my art"—and as for the portrait work of his forebears, he considered it "mill-horse drudgery." Vincent agreed that painting likenesses was a waste of time.

After five years, Vanderlyn was forced home by lack of funds. He was "run down with applications for portraits," but, to Burr's surprise, he refused as many as his pocketbook allowed. When the newly formed American Academy of the Arts offered to send him back to Europe, so that he might copy old masters for them and buy casts, he was delighted. Before he sailed, he began two pictures of Niagara Falls, which he intended to have engraved in Europe. He would have liked to sell the originals to the Academy, but could not conscientiously offer them as works of art. They would be of interest, he admitted, only as "a pretty faithful portrait of one of the greatest curiosities of nature." Not to be outdone in correctness of taste, the connoisseurs spurned the American views.

Vanderlyn became as completely Frenchified as would his compatriots who, more than a century later, crowded the Café du Dôme. During a quick trip to London, he expressed boredom with the English painting that was leading the world procession toward Romanticism. Meeting the young, romantic Allston, he condescended to this compatriot, who was "solicitous" to accompany him back to Paris but knew no

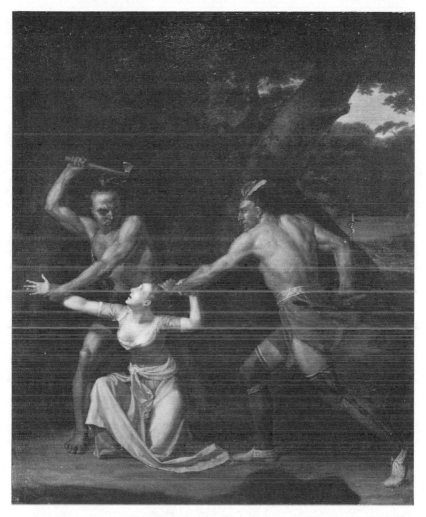

59 JOHN VANDERLYN: The Death of Jane McCrea (*Courtesy Wadsworth Atheneum*)

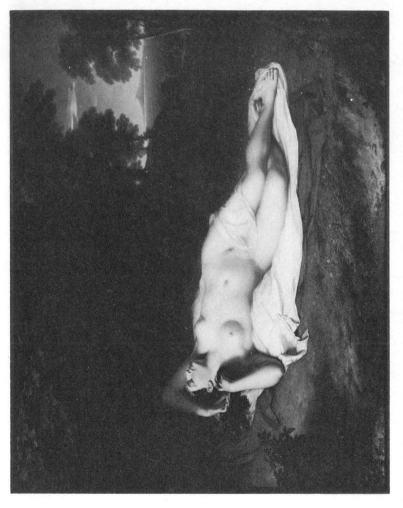

60 JOHN VANDERLYN: Ariadne *(Courtesy Pennsylvania Academy of the Fine Arts)*

French or Dutch. The ecstasies Allston experienced before the Venetian pictures in the Louvre left Vanderlyn unmoved.

Two other expatriots, Robert Fulton, who had abandoned painting, in which he had no skill, for invention, and Joel Barlow commissioned Vanderlyn to illustrate Barlow's patriotic epic, *The Columbiad.* They desired ten quick sketches to guide an engraver, but Vanderlyn had been studying historical painting for seven years without attempting to apply his knowledge; he felt that he was finally ready to impress the world. He composed *The Death of Jane McCrea* (Pl. 42) heroically, in great detail.

The artist had walked forests similar to the tangled wilderness in which the American beauty had been massacred; he had seen Indians like those who had perpetrated the deed, yet he painted a civilized glade and placed in it two semi-nude giants drawn from classic sculpture. Their victim wears a *Directoire* afternoon dress cut so low that her breasts are almost bare. In violent yet arrested action, the figures are integrated into a group reminiscent of late Greek statuary. Although skillfully drawn—no such rounded figure as Miss McCrea's ever bloomed in the school of West—the canvas conveys not savagery on civilization's borders but study in French schools.

When his patrons refused to pay for the additional labor involved in so unexpectedly finished a picture, Vanderlyn abandoned American subject matter, painting *Marius on the Ruins of Carthage.* For his protagonist's head, he enlarged an actual Roman bust; the body derives from other statues; and entire figure is seated, at much more than life size, before classic ruins which Vanderlyn painted from a scale model he had built in his studio. Intended to exemplify the stoicism of

the Roman character, the static composition was a more literal rendering of the neoclassical theories West had brought to London forty-five years before. Although English taste had long moved in more romantic directions, *Marius* won in Paris the Napoleon Gold Medal of the Academy of Arts for 1808. The Emperor, so the painter claimed, wished to buy the picture for the Louvre, but he reserved it for his own nation.

Too slow a painter to support himself with individual historical canvases, Vanderlyn intended, after his return home, to found a museum where one by one his great pictures would accrete. He dreamed of taking over the American Academy and being supported by annual contributions from connoisseurs, but it seemed more likely that he would have to rely on gate receipts. For this, he needed attractions.

The small fortune that had been made in Philadelphia through the exhibition of *Danae,* a painting by the Danish immigrant Adolf Wertmüller of a nude goddess in the very act of being impregnated by a shower of gold, had revealed to American painters on both sides of the ocean that their compatriots would pay well to see pictures they later denounced as immoral. Vanderlyn, who had an ominous gift of subordinating his own personality to an old master, made a brilliant copy of Correggio's *Antiope.* Although, as he explained, the picture might prove too naked for "the house of a private individual, . . . on that account it may attract a greater crowd if exhibited publicly." He reinforced this shameless lady with two others: Titian's *Danae,* and *Ariadne* (Pl. 60), a composition of his own.

Vanderlyn drew Ariadne nude, with very firm outlines, the flesh tones shining brighter than nature. Lying asleep on a white fabric with beneath it a larger red one, the body stands

out like a bugle call, too strong for the rest of the picture. The umbrageous landscape into which it is inserted, the distant vista of bay, mountain, and classic boat are charming but seem irrelevant. Such lack of organic composition was a typical fault of the French school, due to overemphasis on drawing the human figure. Yet *Ariadne* is Vanderlyn's masterpiece, the first impressive nude in American art.

For his final exhibition piece, Vanderlyn decided to capitalize on Americans' curiosity about Europe, and on the new rage for panoramas. He began a huge painting of the gardens of Versailles that would fit inside a dome.

By this time, Allston's personal pupil, Samuel Finley Breese Morse, had reached London after a long skirmish with a father who epitomized the sterner aspects of New England patriotism and Puritanism. Jedediah Morse wrote *The American Geography* to impress on American youth the superior importance of their own country, but as a Congregational minister, he opposed all liberal tendencies, expounded so violently the natural wickedness of man that his own parishioners finally expelled him from his church. When his son was born, the love he could not help feeling for the infant filled him with terror lest it lead him away from his love for God.

The boy, as he grew older, needed perpetual admonishment against high spirits, levity, and the ambition to be a painter which he did not lose even when sent to safely Puritan Yale. Forbidden to be a professional artist, Morse drew in his spare time, but the portraits by Copley and Stuart that hung on his family's walls did not inspire him to imitation. For him, it was all or nothing; as long as he was an amateur, he worked like one. Based on the humble technique of the silhouettist,

his *The Morse Family* (Pl. 62) is a more virile rendering of the art created in ladies' finishing schools.

When the conspicuously moral and well-bred Allston appeared at Boston after his first European trip, his example persuaded Jedediah Morse that art could not really be an immoral and ungentlemanly profession. "In the hope that he will consecrate his acquisitions to the glory of God and the best good of his fellow men," the father allowed his twenty-year-old son to sail with Allston to London in 1811.

"I was astonished," Morse wrote home, "to find such a difference in the encouragement of art between this country and America. In America, it seemed to lie neglected, and only thought to be an employment suited to a lower class of people; but here it is the constant subject of conversation, and the exhibitions of the several painters are fashionable resorts." That "ladies of distinction, without hesitation or reserve, are willing to draw in public" showed "in what estimation the art is held here."

Morse soon took rooms with a younger art student, Charles Robert Leslie, who stemmed not from the Puritanism of New England but the deism of Philadelphia, not from upper-class but artisan stock. Leslie had been born in London, where his father, a Pennsylvania watchmaker, was staying on business; he was carried home when he was five. The elder Leslie had harbored no objection to art—he drew machinery and was a friend of C. W. Peale. Only after the lad was apprenticed to a bookseller did he have to hide his pictures, and that opposition was quickly overcome. At the age of fifteen, he had made a sketch of the actor George Cooke which impressed his employer and created a sensation among the merchants who haunted the Exchange Coffee House. Philadelphia's theatrical

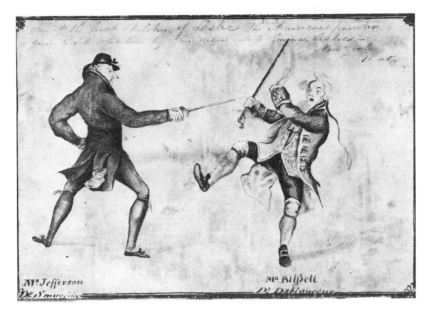

61 CHARLES R. LESLIE: Actors' Duel: Mr. Jefferson and Mr. Blissett (Courtesy New York Public Library)

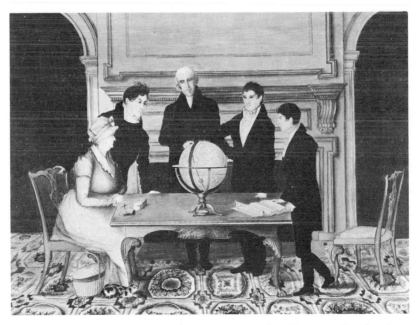

62 SAMUEL F. B. MORSE: The Morse Family (Courtesy Smithsonian Institution)

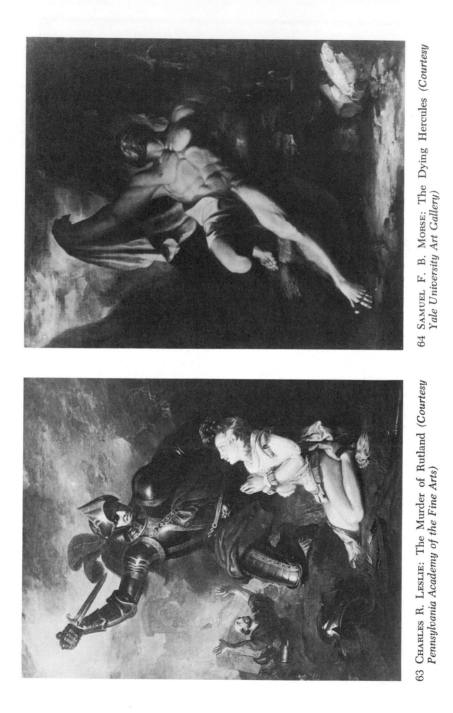

63 CHARLES R. LESLIE: The Murder of Rutland (*Courtesy Pennsylvania Academy of the Fine Arts*)

64 SAMUEL F. B. MORSE: The Dying Hercules (*Courtesy Yale University Art Gallery*)

magazine, *The Mirror of Taste* made "Master Leslie" its principal illustrator.

Although West's stormy *Madness of Lear* was being exhibited at Philadelphia to great praise, in his *Cooke as Lear* Leslie was true to his own delicate, restrained way of seeing. Avoiding the melodrama of West's composition, he portrayed Lear shrinking into himself. Some indefinable subtlety of line indicates that the body is shivering under its clothes; the sweet, mild face is almost motionless, yet a hunted look is there. When Leslie indicated gay action, as in his drawing of two actors fighting a duel (Pl. 61) he spurned all exaggeration and caricature. At first, the Philadelphians feared that he had copied engravings. Convinced that his work was indeed original, in 1811 they took up a subscription so that "this native jewel" could be polished by European study, and become "a brilliant ornament" in American annals.

Living with Morse in London, Leslie was also a pupil of Allston's. Their master had come to regard the great landscapes he himself had created as no more than student exercises for the historical pictures on which he was now at work. He assigned his pupils to paint the effects of dawn and sunset, and even to make likenesses of each other, yet encouraged Morse to state, "I cannot be happy unless I am pursuing the intellectual branch of the art. Portraits have none of it; landscape has some of it; but history has it wholly."

However, the two young men were, for fledgling historical painters, amazingly unconcerned with the great traditions of art. The longest and most lyrical passages in their letters home described plays they had seen, and life on the London streets. When the War of 1812 broke out, Leslie ignored it, but Morse

worked up a fever of patriotic resentment. Taunted that America had produced no men of genius, he resolved "to be the *greatest painter purely out of revenge.*" So as not to waste a moment, he started on a heroic composition, *The Dying Hercules* (Pl. 64).

Leslie tried to tag along, beginning his own Hercules, but he could not forget so easily what really interested him. He would have liked to illustrate the theater, or do scenes of ordinary life based on modern poets, but was informed, so he complained, that "to insure a picture currency . . . it is necessary to tell either some scriptural or classic story." West suggested *Saul and the Witch of Endor*, a subject he had himself enjoyed, and helped Leslie lay out the composition. Allston assisted him with *Murder* based on the description in *Macbeth* of how an assassin

> *Alarum'd by his sentinel, the wolf,*
> *Whose howl's his watch, thus with a stealthy pace,*
> *With Tarquin's ravishing stride, towards his design,*
> *Moves like a ghost.*

Even as Leslie worked on this picture, he mocked it to his sister by writing that the miscreant was holding his dagger with one hand and his breath with the other.

Morse was plugging cheerfully away at his *The Dying Hercules*. The emphasis on statuary which had plagued Vanderlyn had been communicated to him, but with a difference. In more romantic London, Allston did not draw from casts of the antique, but himself modeled figures which he then placed in his historical paintings. He urged this method on his pupil, and the resulting clay figurine won the Society of Artists' gold medal for students of sculpture. However, in

America the age of statuary had not dawned; Morse did not feel encouraged to work seriously in the round.

Like Vanderlyn's *Marius,* Morse's finished canvas reconstructs from ancient times a single huge figure, but the mood is not noble stoicism, nor is the background prosed out in archaeological detail. Hercules writhes with extreme death agonies before a grotto murkily indicated for emotional effect. In this Morse was more modern than his French-trained compatriot, yet he had not learned to draw half as well. Hercules, though tremendous, has no weight, and no true position in the picture space.

Allston and Morse recognized that *Hercules* represented only a short step toward high art, yet neither felt that Parisian methods would have contributed anything. They considered the French "as corrupt in the principles of painting as in religion and in everything else." Even casual association with Frenchmen tended to "subvert morals," to make Americans "frivolous and insincere." The master urged his pupil not to cross the Channel until he was "deeply enough grounded in the principles of the English school . . . to select the few beauties of the French without being in danger of falling into their many errors."

After three years of study, Morse received a letter from his father suggesting that he should now be ready to make his living. Allston answered that his pupil's progress had been "unusually great" but he had only learned enough to paint portraits. Morse added that, if he went home, he would have to "settle down into a mere portrait painter." He considered artistic progress impossible in America. Certainly, his parents would not wish him to throw away "the talents which Heaven has given me for the higher branches of art!"

The father scraped the bottom of the barrel for another thousand dollars, but this was not enough; Morse found himself in the industrial city of Bristol, painting bourgeois faces. He expected such condescension to be rewarded, and when patrons did not flock to him, he was furious. "I have been immured," he wrote, "in the paralyzing atmosphere of trade till my mind was near partaking of the infection. I have been listening to the groveling, avaricious devotees of mammon . . . till the idea did not seem so repugnant to me of lowering my noble art to a trade, of painting for money, of degrading myself and the soul-enlarging art which I possess to the narrow idea of merely making money. Fie on myself! I am ashamed of myself! No, never will I degrade myself by making a trade of a profession. If I cannot live a gentleman, I will starve a gentleman."

How markedly students like Morse differed from the self-graduated artisans who had till then dominated American art! Previously, our painters had learned by doing, every step in their education a pragmatic one. Many a native painter had executed his second or third picture for a market, a humble market, it is true, but one that had to be satisfied. As his skill increased, he charged more and attempted more until he climbed as high as his opportunities and abilities permitted.

Unable or unwilling to earn their livings as they went along, such students as Morse needed to be backed by capital. And if they were driven at last to sell some of their talents, they felt they were demeaning themselves. The pictures they threw on the market were mere potboilers, not fair examples of their work. Even if they exhibited their more ambitious efforts, as Morse exhibited his *Hercules* at the Royal Academy, they con-

sidered them classroom exercises, significant only for what they portended.

In contradistinction to the artisan, such students could, as far as serious work was concerned, ignore their environment. They were free, free to be brilliant or foolish. No one, not even the artists themselves, could judge which they were being, for the pictures on their easels were never considered a judgeable expression of their talents; the goal was never now, always tomorrow. Years could pass without any vision coalescing, without the moment of trial, of truth.

Benjamin West had been a professional before he was in his teens, and, after hardly more than a year in Italy, he was admired there as "the American Raphael." C. W. Peale had spent two years in London, working on the side to make his living, and had returned to a triumphant American career. However, Vanderlyn studied for seven years before attempting a major picture, and Morse, when finally called home after four years in England, urged his parents not to be "too sanguine in respect to me. . . . You must recollect I am yet but a student."

"My ambition," Morse explained, "is to be among those who shall revive the splendor of the fifteenth century; to rival the genius of a Raphael, a Michelangelo, or a Titian. My ambition is to be enlisted in the constellation of genius now rising in this country [England]. I wish to shine not by a light borrowed from them, but to strive to shine the brightest." So far, so good, but how was he to achieve this end? By painting history. Why history? Because everyone agreed it was the highest form of art, and he would be satisfied with nothing but the best. Did he have any taste for history, anything he wanted to say, any inspirations, any visions? On this matter, his let-

ters are silent; he seems to have given it no particular thought. Clearly he regarded the pictures he would paint not as ends in themselves, but as means, the means for achieving personal fame. The rhapsodies of this gentleman-student certainly had a nobler sound than the statistics of sales in an artisan-painter's ledger, but would they produce better art?

Since Leslie had strong beliefs of his own which did not accord with the accepted tastes of his time, he was much less sure than Morse of what he wanted to do, yet he had functioned as a professional when a boy; he continued to paint for the market place. If his inner uncertainties made him press too hard—never were melodramatic pictures more obviously melodramatic—this did not bother his American teachers and backers, who knew, even if he did not, that he was on the right road. Allston attributed to Leslie "the rare merit of combining the excess of imploring terror with uncommon beauty." West sold Leslie's *Saul and the Witch of Endor* to one of his own patrons; the Baltimore collector, Robert Gilmor, added *Murder* to his celebrated gallery; and another bloody subject from Shakespeare, *The Murder of Rutland* (Pl. 63), became the feature attraction in 1816 of a Pennsylvania Academy show, where it was backed up by eighteen other pictures that exemplified Leslie's development "from his first commencement of the art."

Earnings from his historical pictures, and the portrait work on which he engaged without repining, enabled him to stay abroad when Morse sailed sadly home. Leslie went on to Paris, where he showed no interest in old masters, considered the official classical style "unnatural," but was moved to hear the work of David Wilkie, Britain's pioneer genre painter,

praised by an occasional advanced Frenchman. And then he met a younger transatlantic painter, Gilbert Stuart Newton.

Born among Tory refugees at Halifax, the son of Gilbert Stuart's sister, Newton was brought to Massachusetts in 1803, when he was ten, and given the run of his uncle's studio. He became surprisingly adept at applying that master's style, at building up a face from a generalized blur to a sharp and lineless image. However, the kinsmen were too similar in temperament to get on together. Having made a particularly happy stroke, Newton dashed into Stuart's painting room and cried, "Now, old gentleman, I'll teach you to paint."

"You'll teach me to paint, will you? I'll teach you manners!" And not happening to have gout that day, Stuart kicked him out of the room. The two came to hate each other. Newton worked out a style of his own, but was indelibly marked by Stuart's point of view.

Carried to Italy in 1817 on a boat owned by his brother, Newton refused to learn how to draw but impressed everyone with his sense of color. Asked if he were a historical painter, he answered as his uncle might have done, "No, but I shall be one next week." Newton decided—Leslie was to regard this as "sagacity"—that the old masters had little to offer living painters, and that Italy was a dangerous place for beginners. Moving quickly to Paris, he carried with him a dislike of the grand style which echoed Leslie's own.

Together the two young artists visited the Low Countries, where they stared with rapture at the greatest pictures of ordinary life Western civilization had produced. Reaching London, they closed Leslie's volume of Shakespeare's tragedies, opened the comedies to *The Merry Wives of Windsor*. Leslie depicted the comic wooing of the bashful Anne Page

by the shy Slender, and Newton, after watching enviously for a time, started with his slap-dash impetuosity on the more raucous *Falstaff in the Buck-Basket*. As they worked, the room was filled with a sound that would have been shocking in the cathedral hush of West's or Allston's studios. The room was filled with laughter.

Old Temples in a New Land

WHILE the painters who were to dominate the next generation prepared themselves in Europe, a major change in artistic life was developing at home. Before the nineteenth century, American artists had commonly found no place to exhibit their pictures except their own studios. Only the Columbianum exhibition of 1795 had brought together a cross section of contemporary work. Paintings could rarely be sold unless they were the right size and subject for a private wall, the right price for a private purse. And as soon as a canvas was disposed of, it passed forever out of sight, since no force could rescue it from the home of the buyer. As Copley wrote, "Fame cannot be durable where pictures are confined to sitting rooms." Persons desiring art had to ferret out the name of a suitable painter: they would hear by word of mouth of a reputation, or admire examples in the possession of their friends, or answer one of those newspaper advertisements which constituted the best-organized way for an artist to bring his name before the public.

The ubiquitous drawing classes were too exclusively aimed at teaching polite people a polite accomplishment to be of much use to professionals. Beginners had to find the courage

to knock on a studio door, beg for advice and the sight of pictures. Usually they were cordially received, for older painters could remember when they too had stuttered out their ambitions to strangers. If the student could pay, he might be charged, but often, in the manner of West, instruction was given for the love of art.

The more successful the teacher, the less likely he was to have available many finished examples of his work. A portraitist might be able to show likenesses of himself and his family, made at an earlier date when he was less busy, and a few figure pieces, often based on engravings, that were not typical of his output but had been painted for his own instruction or to prove his high taste. Thus Copley lent the youthful C. W. Peale his *Nun by Candlelight,* till then his only experiment in chiaroscuro; and Peale gave his students a similar candlelight picture to copy.

There were, of course, minor breaks in the domestic organization of American art. Importers of foreign prints and decorative paintings sometimes displayed some local work. The few churches not doctrinally opposed to religious pictures commissioned an occasional altarpiece; legislatures commissioned an occasional portrait. Among museums, Peale's was the most elaborate and contained the best art, yet many mingled pictures with more sensational exhibits. Occasionally, a showman relied on art alone. Thus in 1802 the Shakespeare Gallery was set up in New York to display Boydell's famous engravings of English historical paintings based on the plays. There were also a portrait of the Bard by "Ward of Newark," likenesses of American political leaders, compositions mourning Washington's recent death, and a smattering of imported pictures including pieces attributed

to "Greuze of Paris" and "Natoire of Rome." All could be admired for twelve and a half cents.

By the turn of the nineteenth century, the same social forces that inspired the well-bred Allston to boast of being a painter made his fellow gentlemen take more seriously the role of connoisseur. Robert R. Livingston and the other New York patricians who had ten years before founded the Columbian Academy as a drawing school for amateurs now wished to bring American professional instruction in line with the European. Our self-taught artists had painted without any long apprenticeship to drawing, copied nature, not old masters. methods that were not to become common abroad until the era of the Impressionists. Although West and Stuart argued for this approach, the connoisseurs knew better. They knew that the basis of teaching in all correct European academies was drawing from the antique. Nature was a bumpkin until refined by tradition.

Going to France in 1801 as American minister, Livingston wished to send home casts from "the most admired works of the ancient Greek and Roman sculptors"; he founded the New York Academy of the Fine Arts. The merchants, lawyers, politicians, bankers, physicians, and other laymen who subscribed fifty dollars apiece outnumbered artists twenty or twenty-five to one; all the officers were amateurs. The Academy, they announced, would "be a germ of those arts so highly cultivated in Europe, but not yet planted here." It was to be a new beginning.

Casts of the *Apollo Belvedere,* the *Capitoline Venus,* the *Laocoön,* the *Dying Gladiator,* and twelve others reached New York in 1803. After $12.50 had been paid "for affixing fig leaves," the ancients were exhibited "in a very elegant

manner" at a deserted riding school. Public response encouraged the directors to send Vanderlyn abroad for more casts and to copy some paintings.

The success inspired C. W. Peale to make a new attempt in Philadelphia, relying not on the artists, who had proved too divided and weak to support his Columbianum, but, in the New York manner, on prosperous laymen. The Pennsylvania Academy of the Fine Arts was founded in 1805, but as Peale surveyed the patrons he had organized, he had misgivings. He wanted an institution more keyed to the needs of living artists than the one in New York. Imported casts and copies should be only a beginning; there should be a life class; and above all there should be an annual exhibition where the works of contemporary Americans could be shown and sold. "The whole business," he wrote hopefully, "will be cut and dried before a general meeting is called. . . . They will have nothing to do but give consent and approbation."

West backed Peale with a letter stating that the way to make Philadelphia "the Athens of the Western World" was to support Philadelphia artists, but the patrons disagreed. They secured a charter of incorporation that, although it left the way open for Peale's schemes, placed its emphasis on "the reception and exhibition of statuary," *i.e.*, casts.

Interest in the New York venture had now so waned that the antique gods were cooped up in a cellar; the Pennsylvanians concluded that an academy could not succeed without a building of its own. Instantly there appeared that lust of patrons to associate their names with an elegant structure which has defeated so many modern college presidents. Although Peale pleaded with his businessmen directors to "keep out of debt as much as possible," they would have a Pan-

theon-domed structure in the classic taste, and debt inevitably followed.

The building opened in 1807 with an exhibition in which local artists were pushed aside to make way for casts, many duplicating those in New York, and a collection borrowed from Fulton: two paintings by West, a few contemporary English pictures, and some "old masters" which, since they came without labels, gave Peale much trouble. He could not, for instance, decide whether *Abel* was painted by Titian or Poussin. When admiring crowds rescued the academy from debt, the directors made a gesture toward native art: they gave the youthful Leslie a sheet of paper saying he was their "*élève*," and subscribed, to help him reach Europe, the not munificent sum of $100.

Bostonians now considered starting an academy of their own, but the scheme was blocked by Stuart. The founders of such institutions, he explained, usually had more wealth than taste.

In 1810, some hundred Philadelphia artists revolted. Resolving that the Pennsylvania Academy was "intended merely for a museum and consequently not likely to be of much importance either in the improvement of artists or the correction of public taste," they formed the Society of Artists of the United States, dedicated, among other things, to exhibiting contemporary work. However, when the academy lent them its gallery in 1811, they did not dare exclude old masters; they borrowed some 250, most of them copies or misattributions, to hang beside an equal number of their own works. The nude classic gods already in the building were un-co-operative—they scared away ladies—but after the Olympians were banished, the rooms filled "with a vast concourse of visitors."

The academicians were impressed. Although they still refused to give professional artists who were not stockholders any say in their policies, they included many local pictures in their subsequent shows. Having won its main point, the society faded away.

The New York Academy had assumed a more grandiose title—the American Academy of the Arts—but it remained "an expiring taper" until Trumbull and Vanderlyn returned to the city in 1815, and shortly thereafter the municipal government lent the institution suitable rooms. In 1816, an exhibition, which, in the Philadelphia manner, mingled local work with borrowed old masters, sold 1,500 admission tickets, creating a prosperity that made the academy's patronage seem worth fighting for.

Vanderlyn had a head start; every American picture the institution had owned in 1816 was from his hand. He was given space in which to show, for a fee, his nude copies, his *Ariadne* and *Marius*. However, beneath his Parisian airs he remained a blunt man of the people, to connoisseurs not an object of friendship but of patronage. Trumbull, with his more aristocratic background, could talk to merchants and lawyers as an equal. He was elected president of the academy, and Vanderlyn blamed Trumbull when, because of complaints that his naked pictures shocked visitors, he was asked to remove them.

The connoisseurs, however, were classical-minded and not shocked; 112 citizens subscribed over $6,000 to help Vanderlyn build a personal museum, and the city gave him free for nine years the plot on which he built a rotunda suited to exhibiting panoramas; his view of Versailles or such other features as he could make or get his hands on. He moved in his

original easel pictures and his copies. Although unexpected costs had put him in debt, things had worked out largely according to his plan; the next step was the production of more historical pictures. Somehow, he never got started.

He painted portraits for eager legislatures and citizens; he wallowed in the problems of showmanship; and soon his voice was loud in complaint that he had not received enough encouragement to continue with high art. When his nine years elapsed, the city renewed his free lease for another three years, but at last they repossessed the land and with it the rotunda. Instead of turning with new energy to his easel, as West had done when deprived of royal patronage, Vanderlyn toured with his old pictures and worked up a resentment that took the place of creation as his emotional release. "His first success," the critic Tuckerman explained, "made him intent only on great commissions, and, not obtaining these, he tried every expedient . . . except methodical painting."

Trumbull, meanwhile, induced the American Academy to promise him, in return for his recently painted feeble historical pictures, a lifetime annuity of $900 a year. However, he himself destroyed this bonanza. He was so successful in persuading the directors to despise less well-born artists that his own compositions continued year after year to dominate the semiannual shows. The public became bored; gate receipts plummeted; Trumbull was forced to take back his pictures and relinquish his annuity.

His most valuable assets proved to be the Revolutionary scenes he had painted as a young man. In 1817, Congress offered him the vast sum of $32,000 to enlarge four of the compositions for the rotunda of the Capitol. The figures were to be life-size, a scale that had given the one-eyed painter

difficulty even in his best days; those days were far behind him. Yet he painted with energy and, as each monstrosity was completed, further lined his pockets by exhibiting it throughout the country to patriotic crowds.

Morse had returned to America in the same year as Vanderlyn and Trumbull. He considered the historical canvases he brought with him student exercises that would not pass muster in England, but he felt that they would serve in the United States "to elevate and refine public feeling." His compatriots, however, refused to make them, as he had hoped, the nucleus of a national collection, or to commission others.

His father suggested that depictions of American naval victories during the War of 1812 would have a ready sale, but Morse despised half measures. If he could not work like an old master, he would be frankly commercial, make so much from that lowest form of art, portraiture, that he could secure in Italy training that would enable him to compete as a historical painter in London. He secured much business, but marriage and the arrival of children ate up his earnings. He considered abandoning pictures for the ministry, made unsuccessful stabs at invention.

Morse despaired of improving his art in America. Although he wrote Allston that he labored to make each of his portraits better than the last, he could not really put his heart into so discouraging a mode. *Hercules* had taken him three years; he often completed a likeness in a day. When he happened in Charleston on a cast of the *Venus de' Medici,* he drew "from the antique . . . as I did in London"; but business did not carry him to the cities where many casts were available. From Albany, he complained he could find nothing "which can profitably employ my leisure hours. If there were any pictures

or statuary I could draw, it would be different." A few miles from the town, of course, majestic scenery awaited the pencil, but when Morse made a landscape, he was careful to point out that it was only the amusement of an idle hour.

The most ambitious canvas he attempted as the years rolled by was frankly a money-making venture. The version of *Christ Healing the Sick* which West had donated to the Pennsylvania Hospital earned, when exhibited in Philadelphia, huge sums despite a financial depression that damaged ordinary business for portraitists. Various artists drew identical conclusions, and soon so many large historical pictures were touring the country that laws were passed to regulate their exhibition. Sully followed Trumbull into Revolutionary history, circulating his uninspired *Washington at the Delaware*, but most artists preferred West's religious subject matter.

Dunlap, who had studied with West thirty years before but had concerned himself with business, theatrical production, and the writing of plays, was not much of a painter, yet he had experience in showmanship, and he was not inhibited by any ambitions to be an old master. From a printed description of West's *Christ Rejected* (Pl. 56), he ran up a tremendous exhibition piece, and then went on to other Biblical homilies pieced together from engravings. These were entrusted to professional carnival men, one of whom revealed his education in the following report:

"The proceeds of the painting was 110 dollars in Richmond [Virginia]—it wos very bad weather all the time—I Cold not Geat the Church in Pitsburge, it wos sold to the Freemasons for a Log, and it was Poold all to Peasses in the in Side, I have a Ball Room in the sentre of the Town, it is a much better Plass. I open'd on Mounday Eavning at 6 o'clock, at seven it

began to rain. I receive $1.50; Tuesday $17.50 Wensday $6.25 Thursday at 1 o'clock $6.25. . . . P.S. I pay $1.50 Per Day four a room."

In one town, a canvas would be hung in a church and used as the text for a sermon; in another it would be denounced from the pulpit as blasphemous. Sometimes the agent would be arrested for violating the laws taxing puppet shows, sometimes feted by devotees of art.

Rembrandt Peale was an experienced entrepreneur of popular museums; he had studied in France and England; his smooth, semisophisticated manner of laying on paint had made him a leading American portraitist. However, he had never been to Italy, and he agreed with Morse that the muse of painting was, as he rhymed it,

> *. . . a mystic form*
> *That only at a distance could be seen,*
> *The ocean wide and foreign lands between. . . .*
> *A stranger on our soil, she could not dwell*
> *So near the woodsman's axe or savage yell,*
> *But just appeared to kindle an emotion*
> *Then sought a glorious home across the ocean.*

When the temptation to produce a touring picture became too strong, he salved his conscience by stating that he did not expect his *Court of Death* to be admired for the aesthetic virtues he knew it lacked, but for its moral message.

In the center of the thirteen by twenty-four-foot canvas, Death, personified as a dark, shrouded figure, places his foot on the corpse of a youth stricken in the prime of life. The extremities of the corpse touch the waters of oblivion, indicating "we know not whence man cometh or whither he goeth."

On the right, War, attended by Conflagration, Famine, and Pestilence, treads on the Widow and Orphan. On the left are Pleasure, Intemperance, Delirium Tremen, Remorse, Suicide "drawing the dagger from his own heart," Consumption, Despair, Fever, Apoplexy, and Gout. In the foreground, Old Age approaches Death attended, since he has led a Christian life, by Faith. Peale wrote: "An old friend, a man of strong mind, could not be prevailed upon to visit the picture, though he possessed a warm desire to see it, until one day I fairly *pushed* him into the room and left him to meditate. An hour after, I met him coming out, when he grasped my hand and thanked me for the good I had done him, acknowledging a dread of death which he had always disavowed, but which this picture had entirely removed."

Enthusiastically endorsed by the clergy, *The Court of Death* made $9,000 in thirteen months. It revealed, even more than did his portraits, the roughness, the lack of subtlety of Rembrandt Peale's nature; it was powerful, but grated on the nerves. Neal considered it "a most extraordinary performance, when we reflect on the discouragement that the artist experienced, his want of opportunity, and that it was his first attempt to dramatise on a large scale."

About 1821, a Boston collector imported from France one of the many versions of François-Marius Granet's *The Capuchin Chapel*. An extension of historical painting in the direction of genre, the picture was a harbinger of a change of taste. David, the dictator of French art, disapproved, but the public was fascinated to see a re-creation of medieval life so naturalistic that viewers were tempted to offer their handkerchiefs to one of the monks. America was equally fasci-

nated: ten copies, one of them by Sully, were soon rolling across the land.

When Morse had first returned from England, he had hoped his father could get him a commission for an altarpiece, but through the years his confidence had declined, and he did not create a touring picture until *The Capuchin Chapel* showed him how to do so without encroaching on the sacred preserves of high art. He painted a hugh indoor scene of his own—*The House of Representatives.* Avoiding the historical action with which Copley and Trumbull had lifted their legislative scenes (Pls. 13 and 38) into the grand style, Morse grouped portraits of the members inside a portrait of the newly built "national hall." He hoped that painting the individual likenesses would give him valuable contacts in every state, and that citizens would flock to identify their congressmen. But although the picture has technical virtues, it was as lifeless as might be expected. It was a financial failure.

Morse blamed his continuing frustration on the American public, which, he asserted, failed to support his ambition to work in the grand style. Vanderlyn and Trumbull made similar complaints, and down the years the chorus has been joined by most historians of art. A big stick with which to belabor the public when creation fails is standard equipment for painters and their chroniclers.

Actually, during the first decades of the nineteenth century Americans on every social level revealed a hunger for great pictures. On the highest economic plane this led to the establishment of academies; if the connoisseurs rarely moved without crooking their fingers, they nonetheless moved. The urban middle classes stormed exhibitions whenever there was anything of interest to see. And the touring paintings—probably

more than a hundred traveled individually across the land—
revealed that farmers were willing to hitch up their buggies
if any art offered that had relevance to their dreams or their
lives. They were not to blame that the pictures they saw were
almost invariably bad. On the upper levels affectation, on the
lower crudeness; yet everywhere a concern, a desire, a hope.

Trumbull and Vanderlyn held on to their best works for
exhibition purposes; the pictures in the grand style they
offered for sale were usually bought. Morse had no high art
to sell except his student work. We need not be impressed
with statements that the artists would have painted a succes-
sion of masterpieces had masterpieces been commissioned:
men are not very resolute who wait for achievement and fame
to be handed them by others.

The American public lacked not interest but leadership, the
kind of leadership that a truly creative artist exerts. The aged
Trumbull killed the academy he led, and Morse and Van-
derlyn, instead of carrying the torch, self-righteously extin-
guished it when they reached these shores. However, these
men had been joined, three years after their arrival, by a bril-
liant painter who brought with him from Europe even greater
prestige. Perhaps Washington Allston would give American
taste the direction that would change aspiration into reality.

Crumbs from Belshazzar's Table

ALLSTON brought back with him to Boston in 1818 what he considered the best picture he had ever made, a rendition, as he explained to Washington Irving, of "the prophet Daniel interpreting the handwriting on the wall before Belshazzar. . . . Don't you think it a fine subject? I know not any that so happily unites the magnificent and the awful. A mighty sovereign, surrounded by his whole court, intoxicated with his own state, in the midst of his revelings palsied in a moment under the spell of a preternatural hand tracing his doom on the wall before him. His powerless limbs, like a wounded spider's, shrunk up to his body, while his heart, compressed to a point, is only kept from vanishing by the terrified suspense that animates it during the interpretation of his mysterious sentence. His less guilty but scarcely less agitated queen; the panic-struck courtiers and concubines; the splendid and deserted banquet-table; the half-arrogant, half-astonished magicians; the holy vessels of the temple shining, as it were, in triumph through the gloom; and the calm and solemn contrast of the prophet, standing like an animated pillar in the midst, breathing forth the oracular destruction of the empire! The picture will be

twelve feet high by seventeen feet long." A small sketch of the composition (Pl. 65) indicates how the huge canvas then appeared.

When Allston reached America, he believed that "all the laborious part is over, but there still remains about six to eight months work to do on it." Being in immediate need of cash, he left the canvas rolled up and painted small pictures, each of which was bought at once by a grateful Bostonian. However, Allston spent the proceeds with equal quickness. Then the community intervened: ten collectors paid Allston the then tremendous sum of $10,000 for the unfinished picture. In 1820, Allston unrolled *Belshazzar's Feast*.

He was not as pleased with it as he had been, and his apprehensions were confirmed when the aging Stuart, limping goutily into his studio, pointed out a mistake in perspective. Allston got out his manuals on that subject, drew geometric lines, and began to repaint. Despite his most anguished efforts, nothing turned out happily. For eight years, he worked on the picture with increasing frustration, until the handwriting on the wall seemed to be addressed not to the painted king but to him. Anxiety, he wrote "has fallen on me like the gigantic hand in *The Castle of Otranto*."

In 1828, the barn he used as a studio was sold. "I was wholly unprepared for this," Allston told the purchaser. He begged that workmen who had to enter the building before he could move out would walk in backward. "If the picture were seen by any person, I should never finish it."

Although many other barns and lofts were available in Boston, Allston claimed he could find no structure suited to *Belshazzar's Feast;* he laid it aside. Visitors were warned not to mention it to him. According to the essayist, Mrs. Jameson,

"his sensitiveness on this one point did at last verge on insanity. . . . I saw this fatal picture rolled up in a corner of the apartment, and scarcely dared to look that way."

In 1830, Allston, whose first wife had died, married his much younger cousin, Martha Dana, and settled among the pastures of Cambridgeport. Although he built from his own design a large studio shaped like a Greek temple, he did not unroll *Belshazzar* until 1839. Then he felt that he had "returned to my element"; but he was now sixty years old. He found climbing the ladder to the soothsayer's face very fatiguing. He would have flashes of inspiration, and begin to paint the whole vast surface over again, but the impetus would fade, leaving augmented confusion.

Resolved, in July, 1843, on a new start, he pumiced down and painted out the central figure of the king. Within twenty-four hours he was dead, escaping from what his brother-in-law, Richard Henry Dana, called, "that terrible vision, the nightmare, the incubus, the tormentor of his life: his unfinished picture." A delegation of his closest friends tiptoed into his studio and eyed irresolutely the curtain behind which hung the masterpiece no one but the artist had seen for more than twenty years. They threw the curtain back; they recoiled before a tremendous wreck. Different figures were painted in different sizes and perspectives, too large heads floated independently of their shrunken bodies, everywhere chalk marks indicated future repaintings. Pointing to the dead color covering the figure of the king, Dana wept for his departed friend and whispered, "That is his shroud."

The story of the genius and his unfinished picture is retold whenever men wish to prove that America is hostile to art, deadly to sensitive souls, suited only to Babbitts. By the hun-

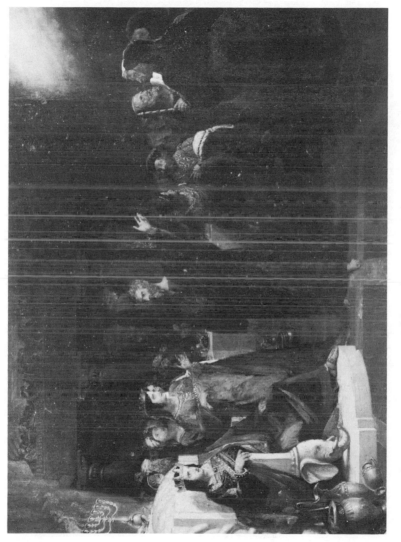

65 WASHINGTON ALLSTON: Belshazzar's Feast [study for] (*Courtesy Allston Trust*)

66 Washington Allston: *Moonlit Landscape (Courtesy Museum of Fine Arts, Boston)*

dreds, artists have used it as an argument for flight to Europe. Henry James, for instance, stated that Allston had "withered in a cruel air." As a matter of fact, the air had been too caressing.

Allston's most high-bred and cultured contemporaries, the only Americans about whose opinions he cared, never doubted that he was the only truly great artist America had ever produced, one of the greatest artists in the world. Margaret Fuller wrote that his canvases were as unlike other native art as the *Vicar of Wakefield* was unlike Cooper's crude novels; Morse challenged critics to name any old master who combined so many aesthetic excellencies; and even the usually nationalistic Emerson stated, under the emotion of Allston's death, that he had been "the solitary link, as it seemed, between America and Italy. . . . A little ray of sunshine this man of beauty made in the American forest." Since Allston never gave in to urgings that he send pictures to London exhibitions, where they would have been compared to the work of other men as aesthetically sophisticated as he, within the circle in which he chose to move, he needed to fear no rival, stood completely alone.

When Allston had returned to America, his English friends had worried lest lack of competition encourage him to dream pictures rather than paint them. Allston, as Irving wrote, tended to forget there was anything to do but think. In Boston, he engaged in metaphysical speculation and prepared a system of aesthetics which he intended to deliver, as a series of lectures, to "a select audience." He turned to literature, allowing himself to write laxly because this was an art in which he considered himself an amateur. His Gothic novel

Monaldi (1841) was overheated and derivative; one of his poems is quoted on the next page.

In portraiture, Stuart enjoyed a position as unassailable as Allston's in landscape and historical painting. Stuart was encouraged to work with increasing vigor and originality, but Allston's output dwindled, until he finished hardly more than one small picture a year. He was, he explained, seeking perfection: "You must not judge of my industry by the number of pictures I have painted, but by the number I have destroyed."

Allston stayed in bed late, reached his studio in the early afternoon, meditated more than he painted, put down his brushes with twilight, and talked late into the night. He became a dabbler, but he was not happy as a dabbler. He would have finished *Belshazzar,* gone on to other artistic triumphs, had he been able.

Of the thirty or forty paintings he did complete in twenty-five years, the most impressive to modern eyes hark back to the style he practiced in Europe before he turned to historical painting. His *Moonlit Landscape* (Pl. 66) is based not on sketches but on dream and memory; it shows no place and time. If the forms—bridge, curving river, sailboat, mountains—are conventional, that is unimportant, for the effect of the picture is in light and color. The viewer is swept into a moonlit reverie where even the most ordinary things seem compacted for some high purpose from the glittering substance of the glittering night. What this purpose is we do not know, for Allston communicates mood not story.

He tried to evoke similar emotions through "ideal portraits." Perhaps he realized that he was less successful, for he often accompanied such figure pieces with poems which spell

out what the forms and colors were supposed to communicate. Thus, the protagonist of *Rosalie* (Pl. 68) is made to speak:

> *"Oh, pour upon my soul again*
> *That sad, unearthly strain,*
> *That seems from other worlds to 'plain;*
> *Thus falling, falling from afar*
> *As if some melancholy star*
> *Had mingled with her light her sighs*
> *And dropped them from the skies. . . ."*
>
> *So thought the gentle Rosalie*
> *As on her maiden reverie*
> *Fell the first strains of him who stole*
> *In music to her soul.*

According to the bluestocking, Emily P. Peabody, *Rosalie* reveals "that susceptible moment when the maiden, forgetful of personality in the fullness of feeling, is just ready to love, but has not yet thought of loving." Miss Peabody insists that the image "uncovers the dearest secrets of the innocent soul," yet it is impossible to agree that any of the "ideal portraits" Allston dedicated to young womanhood reveal anything profound. There is more to female character than innocence and purity, more to innocence and purity than Allston would have dared admit.

He now refused to paint acknowledged portraits. Although the model for *Rosalie* was the daughter of a Boston Brahmin, who paid generously for the picture, the conception and title protected Allston from pressure toward social flattery. However, he fell into an artificiality at least as shallow: the polite

psychological pretenses of the time. Since he was no longer
tied to reality by the need to suggest an actual personality,
his "ideal portraits" seem today to lack the vitality of the like-
nesses he had once created (Pl. 67). But it would be unwise
to express such sentiments in the presence of Miss Peabody.
"Any man," she wrote, "who can sit in the midst of these ideal
pictures and wonder why he who has such visions of the un-
fallen does not paint the *fallen* images of God which are
around us in actual life, is a Goth with whom I, for one, will
not condescend to argue."

The historical pictures Allston now completed succeed in
direct proportion to their emphasis on the landscape ele-
ment. The blonde young lady who gallops on a white steed
through *The Flight of Florimell* is a hackneyed symbol of
femininity yet this hardly damages the effect, which depends
on the romantic setting: an autumnal glade instinct with light
and air. There is nothing to *Jeremiah* (Pl. 69), on the other
hand, except a bearded puppet dictating to a wooden scribe;
their routine nobility fails to indicate that the words being
spoken are shouts of anger and rumbles of doom. In a flash
of inspiration Allston could still, it is true, draw charming
figures. Thus his chalk sketch, *Titania's Court*, breathes a
light, lyrical grace, but one trembles to think what would
have happened to this vision had he worked it over in oil.

Allston sensed that the mood in which *Belshazzar* had been
conceived had faded from him. He abandoned several other
paintings in this vein. The enthusiasm of his environment,
however, made it impossible for him to discard his announced
masterpiece. Not only had it been sold, but as every year
passed public interest mounted in the great picture which
was taking so great an artist so long. Allston added to some

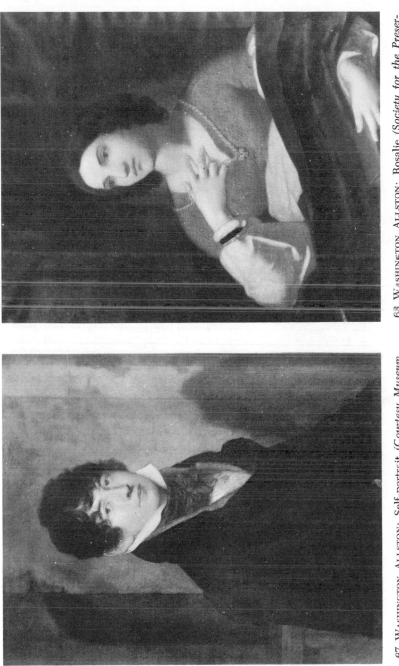

67 WASHINGTON ALLSTON: Self-portrait (Courtesy Museum of Fine Arts, Boston)

63 WASHINGTON ALLSTON: Rosalie (Society for the Preservation of New England Antiquities)

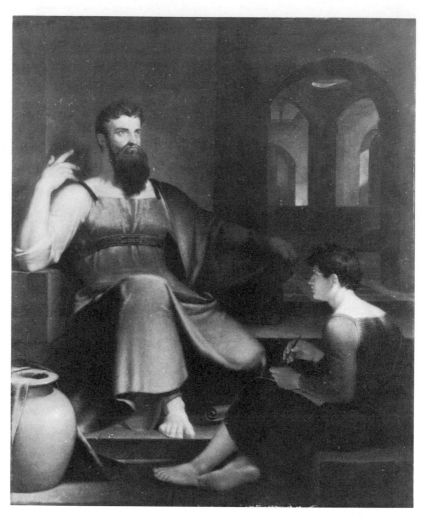

69 WASHINGTON ALLSTON: Jeremiah Dictating His Prophecy of the Destruction of Jerusalem *(Courtesy Yale University Art Gallery)*

of his letters about *Belshazzar* that they should not be shown
to the press. Afraid to admit defeat, he did the best he could
by trying, in his successive revisions, to make grandeur take
the place of violence, solemnity of drama. But his inspiration
could not be revived.

To defend himself against the rising rumor that he was an
idler, Allston blamed his frustrations on the failure of his
patrimony. From the moment he "began to look upon my pic-
tures as something I must finish in order to get so much money
. . . I worked to disadvantage, and the spirit of the artist
died away within me." *Belshazzar* represented a debt; work-
ing while in debt, "I was like a bee trying to make honey
in a coal hole."

The more we examine the causes of Allston's financial dif-
ficulties, the stranger the conclusions to which we are forced.
On one occasion, Allston confided to Miss Peabody that he
had enough work planned to last him a hundred years. "Were
I rich, I would open a school, as the old Italian artists did, and
sketch and finish only, leaving my students to do the rest of
the work under my direction."

"Let me tell *that* in Boston," cried Miss Peabody, "and all
the money needed to put such a school in operation would
be raised and put at your command in a month."

"I said, 'If I were rich,' not if *Boston* were rich."

Miss Peabody argued that to work with Allston would be
a tremendous advantage to the students themselves. The
painter replied, "There is much genius in this country, espe-
cially for color; and Morse's drawing school in New York
is quite a good drawing school." Firmly, he changed the
subject.

Connoisseurs perpetually offered Allston huge sums to paint

any historical subject he pleased, and his friends were amazed that he invariably turned down the offers that would have allowed him to work on *Belshazzar* relieved of financial worry. Allston explained that as a matter of honor he could not undertake any other major task until the picture that had been paid for was completed. He may also have been afraid that new obligations would involve him in new frustrations. Yet how can we reconcile his statements that only poverty stood between him and great pictures with his refusal to accept from a loving sister her share of a family legacy that she did not need? We can only conclude that he was unwilling to relinquish a carefully fostered excuse.

The vitality of the upper-class prejudices that had, since America was settled, impeded gentlemanly painters is shown by the particular appeal this excuse had for Allston. He had rebelled against the low social station accorded professional art to the extent of making art his career, but he still insisted that, from a financial point of view, a gentleman must paint as an amateur. Indeed, the very fact that he had undertaken what his upbringing taught him was an unsuitable calling seems to have made him lean over backward. His forebears had been hucksters in rice, but he would not be a huckster in pictures. If earnings happened to come in, he accepted them as long as he did not need them. But once he needed them, he felt shame. This attitude, which put social imperatives above artistic ones, and made it seem more important to despise money than to be an artist, increased Allston's reputation with the elite of Boston and connoisseurs everywhere.

The corollary that genius was useless unless accompanied by private income did not bother Allston or his friends. Flying in the face of the whole previous history of American paint-

ing, they believed that only gentlemen should be encouraged, for, as Allston put it, "no artist can be found of vulgar taste, even on subject wholly apart from art." He turned away from his studio all beginners except a few upper-class men and women whom he considered "of liberal education, . . . a cultivated mind, and a good taste in letters." Another necessary qualification was that an artist be "a Christian," *i.e.*, a professing member of a suitable church.

Always devout, Allston had during his most productive years belonged to no specific sect. After his nervous breakdown, he had joined the Church of England, and in Boston he had shifted to Congregationalism. His brother-in-law, William Ellery Channing, was considered responsible for this second conversion, yet Allston's beliefs were basically opposite to those of the Unitarian divine whose faith in the perfectibility of man pointed toward transcendentalism. Allston had not forgotten the diabolical visions that had driven him to the point of madness; he considered human nature "an evil deeper than all transgression." The man who had once believed that the senses open the way to the infinite had achieved such tranquillity as he possessed by subordinating his emotions to his will. Now he stated that, in the search for perfection, the senses were "an awful, a tragic hindrance." (Not conscious of the artist's deep personal wounds, Miss Peabody wrote, "It seems to me that this sense of hindrance is too bitter for the individual case.") Allston was no longer a romantic who wished, by exploring the extremes of emotion, to "lap the soul in Elysium." He had receded into the Puritanism of a previous age.

Only when Allston forgot his fears and the philosophy they had inspired, only when the portals in his mind which he had

slammed shut swung dangerously open, could he whole-heartedly seek beauty through shape and color. This he dared do sometimes when he depicted landscape, never when he painted people. As a figure artist, he tried to escape from reality into the "ideal"—but how could a man who believed that the human animal had fallen to the lowest bestiality effectively visualize "the unfallen" in human shape?

Believing as he did, Allston could have no sympathy with the equalitarianism rising around him in America. "I know the faults of my country," he wrote, "and there are few Americans who feel them more than I do." When Congress wished him to paint a picture for the Capitol, he could think of no aspect of our history worth depicting except battles.

Not a military painter, banned by the canons of the grand style from painting invective or satire, Allston tried, in the manner sanctioned by romantic theory, to return to the inno-cence of childhood. "I seldom step into the ideal world but I find myself going back to the age of first impressions," he wrote, yet the artist who was now convinced of original sin could not really find the ideal there. Actually, his happiest memories were of the trip to Italy he had made in his healthy young manhood. It was on the scenery of that sunlit land, the shepherd boys and the temples, that he brooded as the world faded from him.

Allston's pupil, the sculptor William Wetmore Story, wrote, "Allston starved spiritually in Cambridgeport, . . . stunted by the scant soil and cold winds. . . . There was nothing con-genial without, and he turned his powers inward and drained his memory dry." Without transition, Story moved to his own reactions, confiding that he hated everything American. The weather, compared to that of Italy, was cold and critical.

"Every leaf is intensely defined against the sky. Earth never takes the hue of heaven. The heart grows to stone."

Story settled permanently in Rome, but Allston made no effort to return to Italy. He himself never joined the chorus that blamed his difficulties on his American environment. As an artist, he considered himself superior to environment; as a man, he found Massachusetts congenial. In Europe he would have to fight for his reputation, and that most intellectual, antisensuous group in the United States, the Boston Brahmins, fitted in well with his turn of mind. New Englanders deified Allston for conceiving thoughts so noble he could not paint them. As late as 1883, the *Memorial History of Boston* stated that "the excess of finer qualities in his nature stood in the way of many of his pictures," and this made him "an artist in the highest and fullest sense of the word, . . . the only old master of modern times."

On his return to the United States, Allston had repudiated those elements in a nation still at the forefront of social evolution that, because they exemplified the philosophy of the Romantic movement, would have strengthened his best and most original talents; he came home only in body, not in mind. The contention that his frustrations prove America inimical to art is based not on fact but on special pleading. It has received wide currency because it has been satisfactory to that sterile legion who interpret a dislike for business as a call to art, and also, amusingly enough, to their opposites, those down-to-earth businessmen who, because they distrust art, do not wish to see it flourish on these shores. From all its legendary angles, the Allston saga has encouraged the belief that in aesthetic matters failure is a proof of success. If ordinary citizens like a picture, there must be something wrong

with it; if an artistic venture collapses for lack of support, that proves the sensitivity of its founders.

Sent into the world, as James Russell Lowell put it, "to fill the arduous office of Gentleman," Allston had failed to lead American art in any productive direction. Yet the technical proficiency of all the pictures he painted on these shores, and the lyrical beauty of a few, offered valuable lessons.

American Land and Life

WHEN, in 1827, the Boston Athenaeum opened the first public picture gallery in that city, the crowds who paid some $4,000 in admission fees had their first opportunity to see a group of Allston's pictures. They stared respectfully at his historical paintings, which had all the prestige of European culture behind them, but found his landscapes too exotic and vague. They preferred to his Italian views vastly inferior canvases by Alvan Fisher that depicted American scenes with mushy clarity.

Our rivers and mountains, still close to the natural state regarded as the handiwork of God, appealed to international romantic taste. Old World travelers had long criticized Americans for walking blindly through unspoiled wonders. Now Cooper, Irving, and Bryant were earning celebrity abroad as well as at home with their rhapsodic word pictures of the United States. Erudite artists and connoisseurs still doubted that this subject matter was suited to the brush, but the public felt no such inhibitions; they yearned to admire "real American scenes and compositions." Had an American Constable appeared, an able artist dedicated to depicting local landscape for its own sake, his work would have satisfied this demand in a way that Allston's failed to do.

Since Allston concentrated on European scenes and showed not nature pure but as edited by nostalgic memory, his compatriots were not naturally drawn to his style. They were given little opportunity to be converted. Not only were his landscapes usually locked up in parlors, but he trained no pupils who carried on his manner or modified it according to the needs of America and the times. To the few blue-blooded students he allowed in his studio he preached historical art; the most successful of them abandoned color altogether, became monumental sculptors. Outside his studio, his methods remained a puzzle. The run of American painters, practicing a much more direct technique, were at a loss to duplicate effects achieved by applying to broad areas of underpaint successions of subtle glazes.

A low-born and slightly trained sign painter, Fisher tried to overlay his pedestrian vision with Allston's poetic mood. His rocks and trees look as if they had been painted with congealed grease, and in his efforts to achieve luminosity he seems to have dipped his canvases in diluted maple syrup.

Although Allston's first pupil, Morse, had pupils of his own in New York, he was no help to landscapists. He felt it was only permissible to depict the storied hills of Italy. Having finally fought his way there, he produced a series of views in which Allston's influence is evident: the luminous effects are successfully achieved, but the poetic mood seems to have been whipped up for the occasion. Back home, Morse painted the pseudo-Gothic building that contained his studio in the surroundings he felt it should have had: New York's Washington Square is transmuted into a lagoon under a becastled mountain.

When he had traveled the country as a younger man, Morse

70 Samuel F. B. Morse: View from Apple Hill (*Courtesy Stephen C. Clark*)

71 John Vanderlyn: *Niagra (Courtesy State House Association, Kingston, N.Y.)*

had sometimes been commissioned to paint such local land-scapes as *View from Apple Hill* (Pl. 70). Engaged in what he considered hack work, he blended Allston's style with that interest in the native and the specific which characterized American taste. The charm of his master's color, a buoyant sense of light and atmosphere, are applied not to ideal forms but to a literal rendering: the utilitarian bridge across the stream remains ungainly, the boxlike house is in no way heightened. The synthesis is not altogether happy—how could it be when the artist cared so little?—yet such pictures are much the freshest, the most impressive of Morse's landscapes.

Trumbull and Vanderlyn also felt superior to American scenery. The former dashed off uninspired portraits of places, but when Vanderlyn undertook a landscape, he worked conscientiously. In his *Niagara* (Pl. 71) he did not focus his composition, as Allston would have done, on a human figure staring in at nature; he showed a wild animal staring out at men. A deformed dead tree, a rotted fence give further evidence that this is reality, not a world heightened by artistic memory. Although atmosphere exists only in a sky that seems a backdrop independent of the land, the firm drawing, the harmony of the composition, and the clear colors, reveal that Vanderlyn was on the edge of developing a personal landscape style. It was an edge he never crossed.

Having little interest in indigenous landscape, the leading painters left it to their humbler colleagues, who, since they were shunned by the connoisseurs, found their best source of income in engravings salable to a wide public. This situation had existed for a long time: the principal change was an increase of activity. During 1811-1813, 37 per cent of the

exhibitors at the Pennsylvania Academy showed landscapes as compared with 28 per cent at the Columbianum of 1795.

In 1816, the arrival of two expert British aquatinters, John Hill and William J. Bennett, ended the need for having American views reproduced abroad. Bennett drew his own competent illustrations, crowded with genre action, of cities and harbors, but Hill commissioned independent artists to prepare two extensive portfolios: *Picturesque Views of American Scenery* (1820) by Joshua Shaw; *The Hudson River Portfolio* (1822-25) by William Guy Wall. Shaw was an Englishman who had earned a modest reputation in his homeland. His *The Deluge* (Pl. 72), a frightening rendering of the Biblical flood, was long attributed to Allston. That this was possible reveals that Shaw could create a brilliant imaginative landscape. However, his views of actual America were much less impressive. Applying formulas to the depiction of ordinary rocks and foliage, he made the United States look like his English homeland. Thus he was less popular than Wall, an obscure Irishman who ignored atmosphere and over-emphasized detail to achieve wide, particularized views which, for all their naïveté, pleased the untrained eye (Pl. 73).

The arrival, twenty-two years before the aquatinters, of an English enamel painter and line engraver, William Russell Birch, is principally memorable because he brought with him his fifteen-year-old son Thomas. Immersed from childhood in the international topographical tradition, Thomas created oil views for his father to reproduce. His *Penn's Treaty Tree* (Pl. 74), published in 1800, shows Philadelphia and its harbor in the background, while across the foreground are strung figures in action: men chopping, fixing boats, leading horses. This emphasis on genre elements was typical of such composi-

72 Joshua Shaw: The Deluge (Courtesy Metropolitan Museum of Art)

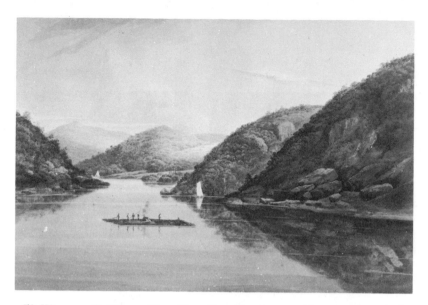

73 WILLIAM G. WALL: View Near Fort Montgomery *(Courtesy New-York Historical Society)*

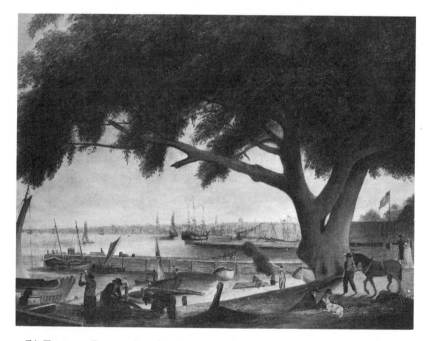

74 THOMAS BIRCH: Penn's Treaty Tree *(Courtesy Historical Society of Pennsylvania)*

tions; purchasers interested in local landscape wished also to see local life. Although *Penn's Treaty Tree* is conventional in conception, the execution shows observation and solid craft knowledge.

Birch's landscapes never transcended the illustrator's tradition; his seascapes were more free. He had early been impressed with the stagey rhetoric of the Frenchman Vernet, and, when the War of 1812 created a great market for pictures of sea battles, he threw his soul into depicting stormy water. For the time being, his boats remained clumsy stage properties, his clouds and pink skies were arranged self-consciously for effect, yet he was moving in the direction of romantic mood and emotion.

The old activities of sign and wall painting went on, and sometimes craftsmen labored to put down the world literally, just as they saw it. The son of a New Hampshire sea captain, John S. Blunt was too humble to paint faces except in profile. He turned to what he thought simple things: likenesses of prize horses and cows, views he shared with his neighbors. Possessing no recipes to protect him from so difficult a study, he went to nature's own school and created, in a halting, limited technique, pictures (Pl. 75) that can excite because they reveal a personal reaction to light and cloud, tree, hill, and glassy water.

Despite opposition from the sophisticated, taste for local landscape and activity in depicting it mounted like a subterranean stream. In 1820, Thomas Doughty, age twenty-seven, changed his profession in the *Philadelphia Directory* from "leather currier" to "landscape painter." Three years later, a calico designer named Thomas Cole, age twenty-one, carried some views he had painted to Philadelphia, where he met

Doughty. Still struggling, the young men held the future of American painting in their hands. Their sources were topographical and decorative engravings; their tools were their own eyes and temperaments. They owed nothing to aesthetic theorizing, to the school of West, to poetic landscapes by Washington Allston.

Of the painters Allston trained, the only one who enjoyed a truly productive career braved the master's disapproval. To the exhortations Allston sent across the ocean that he abandon genre, return to historical painting, Leslie replied politely that he was "content with a humble sphere." But to others Leslie denounced the grand style as a branch of architecture, and praised "the admirable matter-of-fact painters" of Holland. West, he stated, should have remained a portraitist, and, as for "dramatic invention" and "the depiction of human passions," in those qualities no historical painter could touch Hogarth.

Leslie became one of those now half-forgotten figure painters who, in that cradle of mid-nineteenth-century styles, London, bridged the gap between "the ideal" and the ordinary facts of living. Their pioneering continued directions pioneered a half-century before by West and Copley. Where the earlier artists had brought the heroic down to a modern earth, the younger banished it altogether to depict with gentle humor the charms of simple existence. More time had to pass before the nineteenth century reached that concern with the sordid as well as the pretty which had characterized Hogarth and the Dutch. Millet's *Man with the Hoe* seemed shocking in 1864.

Like Allston, Leslie valued "good taste and moderation in art as in manners." One of his most famous pictures depicted

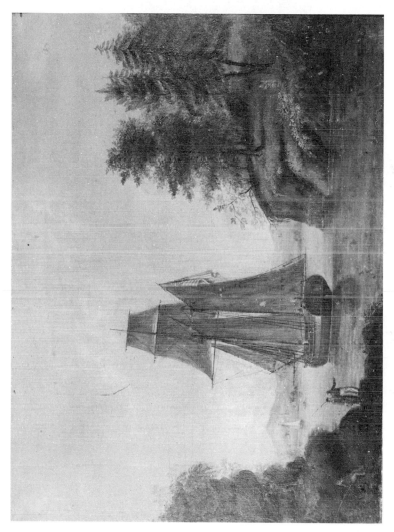

75 J. S. BLUNT: Topsail Schooner in Sheltered Waters (Courtesy Donald T. Hood)

76 CHARLES R. LESLIE: Sophia Western *(Courtesy Pennsylvania Academy of the Fine Arts)*

a ribald passage from Sterne, *Uncle Toby Undergoing the Fire of Widow Wadman,* but, so his biographer continues, "there is more prurience in Sterne's pen than in Leslie's pencil. In his hands, the widow becomes so lovable a person that we overlook the fierceness of the amorous siege, . . . while Uncle Toby himself is so thoroughly the gentleman . . . that the humor of the situation is filtered of all grossness."

Although hampered by a similar gentility, David Wilkie, the Scotch artist who was the ablest member of the British genre school, went to the world around him for subjects. Leslie preferred to work, like a historical painter, from texts, and to move at least a generation into the past. Wilkie painted Scotch scenes: Leslie did not paint American. Called home in 1833 to the professorship of drawing at West Point, Leslie felt "like a stranger." Making what he himself realized were excuses—the climate of the Hudson Valley induced consumption, and so forth—he quickly returned to England where he remained till his death in 1859.

On receiving illustrations Allston and Leslie had drawn for his *The Knickerbocker History of New York,* Irving wrote, "I shall dwell on these little sketches because they give me quite a new train of ideas in respect to my work; and I only wish I had it now to write, as I am sure that I should conceive the scenes in a much purer style, having these pictures before me as corrections of the *grossièreté* into which the writer of a work of humor is likely to run." After Allston had returned to America, Irving wrote *The Sketch Book* in daily contact with Leslie and Newton: he gave Leslie his next two books for criticism, and changed the plan of *Bracebridge Hall* at Leslie's suggestion. The painters' influence carried Irving away from the American themes that produced his most vital work into

rhapsodies to English gentility. Art was now a depressing in-
fluence on literature.

Irving might have been speaking for Leslie when he wrote,
"Nothing in England exercises a more delightful spell over
my imagination than the lingering holiday customs and rural
games of olden times. They recall the pictures my fancy used
to draw in the May morning of life, when I knew the world
only through books." Like his gracious rendering of Sophia
Western, the heroine of *Tom Jones* (Pl. 76), most of Leslie's
pictures illustrate the books he had read during his American
boyhood.

When prosperity enabled him to buy an old-fashioned
manor house, he peopled it with characters from Shakespeare's
comedies. What a pleasure it was to a man who had once run
errands for a Philadelphia bookseller to paint Anne Page
standing in the light of his bay window, Falstaff blustering
heavily in through his own door! Perhaps because his contact
with English life was not profound—until past middle age he
had lived in London as a member of the American colony—
his vision was rosier than that which native painters achieved.
His flattered neighbors considered him the most English of
painters, *"ipsis Anglis Anglior."*

The dream of a refined Europe was to Leslie, who during
his first forty years had put his roots down nowhere, more
vital than to the basically American Irving; it gave meaning
to his life. Grouping his painted characters into skillful com-
positions that seem in no way contrived, he told his stories
clearly, depicted emotions without exaggeration, achieved
verisimilitude. His drawing was excellent, but he was always
worried by color. After Allston had persuaded him to admire
the Venetians, he sweated hard to approximate their hues.

77 GILBERT STUART NEWTON: The Dull Lecture (*Present owner unkown*)

78 John Neagle: Pat Lyon at His Forge *(Courtesy Boston Athenaeum)*
Benjamin West: Colonel Guy Johnson *(Courtesy National Gallery of Art, Mellon Collection)*

He imitated the palette Newton had learned from Stuart, and studied the Dutch masters for their handling of light and air. Later he had the misfortune to fall under the spell of a genius. As a painter of ordinary things, he was one of the few Royal Academicians who urged that conservative body to admit Constable. Repaying him with friendship, Constable laid out the chiaroscuro for his pictures. This confused Leslie's style, but his output and popularity went on. He never suffered the frustrations of Allston, Morse, and Vanderlyn.

Although Newton remained under the shadow of Leslie, he found a ready market for his pictures and was elected to the Royal Academy. Imbued with the Stuart temperament, he painted spasmodically and with great speed, slighting drawing, relying on his taste in composition and color to cover all defects (Pl. 77). He turned more to contemporary life than Leslie and indulged in slightly broader humor, yet his exuberance was too often channeled by the customs of the time into sentimentality. On a visit to the United States, he married an American wife. However, he repudiated the desire of his compatriots to take pride in his successes: he was, he insisted, an English artist. Despite his death at the early age of forty-one, he is regarded by British historians as an important member of their genre school.

In America, there was no genre school. Those influential artists, Allston, Vanderlyn, and Morse subscribed to a modification of neoclassical theory not uncommon in Europe. The doctrine that, because of the superiority of classic society, only the ancients had perfect bodies, had been broadened to postulate that among ordinary men only Italian peasants were worth painting, because, as Vanderlyn explained, their lack of "fashion and frivolity" gave them a closeness to nature, a

universality not found elsewhere. Differing widely from the European norm, Americans were clearly the least universal of Western men. In Massachusetts, Allston painted *Roman Lady Reading*. Of the nine genre scenes Morse publicly exhibited in New York, seven were European.

The attitude of home-trained portraitists toward American genre was epitomized by John Neagle, a former sign painter's apprentice who had frequented Stuart's studio. He was surprised when a prosperous blacksmith told him, "I do not wish to be painted as what I am not: a gentleman." Pat Lyon wished to be painted in his leather apron, standing beside his forge with his hammer in his hand.

The commission must have appealed to something basic in Neagle's nature, for he produced by far his best picture (Pl. 78). Cool blue sky seen through a window complements the glow of the fire which turns the interior of the smithy reddish-brown. A boy manning the bellows is effectively subordinated to Pat himself, who stands at full length with negligent strength, his expression good-humored, the red of his nose vying as the brightest color with the hot coals behind him. In 1828, this genre portrait was the popular hit of a Boston Athenaeum exhibition; the directors bought it for their permanent collection. Neagle executed a copy for Lyon, but made no further effort to repeat his triumph. He had been given an eccentric commission and had executed it twice; he returned to conventional portraits.

In the early nineteenth century, gales of youthful laughter swept the adolescent nation. Irving's literary career began with a series of hoaxes. Although Irving became more restrained during his travels, on this side of the water the high spirits continued. When in the 1820's New York's leading

79 John Lewis Krimmel A Country Wedding (Courtesy Pennsylvania Academy of the Fine Arts)

80 J. A. Woodside: Country Fair (*Courtesy the late Harry T. Peters*)

artists and writers formed a Sketch Club, they spread the rumor that it was a secret society aimed at the establishment of an absolute monarchy and abolition of "the odious practice of making visits on New Year's day." At a meeting, Bryant propounded "a sage notion that the perfection of bathing is to jump head foremost into a snow bank"; and they held formal debates on such questions as "does heat expand the days in summer?"

At the center of such revels was a portrait painter, John Wesley Jarvis, whose funny stories were as celebrated as his art: Neal considered him "one of the greatest humorists of the age." As a joke, Jarvis would dash off such hilarious drawings as his caricature of a barber who crowned himself emperor to prove that any American, "if he had spirit enough to assume and talents enough to support the title" could be the equal of any European king. When Jarvis engaged in more serious book illustration, he turned out gruel, and he never attempted comic paintings. Among his pupils, he preferred the correct portraitist Henry Inman to John Quidor, who was in the next generation to bring American humorous art to its own.

Local life was considered by Americans too mean to paint, but it fascinated John Lewis Krimmel, who came from Germany to Philadelphia during 1810. In a miniaturist's technique, using brushes sometimes no larger than the head of a pin, he crowded small canvases with full-length figures. More in the illustrators' than the fine arts tradition, he did not accompany Leslie into the genteel, but delighted in showing bumpkins as bumpkins. When he painted *A Country Wedding* (Pl. 79), he reproduced a cluttered rural parlor even to chips in the paint of well-worn chairs, the cat brooding amidst

the clutter on top of a closet. His passion for detail kept him, as he himself realized, from achieving unity of effect, yet the gay little canvases are instinct with naïve charm.

A gruff, unsociable foreigner, who scorned to dress like a gentleman and was pioneering in an unfashionable mode, Krimmel had his difficulties at first, but an engraver became interested in his work, other purchasers came along, and a group of connoisseurs was finally impressed into trying to reform him: they commissioned a historical subject, *The Landing of Penn.* Whether Krimmel would have given in to such pressure it is impossible to know, for he died at the age of thirty-two. His scenes of his American life continued, as did those by Guy, to have an amazing currency: they were exhibited at academies and sold at auction beside spurious Raphaels. Yet he had no followers. On a professional level, genre persisted primarily in topographical drawings and engravings, and in the work of artisans who continued the old Colonial tradition of "painting in general."

Considered "one of the best sign painters in this state and perhaps in the country," John A. Woodside, who seems to have been apprenticed to Pratt's Philadelphia firm, exhibited at the Pennsylvania Academy easel pictures that were an extension of the demands made on him by his commercial patrons. Still life was essential to signs identifying butcher and grocery stores, but it had become so identified with beginners and artisans that between the Columbianum and the 1811-1813 shows at the Pennsylvania Academy the percentage of artists who exhibited such pictures dropped from twenty-eight to twelve. (Boasting of his catholic taste, Allston wrote, "I cannot honestly turn up my nose even at a piece of still life.") Undaunted, Woodside submitted fruit and flower

81 AMERICAN SCHOOL: Young Ladies' Seminary, Va. *(Courtesy Edgar William and Bernice Chrysler Garbisch)*

82 LUCY DOUGLASS: The Royal Psalmist *(Courtesy Edith G. Halpert)*

83 Susan Whitcomb: Mount Vernon *(Courtesy Colonial Williamsburg)*

84 Eunice Pinney: Two Women *(Courtesy New York State Historical Association)*

pieces reminiscent of the Peales but with a brash hardness suited to boards that swung high over a street.

For the sides of fire engines, Woodside enlarged those engravings of buxom maidens, whose seminudity was not considered shocking because it resulted from draperies in the correct classical taste, which served the advertising art of those days as "cheesecake." (They were ubiquitous even on the currency with which polite young ladies paid their bills.) When he ventured into historical painting, Woodside sought similar excitements. His *Columbus at the Court of Ferdinand and Isabella* features garish, poster-like colors and scantily clothed Indian coquettes who would make any right-thinking fireman whistle. As landscapes, he painted portraits of gentlemen's estates completely in the topographical tradition.

Woodside's most admired picture is a genre scene, his *Country Fair* (Pl. 80). Seeking, as a sign painter should, an organization that would hold the eye from a distance, he grouped his multitudinous sharply drawn forms into bold masses. Parallel with the frame stretches a frieze of cattle and horses, which protrudes forward into a knot of sheep, and is variegated at the rear by a crenelation of human shoulders and top-hatted heads. Behind there is vacant ground broken with dots of action, and then a similar frieze, smaller but not dimmer with distance. The background is dominated by three shapes: some trees joined into a clump; a free-standing barn, and a house that makes a unit with its vegetation. Because each of the larger shapes goes off in its own direction, this organization fails to give the picture unity. Loved today for its quaint rendition of times long dead, *Country Fair* nonetheless reveals the limitations of the sign-painter's manner.

Amateur art was even more limited, for the maidens who crowded into drawing schools did not stare hard at the world around them. For one thing, they were not trained to see with their own eyes. A teacher might paint, as a showpiece of his skill, such a charming genre scene as *Young Ladies' Seminary, Virginia* (Pl. 81), but he would not recommend anything so difficult to his pupils. The object of instruction was to enable beginners to turn out with little application impressive pictures. Krimmel lost his job as a drawing teacher because he refused to help the process along by executing difficult passages himself.

At one moment, Archibald Robertson would state that the best art galleries were the parlors of "people of importance" containing pictures by their "particular relations"; in the next, he would advertise that "to his very numerous collection of patterns he has added this summer very considerably." Engravings to be reproduced were the basis of every curriculum, so much so that rhapsodists on "folk art" are being perpetually embarrassed by the discovery that the masterpieces they had hailed as untrammeled outpourings of American genius were copies of European prints.

Most helpful was a chemical which, since it made paper that was glued to glass transparent, kept even a girl's parents from knowing that her fancy picture was achieved by washing flat colors over the ink of an engraving. For still lifes on velvet, the teacher obligingly supplied stencils of fruit and flower elements which could be combined to taste. Needlework patterns often doubled as sources for the water colorists. And an easier method than water color was supplied by "monochromatic drawing," somewhat analogous to modern finger paint-

ing, in which daubs of black crayon were pushed out on a white ground to form shapes and shadows.

The abler young ladies, of course, made their own changes in their sources, sometimes giving them a wild, romantic tone suitable to their girlish temperaments: *The Royal Psalmist* (Pl. 82) is an altogether delightful translation of the stern neoclassical mode into a parlor vision. When, as a classroom exercise at the Literary and Scientific Institution, Brandon, Vermont, Susan Whitcomb copied in water color a popular engraving of Mt. Vernon, she simplified the forms and added some touches more commonly found in needlework, transmuting the topographical conventions of her source into much fresher images (Pl. 83). Between the ages of thirty and sixty, the twice-married Connecticut matron Eunice Pinney copied many prints, but also produced an occasional composition, such as the bright and quaintly monumental *Two Women* (Pl. 84), that seems to have been entirely her own.

Even the best of the ladies' pictures were shaped and restained by their social function. Allies in the cause of gentility, with downcast eyes and pretty blushes, they could never be brutal or direct, nor could they be strong in days when a swooning timidity was considered to characterize "the sex." Humor had to be elfin not raucous; love and romance were to be taken seriously but covered with the circumlocutions of modesty; melancholy was suitable; and a spirited rush of feelings attractive as long as it was kept within bounds. Those melancholy storms that were painted as the Romantic movement deepened, those moonlit scenes full of brooding ruins, are stage sets: we enjoy the thrill but are not frightened. The young lady who weeps under a willow by a tomb in the

ubiquitous "mourning pictures" has not disarranged her hair, nor, when she drops her handkerchief, will her eyes be red. Those watermelons and apples on silk have charm, but excite no hunger; those heroines riding through the dark with their lovers are delightful, but incite no lust. Surely the parson waits at the end of the road.

At best, the ladies' art brings to our eyes tears of nostalgia for those dear dead days, and for the graceful hand, the sparkling eyes now gone to dust, which in the exuberance of youth produced these visions. What a flirt the painter must have been to the decorous notes of the waltz, what a gracious bride, what an attractive mother! But she was too corseted by convention to be a great artist.

Like their predecessors since American art began, most amateurs practiced limited techniques, but the same cultural change that permitted gentlemen to be professionals, produced some amateurs of professional training. When Henry Sargent reacted against business, his merchant father sent him to London and Benjamin West. On his return to Boston, Sargent set up as an artist, but no financial necessity kept him at his easel. Drifting into state and militia politics, he neglected his brushes, and picked them up again in the 1820's largely for his own amusement. His best paintings showed festivities at which he had been host.

The Dinner Party (Neal reported that a dog was fooled into begging at the painted table, but the dog must have been nearsighted) and *The Tea Party* (Pl. 85) almost escape from the cluttering of detail that characterized what genre painting was being done in the United States. Sargent's swollen pocketbook enabled him to collect old Dutch masters, and from them

85 HENRY SARGENT: The Tea Party *(Courtesy Museum of Fine Arts, Boston)*

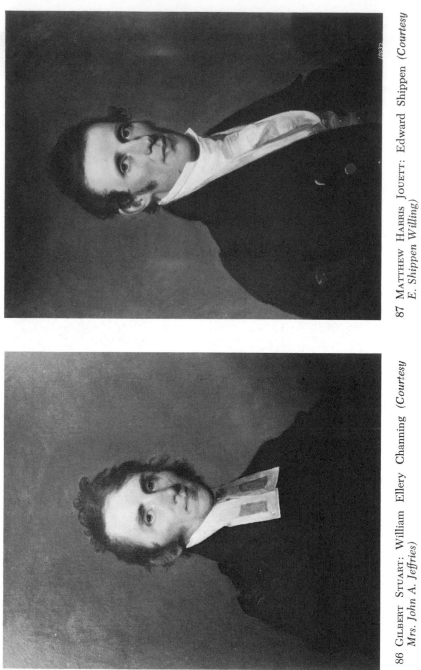

87 MATTHEW HARRIS JOUETT: Edward Shippen (*Courtesy E. Shippen Willing*)

86 GILBERT STUART: William Ellery Channing (*Courtesy Mrs. John A. Jeffries*)

he learned a control of light that, by strengthening the formal grouping of the figures, allowed him to present a unified artistic vision. Such pictures pointed the direction to knowing depictions of American life. They were admired, but not imitated.

A Rage for Portraits

A S FAR back as 1805, Burr urged Vanderlyn to come home from Paris because America was engulfed in "a rage for portraits." Two years later, the first *Salmagundi* paper reported, "everyone is anxious to see his phiz on canvas, however stupid and ugly it may be." Neal summarized the continuing situation when he stated that portraits were regarded as "necessary" and abounded "in every village in our country. You can hardly open the door of a best room anywhere without surprising, or being surprised by, a picture of somebody plastered to the wall and staring at you with both eyes and a bunch of flowers."

Although occasionally dented by financial recessions, business was good for portraitists at every level of skill. In Philadelphia, Sully made between $3,000 and $4,000 a year, the income of a wealthy man. An artist who had exhausted the demand in his own city would travel; fortunes awaited those who hit communities when the passion for likenesses had gone several years unsatisfied. Morse cleared $9,000 during a winter at Charleston; Jarvis $6,000 for two successive seasons in New Orleans.

Success had come to America and with it a wider equali-

tarianism. The farmer, as he rested from his plowing, sat in the shade of a huge barn which hardly served to hold the accumulated wealth of field and pasture: he considered himself a gentleman. The artisan no longer bowed low in his shop; he looked the rich merchant in the eye. True, there were patricians still, owners of huge estates with long lists of ancestors, but they found themselves competing in the market place with upstarts who had neither. Here and there, among the wheels that rotated in every likely stream, were larger wheels fed by deeper pools, and in the buildings that flanked them were men with firm mouths and grandiloquent visions— but the manufacturing aristocracy had not risen to the economic stratosphere, nor had they yet created, except in a few mill towns, their disinherited opposite, the proletariat. America had become a middle-class nation, and almost everyone wished to dip his spoon into dainties that had once been served only on aristocratic tables. Who was so insignificant that his features should not be perpetuated on canvas?

Those were nationalistic years, and facts seemed to bear out the eagle when he screamed. Europe was torn by wars and social revolutions; the United States enjoyed "the era of good feelings," when, unless one were overly concerned with slavery, the only problem seemed to be how best to exploit a vast continent which seemed to offer prosperity to all. By common consent, portraiture was the form of painting in which native deviations could most freely express themselves. The widespread demand for likenesses among people without conscious canons of taste seemed to the connoisseurs who were under the spell of European artistic theory further proof that painting faces was a trade so lowly that the theories were inapplicable. Gilbert Stuart was commonly considered the

greatest portrait painter in the world. Critics who ignored his revolutionary ideas on other artistic matters accepted his dicta on portraiture "as law."

Years before, Stuart had tried to conquer London by continuing to paint in the powerful, crabbed style of the Colonial vernacular. Under the whiplash of hunger, he had finally capitulated to European art, selecting in Old World galleries the techniques that enabled him to express so suavely his personal vision, but, as a self-willed old man, he persuaded himself that the capitulation had never been. Proudest of those aspects of his art that were in fact original, he insisted that he had never followed any master but nature herself.

Contact with the great traditions of art, he told the many young men who passed through his studio, was a dangerous thing. European art was decadent; American students should stay home lest they too be corrupted by a slavish dependence on old masters. All formal instruction, indeed, only encouraged the incompetent; it impeded true painters. Believing that his son, Charles Gilbert Stuart, had inherited genius, he was so fearful of damaging the boy's originality that he refused to let him hear the advice he gave less beloved pupils. The boy became a drunkard, not a painter.

Stuart no longer had the least sympathy with the homegrown American tradition in which he had worked before he had assimilated European styles. He laughed at Copley's Boston masterpieces—the flesh tints were "like tanned leather"—and demanded that his followers achieve, without the opportunities he had himself enjoyed, effects like his own. This point of view was shared by Stuart's contemporaries. Neal wrote concerning youthful pictures by West—which are today much prized by lovers of primitives—that he could re-

member when they "were regarded as prodigies for a boy. Now they would be laughed at were they shown as the early products of an apprentice to a painter of fire buckets." Even those nationalists most eager to develop an American art were not sure enough of themselves to accept anything that would look peculiar to a foreigner. They wished to impress Europeans with indigenous pictures that resembled European pictures but were better. Sophistication of result was to be achieved without sophistication of means.

Stuart's favorite pupil was Matthew Harris Jouett, the first important artist of the new West. He was born on a Kentucky farm from which his father had cleared the forest in the hope that he could make one of his sons a gentleman. Matthew was selected and sent to Transylvania University, but he disappointed his father by becoming "nothing but a damned sign painter." Likenesses turned out at twenty-five dollars a head enabled him to save enough for a European trip. However, Stuart stopped him at the ocean's edge with the warning that his art would be ruined.

After four months of watching Stuart paint and taking notes on the old painter's tirades, Jouett returned to Kentucky, his education completed. Comparison of his *Edward Shippen* with Stuart's *William Ellery Channing* (Pls.87 and 86) shows how literally he attempted to imitate his master. Primarily concerned, as he was told to be, with "the animal before you," Jouett placed the features, delineated as exactly as his skill permitted, against a plain background, and made the body no more than an unparticularized pedestal for the face. He was even untrue to his generation by seeking to duplicate Stuart's calm, classical view of humanity. Possessing natural gifts for color, he approximated Stuart's hues, although the flesh tones

lacked inner vibrancy. For the rest, he changed suggestion into statement. The features are hard and rigid, while the body instead of being brilliantly indicated, is prosed out in sharp outlines.

The style Stuart practiced in his later years was as unsuited as possible for translation by an unsophisticated eye into a thin technique. Like many other pupils, Jouett so lacked the subtlety with which Stuart brought freshness to a few, simple compositions that he seemed to employ stereotypes. While Stuart never allowed his frank vision to descend to caricature, Jouett produced upon occasion such brutal statements of physical ugliness that it is hard to understand why one of the horse-faced women he recorded did not use the prerogatives of a delicately nurtured Southern lady to shoot him straight between the eyes.

Although Jouett's contemporary, John Wesley Jarvis, never studied with Stuart, and even spoke slightingly of that master, he was also, in effect, a follower. Son of a ne'er-do-well and a midwife, Jarvis had been persuaded by the intricate European prints he sometimes saw that engraving was a more elegant trade than painting: he apprenticed himself to an engraver. Even after he had fought his way upward as a portraitist, Jarvis remained completely devoid of the Olympian worldliness that was so basic a part of Stuart's vision. At first, he was banned from polite society by his penchant for "mysterious marriages" which made impossible "respectable communion with ladies"; and, when he was finally accepted, it was as a jester who was laughed at for his impolite ways.

Jarvis wrote a friend in London, "My compliments to West and all the Royal Academy. Tell them I can paint better than any of them." But this was bravado. He sought help from

88 JOHN WESLEY JARVIS: William Samuel Johnson *(Courtesy Columbia University)*

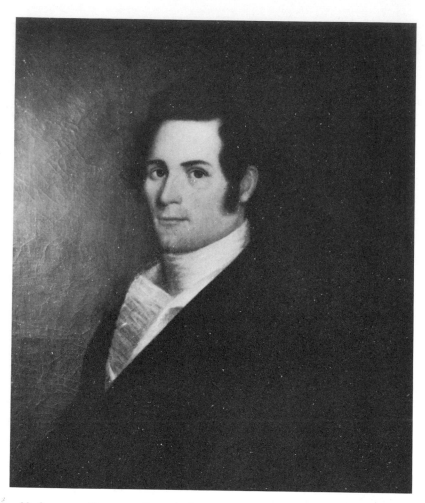

89 CHESTER HARDING: Samuel Cartmill Christy *(Courtesy Mrs. Howard Benoist)*

phrenology in expressing character, and admitted, "I find the greatest difficulty in making a pretty composition." Never quite sure what he was doing, he worked with great facility, turning out, during a short career broken by dissipation, between 750 and 1,000 likenesses. Like many of his rivals, he changed the quick brushwork of Reynolds and Lawrence, brought to America by Stuart and heresay, into a rough chopping reminiscent of the mark of an adze on the framing of a barn. Holding in check his famous sense of humor, he sought a realistic image in the Stuart manner, and, since his complicated pictures are hopelessly confused, he was most successful when he followed Stuart into rendering a face and shoulders, with a few costume accessories, against a plain background. As one of his best portraits, *William Samuel Johnson* (Pl. 88) shows his qualities were vitality and a knack for catching superficial likenesses. Neal pointed out that "his works are neither pictures nor paintings. . . . If they be preserved at all, it will be because they were painted by Jarvis, and because they were, in other days, genuine portraits."

Among the portraitists who disobeyed Stuart and went to Europe, Chester Harding had a career that typified, in an exaggerated form, common tendencies. His father was an inventor of perpetual motion machines, and when they perpetually failed to move, the family was forced to move—from Massachusetts to the wilderness of western New York. There the boy grew into a physical giant. After the dozen ingenious trades he practiced had each augmented his debts, he fled the sheriff to even younger settlements. Becoming a house painter in Pittsburgh, he happened, about 1816, when he was about twenty-four, on the work of an obscure itinerant portraitist named Nelson. Harding was "enamoured at once."

Since the professional refused to give him instruction, he boldly delineated his wife with sign colors. His neighbors were impressed into giving him commissions, but Nelson stalked into his quarters and announced that portraiture was a more difficult trade than painting houses: it required at least ten years' training. Harding was dashed until an apothecary assured him that Nelson's strictures were motivated by sheer envy.

In rapid succession, Harding made acquaintance with the theater (he had not known that plays existed), and with novels, which he had considered too immoral to read. Moving on to an older community, Paris, Kentucky, he was at last convinced that artists outranked artisans and needed more training. He penetrated to the Pennsylvania Academy, but five or six weeks there, studying the works of Sully and Stuart, so "intimidated" him that "it was a good while before I could get into my former free style of painting." No longer able to please the connoisseurs of the American Paris, he employed the family expedient of diving into the further wilderness, where he created the only known portrait of Daniel Boone. His likeness of Samuel Cartmill Christy (Pl. 89) reveals the style he now practiced.

Finally, he went to Washington and Boston in search of further knowledge. Impressed, as he put it, that "a backwoodsman newly caught" could, although "entirely uneducated," paint "a tolerable picture," the citizens begged him not to ruin his natural talent with study. They opposed the trip to England which, in 1823, he stubbornly undertook.

In London society, he became a sensation, his celebrity rivaled only by a well-washed Osage Indian. Royal dukes invited him to their estates for the shooting (he found pheasants

a little dull after bears); and he was forced to refuse all portrait commissions except those from the very highborn so that he could preserve a little time for his studies. Cinderella was begging to be recognized as a scullery maid but being chased by every prince in sight.

He looked at the old masters with some suspicion, afraid he might imbibe an "antiquarian" style, and made his own judgments: Raphael and Rubens bored him, but he did like Rembrandt. He recognized that his pictures lacked "broad effect," but felt that he had "nothing to unlearn"; and, indeed, the fad for his work went on and on. Only the fact that his wife and children were not invited with him for aristocratic week ends brought him back to the United States, where he enjoyed a long, extremely successful career.

What of Harding's pictures? His early portraits (Pl. 89), as unearthed by Wilbur D. Peat, reveal a crisp and harmonious simplicity. Their naturalism, so unusual in naïve art, their emphasis on visual reality rather than subjective patterns, undoubtedly accounted for the phenomenal acclaim he received as a self-taught artist. Although his English experience did not change his matter-of-fact point of view—he ranked Lawrence below Stuart—it encouraged him into more elaboration, which he carried off knowingly but without any flair. On a higher aesthetic plane his later work has so little individuality that most of the thousand or so portraits he painted have never been culled from the work of his American contemporaries.

The bulk of the likenesses created between 1812 and 1835 record the extreme swing of a social pendulum that started to move shortly before the Revolution when artists like Joseph Badger and Copley tempered aristocratic mannerisms with

a realistic, down-to-earth attitude toward character. The dec-
orative full and three-quarter lengths that had remained com-
mon during the Federal period were now a rarity, even though
domestic ceilings were now higher and pocketbooks fuller
than ever before. The artists banned ostentation in any form:
not only graceful poses but the loving catalogue of posses-
sions that had inspired Earl and Clarke. Backgrounds were,
almost without exception, shadings of flat colors imitative of
Stuart.

Rembrandt Peale was typical when he claimed that a paint-
ing he made as a young man of a rich woman "bedizened with
jewels and rings . . . gave me a surfeit of ornaments which
I have never after introduced into my pictures." Ladies, how-
ever, continued to demand that they be depicted in their
finery, and the artists gave in to some extent, but they were
not moved, as their predecessors had been, by the flow of silk
and the gleam of precious stones. Subordinating plumed hat
and ermined cape to a grave, lightless face, Harding gave
the impression that he thought Mrs. Thomas Brewster
Coolidge looked pretty silly. Painting that famous belle,
Dolly Madison (Pl. 90), the Albany portraitist, Ezra Ames,
combined turban, curls, laces, neckless, low-cut empire gown
into a devastating image of a self-satisfied, aging social war-
horse. Ames's intention was certainly accuracy not satire, yet
he caught none of the charm which diarists tell us was pos-
sessed by the queen of Washington society.

Such pictures were hard on the ladies. That they were hung
in the best drawing rooms reveals that American life was
dominated by men. The males did not wish to be mistaken
for English fops or French dancing masters; they were proud
to have their faces and those of their women revealed as

strong, individual, republican. The artists insisted even more consistently on realistic images. "What a damn business is this of a portrait painter?" Stuart had said. "They bring you a potato and expect you to paint a peach." Stuart had painted the potato, but with such consummate skill that ugliness never resulted. His followers produced some of the ugliest social portraits the Western world has known.

Along country roads, in the poorer streets of the big cities, artists who are today called "primitive" or "folk painters" worked in techniques that resembled the old Colonial tradition which Stuart had overthrown. Most were too obscure to leave biographies behind them, but we know that William Matthew Prior, who was born in 1806, married into a family of sign painters and with them set up at Boston a painting factory aimed at reaching a large market through mass production. His advertisements offer everything from varnishing to decorating mirrors and painting faces, from embellishing militia standards to delineating machinery. For merchants too parsimonious to employ carvers, he would paint on ships "imitation carved work . . . in a bold style."

Wishing to sell likenesses in the shipyards and the colored community as well as to the more prosperous, he manufactured them at every price: you could have your face recorded "without shade or shadow" for that most modern sum $2.92. Prior would make any kind of picture to your specification, or translate into oils your favorite print, or sell you over the counter a *Washington* after Stuart painted on glass to make it shine, American landscapes, and European scenes full of castles and gaily dressed peasants. On the back of such merchandise, he stamped "warranted oil colors." He knew, be-

cause they were ground in his cellar by his sons, who also manufactured canvases and frames.

Looking down from a businessman's heaven, Prior must mourn that he lived too soon, for modern collectors sometimes pay $500 for portraits he sacrificed at $2.92. His quick work delights enthusiasts for primitives with its energetic simplicity; his more elaborate pictures are made quaint by an unself-conscious piling up of detail.

Typically, Prior tramped the countryside with canvases and frames on his back. Few farmhouses were so isolated that a painter did not sometimes knock on the door, offer to delineate the inhabitants for a small fee that often included lodging and a daily allowance of rum. Popular legend to the contrary, there is no evidence that the itinerants ever brought with them prefabricated bodies to which they added the sitters' heads. Following immemorial studio practice, they painted the head first, even if the body were later added from imagination or a lay figure. The torsos that duplicate each other only demonstrate that the artists found it less troublesome to repeat themselves.

During the Colonial period, the more ambitious young men who had started as primitives had refined their techniques by personal experimentation and by studying the work of older personal experimenters; the road from obscurity to reputation had moved consistently in a single direction. The years between the Revolution and the War of 1812 witnessed a transition that was now completed. Now beginners who wished to advance as portraitists abandoned the primitive mode as soon as opportunity offered, became members of the school of Stuart. Those who continued to work in the simpler style showed only the most rudimentary contact with earlier

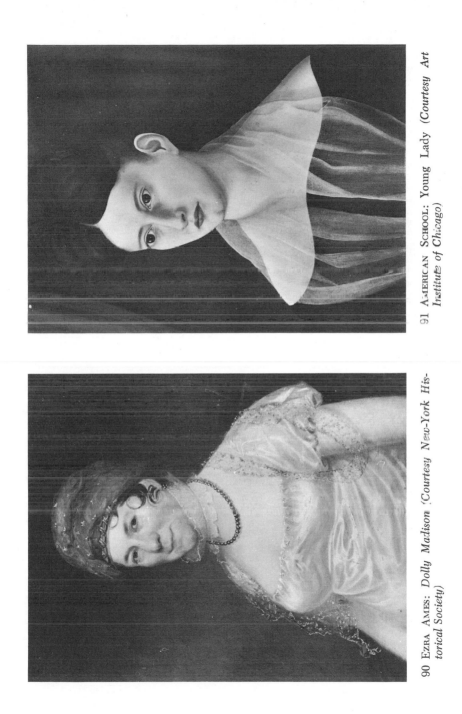

91 AMERICAN SCHOOL: Young Lady (Courtesy Art Institute of Chicago)

90 EZRA AMES: Dolly Madison (Courtesy New-York Historical Society)

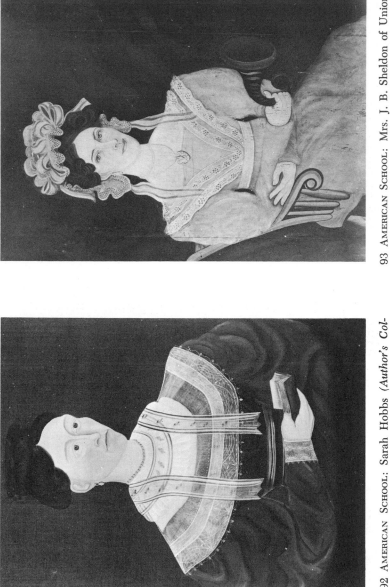

92 AMERICAN SCHOOL: Sarah Hobbs (*Author's Collection*)

93 AMERICAN SCHOOL: Mrs. J. B. Sheldon of Unionville, Ohio (*Courtesy National Gallery of Art, Garbisch Collection*)

American art. A few iconographical elements remained—the most ubiquitous was the device of filling a corner with an irrelevant looped curtain—but there is no evidence that the new crop of primitive portraitists studied Copley's Boston pictures or the work of men like Earl.

The basic techniques of the primitive style did not need to be learned for they were the methods of expression that came naturally to the untaught eye and hand. In applying them, the humble portraitists did not go backward to old points of view but moved with the spirit of the times. Like the Stuart followers, the primitives abandoned elaborate compositions, commonly silhouetted their subjects against plain backgrounds. (The cluttered primitive portraits today so admired usually date from after the mid-century, when similar canvases were being painted on the academic level.) However, the simpler artists were encouraged by their reliance on effects achieved by balancing horizontal lines to show sitters at slightly greater length, to a little below the waist.

In varying degrees and ways the knowing styles were simplified. Sometimes, as in the truly beautiful *Young Lady* at the Art Institute of Chicago (Pl. 91), form was reduced to its basic essentials in a manner that reminds us of Holbein. Concern with the third dimension was confined to the treatment of the head. Like Stuart and his followers, the primitives considered the face the soul of a portrait and tried to depict it realistically. For the rest of the figure, they were content with the flat patterns that come more easily to an untutored hand. It is this contrast that undoubtedly sparked the legend that head and body were painted independently of each other. Female finery, with all its complexities which did not have to be rendered in depth, lent itself particularly well to

variegated and charming designs. Thus, the primitives painted headdresses and laces and jewelry with an enthusiasm the Stuart followers did not share, and, unlike their more sophisticated colleagues, made their best portraits of women. *Mrs. J. B. Sheldon* (Pl. 93) is an example.

Subtlety of shape came to the artists more easily than effective color; it is a rare primitive who, like the New Jersey pastelist Micah Williams, impresses primarily with his hues. In Williams's *Trenton Gentleman,* painted about 1825, a dark blue coat, lightened with brass buttons, stands out startlingly against an emerald green background which enhances the gray-green of the eyes. The hard outlines remind us slightly of David, the color of Van Gogh.

The most extreme variations found in primitive portraiture usually stem from no more than incompetence; exotic conceptions were most successful when acclimated to the dominant mode. Thus, about 1830, the painter of *Sarah Hobbs* (Pl. 92) joined the Stuart conceptions, as the primitives practiced them, with the technique of Chinese ancestor portraits. For a plain background, he left untouched a piece of green window-shade material, using it as the Orientals used silk. In flat colors, he placed a decorative body below a face so realistically conceived, despite the distortions of naïve vision, that the spinster's hair is shown to be a wig by the bit of canvas visible in the part. The result was not varnished or stretched, but kept rolled up in the Chinese manner. The only explanation of this strangely powerful portrait is the road connecting the Hobbs's New Hampshire farm with Portsmouth, whence sailors traveled around the Horn.

Other traditions than those of the fine arts impinged on the humble portraitists. Thus the old yearning to show a human

being in his habitat expressed itself in watercolor imitations of silhouettes. Joseph H. Davis, who tramped the mountainous roads of northern New England from 1832 to 1837 and then vanished into death or some other profession, proudly signed himself "left-handed artist," and spaced charmingly outline renderings of a domestic environment: rug, table, chairs, cat, parents, children, a newspaper, books, and whatever else a sitter might desire, even to a framed picture of the family business placed high on the blank paper that was made to imply a wall (Pl. 94).

As a group, the primitive portraitists gained from a direct relationship with their medium that the Stuart followers lacked—almost all their technical expedients grew from their own temperaments yet their efforts suffered from major impediments. Since their likenesses were very rarely exhibited in public or engraved; since they remained obscure men, often without permanent studios, whose reputations, if they had any, were altogether local, no method surer than chance existed to bring to them knowledge of each other's practice. Such unity as their output possessed was less due to tradition than to the fact that similar conditions produce similar results. All over the nation men repeated in virtual isolation the same experiments; the primitives did not profit from any common reservoir of knowledge.

They were, however, perpetually exposed to the widely publicized practice of more sophisticated artists; ambitious painters could not help being influenced into attempting a style that promised fame and prosperity. Other itinerants, as their age and responsibilities increased, abandoned their humble calling for more rewarding occupations that had nothing to do with art. The few able eccentrics who worked

for a lifetime in the vernacular tradition did not, as a general rule, engage in the social trade of painting faces.

The results of many short careers varied greatly in quality, and the output of individual workmen was far from consistent: a painter not truly in control of his medium is at the mercy of a lucky or an unlucky hit. At worst, early nineteenth-century primitive portraits reveal pure incompetence; at best, they are brilliant improvisations. Created by men in the morning of life, many have the lyricism of youth, but they almost never possess the strength and broadness of scope that make so impressive likenesses by Feke and Copley, Chandler and Earl, artists who lived at a time when American society encouraged maturing careers in a vernacular tradition.

Unlike primitives and even the mass of Stuart followers, three European-trained artists—Vanderlyn, Sully, and Morse—possessed the technical skills to realize in actual portraits the shapes their eyes saw and the conceptions their minds conceived. Although Vanderlyn, as he dreamed of historical masterpieces, undertook likenesses with reluctance, when he did so he painted painstakingly through innumerable sittings. In the manner of his French schooling, he drew outlines expertly and then tinted them with cool colors. Mrs. Marinus Willett and her child (Pl. 95) are revealed as firm masses standing out before a gray background: ivory flesh tones shaped with transparent shadows, a color scheme of dark brown touched with muted gold.

Vanderlyn's portraits are substantial, yet they lack any rush of inspiration, any joy. "Were I to begin life over again," he wrote, "I would not hesitate to follow this plan, that is to paint portraits cheap and slight, for the mass of folks can't judge of the merits of a well-finished picture." By the rapid

94 JOSEPH H. DAVIS: The Tilton Family (Courtesy Colonial Williamsburg)

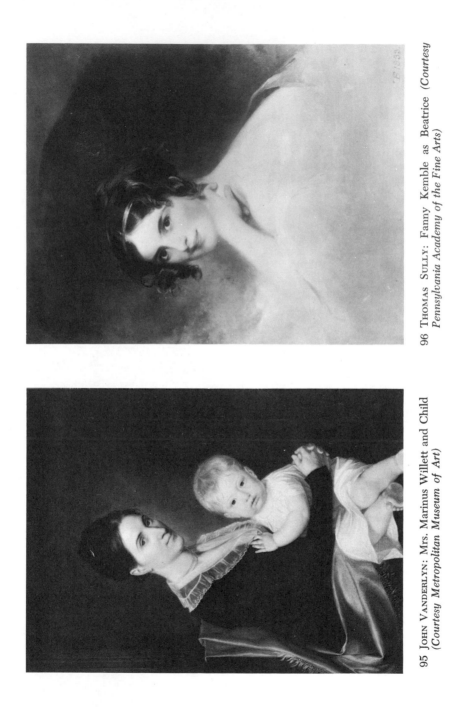

95 JOHN VANDERLYN: Mrs. Marinus Willett and Child *(Courtesy Metropolitan Museum of Art)*

96 THOMAS SULLY: Fanny Kemble as Beatrice *(Courtesy Pennsylvania Academy of the Fine Arts)*

manufacture of likenesses, he would make his fortune. "Property is after all the most important thing, in this country particularly. Fame is little thought of; money is all and everything."

On the opposite temperamental extreme from Vanderlyn was Thomas Sully. Sully came naturally by a histrionic view of the world, for his parents were actors. When he was nine, they brought him from England to Charleston, where French refugees from Santo Domingo had set up a tide of gaiety, dancing, and joy in the theater. A brief effort was made to dedicate the boy to sober pursuits, but the insurance broker with whom he was placed complained that the only figures he was interested in were human figures; you could not pick up a ledger without seeing faces staring from the margins. Sully copied a composition from Angelica Kauffmann, but in his ignorance mixed the pigments with olive oil. When the picture never dried, he sought advice from Benbridge and other local professionals. Finally, he made a pilgrimage to Stuart's Boston studio and watched the master paint, "a situation I valued more at that moment than I shall ever again appreciate any station on earth." He even tried to imitate Stuart's naturalistic attitude toward faces—but not for long. Soon he was off to London, where he found just what he wanted in Lawrence's grandiloquent manner. "Resemblance in a portrait," Sully discovered, "is essential, but no fault will be found with the artist—at least by the sitter—if he improve the appearance." Settling in Philadelphia, he painted visions prophetic of a later day in American life and art.

Sully's *Fanny Kemble* (Pl. 96) exemplifies the effects he achieved by jumping suddenly from shadow to bright light: the actress's glowing head and shoulders, with a graceful

swoop of bare back, rise like a beacon from an amber bodice touched with a foam of pink, yellow, and light red. The brilliant flesh tints contrast with raven hair and rich brown eyes that stare hypnotically. Breathes there a man with soul so dead that he would not fall in love at first sight with this passionate lady? Yet a second glance produces a suspicion of artificiality.

Sully's best portraits are of females (Pl. 97)—his men lack virility—and he saw nineteenth-century ladies with just as generalizing a vision as Sir Peter Lely had used on the countesses of the seventeenth; the difference in result was the difference between two societies. Lely's women are poised and confident, haughtily sure. Proudly they display their beauty, being sometimes shown with one breast bare. Where Lely's women are majestic, Sully's are refined. There is a cringing in their grace, as if they would not be pretty if they could help it; their ringlets and childlike forms reveal that sensuality in reverse which makes motion-picture censors ban as suggestive the word "virgin." Lely's females ride to hounds and shout out a good oath when a horse slips; Sully's use parasols to protect their complexions from the sun and slip to the ground in a faint if a coarse man uses in their presence a coarse expression. The chatelaine of a castle has given way to the bourgeois' delicate daughter. Without any tradition behind her, but determined not to be mistaken for anything but a lady, she imbibes her manners not from her total environment but from a governess who got her manners from a book.

When Sully painted Queen Victoria, he interpreted as stubbornness the imperiousness of this daughter of a hundred kings. "If one might judge from her manner," she intended

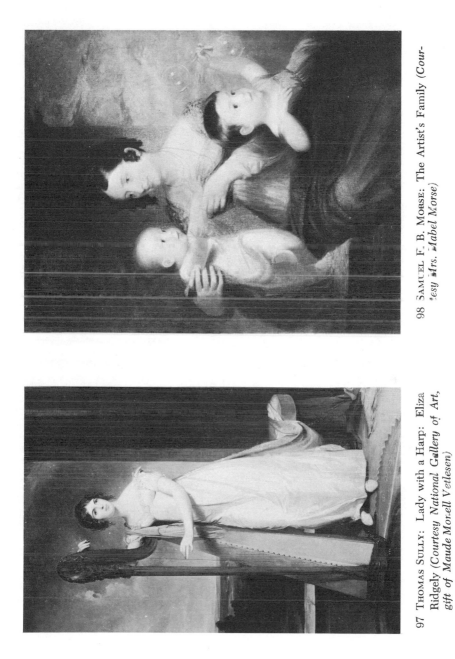

97 THOMAS SULLY: Lady with a Harp: Eliza Ridgely (Courtesy National Gallery of Art, gift of Maude Morell Vetlesen)

98 SAMUEL F. B. MORSE: The Artist's Family (Courtesy Mrs. Mabel Morse)

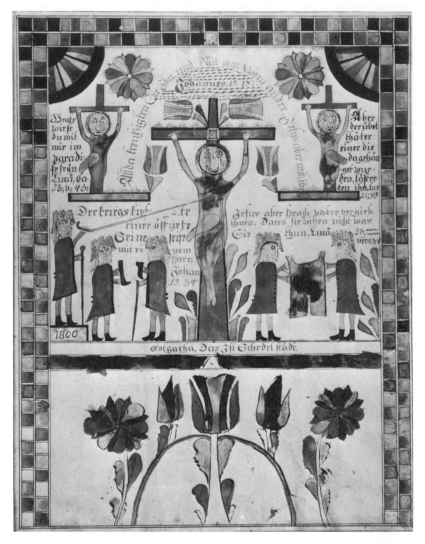

99 PENNSYLVANIA DUTCH ARTIST: Crucifixion (*Courtesy Metropolitan Museum of Art*)

to have "much her own way." For the rest, she was "very affable, like a well-bred lady of Philadelphia or Boston." His son pointed out to the painter that he would have to show her wearing her crown and the robes of state; "it will do for the portrait of anybody without them." Sully religiously added the requisite accessories, but they do not save the picture: Victoria Regina looks like a stockbroker's daughter tricked out for a fancy-dress ball. Yet Sully was doing his best to appreciate and give expression to the glories of royalty.

Primarily a decorative painter, Sully did not cut deep either as a student of human nature or as an artist, yet his visions lack energy only when, in the manner of Allston, he completely emancipated himself from reality by painting "ideal portraits." The sweet innocence of *Little Nell*, who sleeps so purely with her golden hair and a rose in her hand, makes the modern viewer wish to reach for the arsonist's match.

Sully was intensely popular, particularly with the ladies, for he presaged that moment in American society when they were to take over the leadership of polite culture from the men, when their parlors became citadels of "taste" which their husbands, coming home from commercial labors, entered with a mixture of uneasiness and awe. Sully saw in his sitters qualities that the ladies hardly knew were there—and that delighted them. However, not until the mid-century, when society itself had moved in the directions he prophesied, did he have many artistic followers.

Morse struck a happy middle ground between Vanderlyn and Sully. Since he did not take portraiture seriously, he practiced it without affectation, gave full sway to that creative realism which he was later to apply to the telegraph. As an inventor, he was not theoretical but hardheaded; he brought

scientific principles discovered by others to bear on the actual world. As a painter, he could record with an imaginative eye, but lost his way when he tried to make his imagination soar into an aesthetic imperium.

Morse depicted his brother's family in a special exhibition piece. To impress the connoisseurs, he dreamed up a vast marble hall troubled by columns, cut by curtains, the tremendous expanse of floor parqueted in marble. This picture seems comic beside a rendition of his own family (Pl. 98) in which, since it was to be a personal keepsake, he allowed himself to be simple and direct. The rhetorical full length of Lafayette commissioned for New York City Hall is impressive not because of the literary metaphors he threw in— a helianthus flower facing the sun is supposed to illustrate the hero's "unswerving constancy"—but for the strong, unheightened image of the old statesman, still rugged despite disappointments and the passing of years. Many of Morse's best portraits show no more than a head and shoulders. His view is as shrewd as that of the Stuart followers—he, too, may have been influenced—but color, composition, sympathy, save him from ugliness.

Stuart's practice had drawn a surprising number of his disciples into an anachronistic eighteenth-century view of humanity which sought to combine a sitter's multitudinous expressions into a basic, static image. The most important feature to a likeness, Stuart stated, was the nose. Morse agreed with Sully and Jarvis in preferring the mercurial mouth. He filled his portraits with movement, caught in the romantic manner one fleeting expression that seemed to typify all others. The results were lively, decorative, and realistic likenesses.

Depending on their tastes and temperaments, modern critics prefer among the portraitists of this period the primitives, or Vanderlyn, Sully, or Morse. Yet the fact remains that the primitives are not comparable with their eighteenth-century predecessors, that Vanderlyn, Sully, and Morse were inferior to Copley and Stuart. Life was draining out of the portrait mode.

Eccentrics

AT LIMITED times and in isolated places there existed on these shores imported traditions of folk art. The earliest settlers brought British back-country styles to America, but in less than a generation they were overwhelmed by conceptions arrived from London. Folk painting continued only among non-English-speaking immigrants huddled in narrow areas. For a while, the Germans known as the "Pennsylvania Dutch" practiced calligraphy as if printing had never been invented: artisans illuminated birth certificates with moral sentiments in their native tongue, and with stylized nature forms of great antiquity. Human beings are not shown as the particularized persons who entered art during the Renaissance, but, in the medieval manner, as symbols distorted for emotional effect (Pl. 99). True, we find paintings on glass of American military heroes labeled "Wasington" or "Jagson," but the faces might be anyone's. When actual portraits appeared, the tradition was breaking down.

The peasant arts, which had persisted in Europe hardly influenced by upper-class styles, were dependent on static social systems where well-defined hereditary groups accepted a humble worldly role; folk painting could not survive close

contact with American equalitarianism. As soon as men hoped that they or their sons would become gentlemen, they scrambled to imitate the more conspicuous cultural tastes of the class toward which they aspired.

The printing press disseminated to every corner of the United States examples of the arts of design as they were practiced in the centers, both at home and abroad: fine arts or cheap reproductions of historical paintings and of likenesses, topographical views, book and magazine illustrations, wallpapers, advertisements, vignettes on dollar bills, trade marks, watch papers, fashion plates, embroidery patterns, books of art instructions and criticism, architectural engravings, etc., etc. Every American artist was dependent to some extent on these sources, and the humbler the painter, the greater the dependence. As we have seen, prints dominated the schools in which amateurs were taught, and brought to primitive portraitists the compositional devices of their more exalted colleagues. In the fields of landscape and genre, which were left to them, simple painters often made the engravings that even simpler painters copied. The printing press filled the role in our society that was filled in peasant societies by folk traditions.

The fundamental unity of American art was further enhanced by the fact that, with the exception of a few gentlemen who had recently entered the profession, all the painters of importance began in the artisan ranks; many, like Pratt, continued to create signs as well as likenesses. History does not bear out the contention of modern enthusiasts for naïve art that the "primitive" and the "academic" painters functioned as independent groups in active aesthetic disagreement. It would be more accurate to visualize the organization

of our art as a stairway mounting without any break from the humblest artists with the least illusionistic techniques to their celebrated colleagues who fooled the eye with complicated naturalistic images. No one argued for the canons of twentieth-century taste; as far as public statements went, everyone agreed that a painter was the more admirable the higher he penetrated up the stair. Thus the sign painters and professors of drawing who belonged to the Society of Artists of the United States joined with the leaders of the profession in ignoring the Colonial vernacular tradition. The history of American art began, they stated, when West sailed for Europe.

The best of the primitives must have enjoyed their practice since they worked with conviction, and they undoubtedly grumbled in private to their friends, as modern illustrators do, against the low rank accorded to their output. However, the fact remains that the two greatest workmen who spent a lifetime going their own way did so, at least in their conscious minds, on other grounds than aesthetic conviction. Edward Hicks obeyed a religious obsession; John James Audubon thought of himself as a scientific illustrator.

Hicks's parents belonged to the Tory aristocracy that was impoverished by the Revolution. Hankering always for what he had lost, the father became a ne'er-do-well; and the mother came back in memory to her son as "the very reverse of a perfect woman," an example "of pride and idleness." When she died, the father drifted away, leaving the infant to be supported by a colored servant. Edward was finally taken into the house of some prosperous Quakers who, as soon as they could, apprenticed him to a coachmaker. He specialized

in the painting aspects of the trade and, on his release in
1799, set up as a sign painter.

In those years, he attended what he later described as
"cutting apple frolics, spinning frolics, raffling matches, and,
indeed, all kinds of low, convivial parties"; he danced and
drank and sang; yet he felt in himself so great a propensity
for evil that when he had "licentious thoughts" he feared that
"the strength of my passions and the weakness of my resolu-
tion" were carrying him into "the pit of pollution." He sought
sanctuary in the most extreme doctrines of the Quakers.

Although he realized that painting was "the only business
I understood and for which I had capacity," he now con-
cluded that "if the Christian world were in the real spirit of
Christ . . . there would not be such a thing as a fine painter
in Christendom. It appears to me to be one of those trifling,
insignificant arts, which has never been of any substantial
benefit to mankind. But as the inseparable companion of
voluptuousness and pride, it has presaged the downfall of
empires and kingdoms; and in my view stands enrolled among
the premonitory symptoms of the rapid decline of the Ameri-
can republic."

Hicks made himself over into a farmer, "for which I had
no qualifications whatsoever"; complete ruin was only averted
by his discovery that he had great gifts as an evangelist. He
traveled the country spreading God's word, and joined his
distant cousin, Elias Hicks, in leading the "Hicksite" secession
from the "Orthodox" Meeting: they had doctrinal disagree-
ments and accused the more prosperous Quakers of selling
out to the gewgaws of the world. However, Edward's reli-
gious prominence gave him little interior satisfaction. Was
he not guilty of the sin of pride; did not "the primitive Chris-

tians . . . work with their hands, avoiding idleness and fanaticism"? With at least conscious reluctance, he returned to his only manual skill, "my peculiar talent for painting." As an old man, he wrote, "Oh, how awful the consideration! I have nothing to depend on but the mercy and forgiveness of God, for I have no works of righteousness of my own. I am nothing but a poor old worthless insignificant painter."

Convinced that all educational institutions were "the bane of true republicanism and the most efficient contrivance of Satan for the destruction of primitive Christianity," determined to keep his art "within the bounds of innocence," he limited himself to what he considered "useful learning." Hicks was isolated from the artistic conceptions of the academies by religious beliefs similar to those of the Pennsylvania Dutch sectarians, and he lived near their settlements. That even he found no inspiration in their medieval crafts seems the final proof that Americans were completely unresponsive to true folk art. In a manner conventional for sign painters, Hicks based compositions on engravings after West, Trumbull, and Sully. When he depicted animals, he turned not to the stylized fauna of the European peasants but made his own simplifications from commercial prints.

Hicks painted signs to order, even copying from a print a likeness of that old heathen Franklin, but he preferred to dedicate his art to the way of life in which he believed. His farm scenes, featuring neat fences, healthy animals, and sturdy tillers of the soil, symbolize the plenty that rewards virtuous labor. By the dozens, perhaps by the hundreds, he painted *Peaceable Kingdoms* (Pl. 100) illustrating the prophecy of Isaiah that the wild animals would lie down with the kid and calf, "and a little child shall lead them."

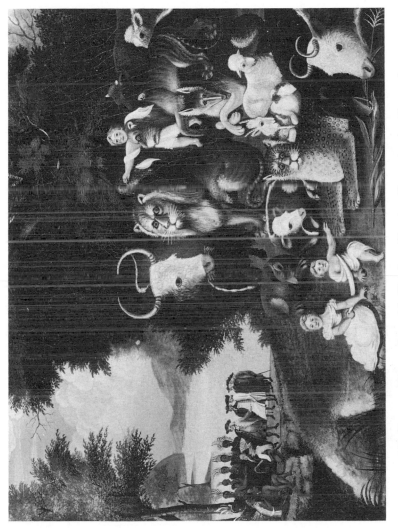

100 Edward Hicks: Peaceable Kingdom (*Courtesy Worcester Art Museum*)

101 EDWARD HICKS: Penn's Treaty with the Indians (*Courtesy Robert W. Carle*)

Often he showed in the background Penn signing his famous treaty with the Indians, an extension of the allegory into historical fact. Other backgrounds show Penn leading the Quakers to holiness, while a long pennant stretching off to Heaven bears the message, "Behold I bring you glad tidings of great joy. . . ."

The paintings are agreeable in color and majestic in design; intensity moves directly from the artist's mind to the mind of the viewer. Engaged in a perpetual struggle to suppress his own pride, his own lust and love of song, Hicks knew that the lion would not find it easy to lie down with the lamb. The oxen and lambs doze away, contented and smug, but carnivores stare with a fierce melancholy. Entirely apart from his conscious intention, Hicks indicates that God's grace has restrained, not washed away, the leopard's blood thirst. A true solution of the problem of evil awaits some paradise beyond man's imagining.

Often Hicks depicted Penn's treaty in separate pictures (Pl. 101). His model was always West's celebrated reconstruction of a historical happening, but the drama Hicks painted did not take place in the exterior world. We see normally shaped Quakers trying to make peace with monsters who, although for the moment benign, remain distorted, horrible. The forces of evil are being neutralized, not subdued. As soon as the parley is over, they will return to the wilderness of the subconscious, to an existence reason does not know. Ignoring conventional artistic theories, Hicks expressed, however crudely, his deepest emotions. His pictures could not help being powerful.

While Hicks dreamed of being an early Christian, Audubon dreamed of being a great aristocrat. Born at Santo Domingo,

the illegitimate son of a French merchant and a Creole woman, he nourished the belief that he had been born in France and was so highly descended that his true identity had been hidden lest he be carried to the guillotine. This delusion was not weakened by his inability to decide exactly which nobleman he was. Although his father brought him up as a well-to-do French bourgeois, he considered money-grubbing beneath his imagined station. He mingled an aristocratic pleasure in sport with a more modern concern for natural history; he shot birds in the daytime and drew them at night. His father hopefully sent him to study with David, but how could a man of his station occupy himself with the endless drawing of casts that would make him—of all things—a professional painter? Such study was "immediately laid aside by me."

In another effort to bring the youth down to earth, his father sent him, during 1803, to America on business. Audubon neglected the business as he chased birds, wearing, so no one would mistake him for an ordinary hunter, black satin breeches and silk stockings. When Alexander Wilson published his *American Ornithology,* Audubon merely expressed satisfaction that the collection he had gathered as a gentlemanly hobby was more complete than Wilson's. Even after he was thrown into debtors' prison and left, on his release, with no possessions but his clothes, his gun, and his drawings, he mulled over other possibilities for several months before he decided to publish his own ornithology. He was thirty-five when, in search of further specimens, he plunged with new energy into the wilderness. Sometimes he made a few dollars by drawing crayon likenesses in a typical primitive technique.

Since Wilson had pre-empted the possibilities in America,

during 1826 Audubon took his collection to England for pub-
lication. Allowing his hair to flow down to his shoulders and
glorying in the epithet "the American woodsman," he became
such a social rage as Harding had been a few years before.
His drawings were admired not only for their ornithological
interest but as "a real and palpable vision of the New World,"
the "landscape wholly American: trees, flowers, grass, even
the tints of the skies and the waters quickened with a life
that is real, peculiar, trans-Atlantic."

With the typical perversity of patrons thrilled by a fresh
talent, the connoisseurs tried to push Audubon into more
conventional modes. They persuaded him to paint in oil, a
medium with which he was uneasy, and to execute, in the
Flemish manner, *Pheasants Attacked by a Fox.* "Sometimes
I like the picture," he wrote. "Then a heat rises in my face
and I think it a miserable daub. . . . The ground, the foliage,
the distances are dreadful." Finally, he resolved to "spoil no
more canvas," but draw "in my usual untaught way which
God meant me to." He criticized that most celebrated con-
temporary animal picture, Landseer's *The Dying Stag,* as un
true to nature; an artist, he sometimes argued, needed only
to record since "nature, after all, has done all for us"—yet he
could not help being cast down by his failure at applying
correct theories of art. Unable to "make on canvas a noble
commander speak," or "carry in my mind's eye all my mind
feels," he was not, he admitted, truly a painter. He encour-
aged his engraver to insert behind his birds suitable landscape
backgrounds; he decided that, as soon as his son John Wood-
house Audubon became proficient in drawing, he would "give
this department of my duty up to him altogether," and con-
centrate on the executive direction of what he called "our

wonderful undertaking"—the publication of a complete ornithology.

No more than Hicks did Audubon recognize his role as an artist. His contribution, he stated, was to record "plain truths," yet he damaged the work of fellow naturalists by fooling them with reports of fabulous animals, and, in his own drawings, he often sacrificed accuracy to the picturesque. Ornithologists criticize the unnaturalistically violent attitudes into which he threw such subjects as his mockingbirds, who are shown fighting a rattlesnake. A true romantic, Audubon found pleasure in bloody episodes—some of his renditions of birds hunting are too gruesome for modern walls—and believed that nature was most typical in its most intense action.

As C. W. Peale had in his museum extended the theories of historical painting in the direction of natural history, so Audubon extended the rising interest in romantic genre. For the purposes of scientific classification, it was only necessary to draw birds accurately in static poses, but Audubon showed them flying free, acting out their lives dramatically in a world of light and air.

To reach so original an end, he invented his own means. He began with a weird kind of sculpture, transfixing the dead body with wires which he bent until he had achieved the sense of motion he desired. Then he drew as accurately as he could in a combination of water color and pastel. Since form and sheen of feather had to be caught before the bodies had started to decompose, he worked in bursts of intensity; years might pass before he had another chance to record a rare specimen. Whenever possible he made many drawings of the same species, each time throwing the less satisfactory ones away.

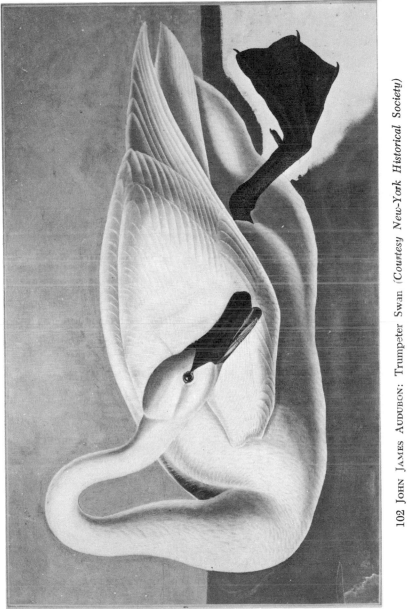

102 John James Audubon: Trumpeter Swan *(Courtesy New-York Historical Society)*

Audubon's nonartistic purpose forced him to ignore the canons of high art. His contribution was to be the discovery of new species in the New World; he would violate the truth if he did not put native birds in native settings; there was no place in his practice for dreams of Roman or Biblical times. To generalize like a historical painter would destroy everything. His interest, indeed, extended only to depicting the minute. He surrounded his birds with natural objects that were in their scale, silhouetting, in his most successful pictures, the resulting shapes against white paper or broad sweeps of color that represented the heavens. Thus he created in the shallow, linear patterns that are the natural medium of untaught painters, while strict adherence to the hues of plumage and petal fitted in with the episodic rather than organic harmony of colors that comes most easily to the innocent eye. Thus his ends and his means worked perfectly together to form the majestic designs in which for once the technique of the primitive achieved the verisimilitude that was the conscious objective of all early nineteenth-century artists (Pl. 102).

The muses were coy to Morse and Vanderlyn, who swooned at their feet, but they knocked at the door of Hicks's rural paint shop, chased through the wilderness after "the American woodsman." Morse and Vanderlyn did not love enough to lay their souls before their mistresses. They had learned to woo from textbooks, and were only in love with love. Yet the very isolation from their fellow artists that made possible in a sterile period the sincerity of the great eccentrics could not help limiting their triumphs. Deprived of the riches that flow from deep traditions, Hicks and Audubon worked each within a narrow scope.

CHAPTER SIXTEEN

The End of an Era

IN 1825, American artists finally revolted against domination by the connoisseurs. This belated action—the English profession had rebelled in 1760—was touched off by a squabble before the locked doors of the American Academy. The building was supposed to be open to students. When a group insisted they had the right to be admitted, Trumbull replied in his official role as president that the gentlemen, not the students, paid the bills: "Beggars are not to be choosers."

The elderly Trumbull considered it more important to be a gentleman than a painter; the younger Morse wished to obliterate all distinction between the two groups. If most artists were, as a matter of fact, not socially correct, that situation, Morse believed, should not be emphasized but remedied; and an essential step was to keep the calling from being looked down on by merchants and lawyers. He presided over meetings in which the professionals founded the National Academy of Design and planned to support its activities and schools with the earnings of exhibitions limited to new work by contemporaries. The connoisseurs laughed at the idea that the artists could go it alone, but their American Academy soon

withered, while an eager public thronged the ever-changing shows of the National Academy. As Bryant wrote, the artists had "appealed from the patronage of the few to the general judgment of the community, and triumphed."

In his inaugural address as president of the professional academy, Morse lashed out at his own disappointments. He stated that an artist who has studied in Europe faces on his return to America "misanthropic seclusion and despair." Such a man has "unfolded his powers" in a society far advanced "in the march of taste, but he comes back to society which has scarcely begun to move in the great procession." Having "outstripped in knowledge the public he leaves behind him," he finds his compatriots "unprepared, however much they may be disposed, to understand him. . . . Plucked up and replanted in the cold and sterile desert," he would "perish by neglect," or even be overshadowed by some "pretending weed" who has never studied in Europe. "An artist," Morse concluded, "may go abroad but he must not return."

Defending America against this attack, an anonymous writer in the *North American Review* agreed that "our taste in these things is not of national origin." However, connoisseurs also went abroad, and, "by simply adopting the fruit of their labors," covered in years what had taken the European nations centuries. The difficulty was with artists who hurried across the ocean "before it is well ascertained whether it is worthwhile for them to go" and "seeming to make prodigious advances," they returned before they were trained. If a graduate of foreign studios were worthy of admiration, he would receive it. Then the writer made a most interesting statement which he elaborated no further: "It would be more

likely that, led away by our admiration of foreign models, we should neglect the original beauties of some home-taught student of nature."

Morse did not take too seriously his own advice about staying home. Prosperity followed his high office, and in 1829, after fourteen years as a portraitist in America, he embarked on that long-awaited trip to Italy which he believed would enable him to create great art. From Cambridgeport, Allston applauded: "Morse I consider as a child of my own. . . . The quickening atmosphere which he is now breathing in Europe will open some original and powerful seeds which I long ago saw in him."

However, Morse's Italian writings are primarily given to attacking Catholicism. Concerning a procession of monks: "Pale and haggard and unearthly, the wild eye of the visionary and the stupid stare of the idiot were seen among them; and it needed no stretch of the imagination to find in most the expression of the worst passions of our nature." Concerning the great religious pictures he had come so far to see: the "prostitution" of painting in Catholic churches "almost makes me doubt the lawfulness of my own art." He tried to reassure himself that painting, "when used for its legitimate purposes, is one of the greatest correctors of grossness and promoters of refinement." Yet, he could not deny that "man is led astray by his imagination more than any other faculty. . . . If there is any collision," he would rather abolish painting altogether than endanger the salvation of the human race. Stepping even deeper into Puritanism than Allston had done, Morse resolved that it was not enough to ban from art depictions of the Godhead. All religious sentiment must be banned.

Europe disappointed him in every particular. He wrote

that Gasparo Landi was considered the greatest modern
colorist, but was not "on a level with the commonest sign
painter in America. . . . I have not seen more beauty and
taste in any country, combined with cultivation of mind and
delicacy of character, than in our own. . . . While pestilence
and famine and war surround me here," he decided that the
United States was "the one bright spot on earth. . . . An
American gentleman is equal to any title or rank in Europe,
kings and emperors not excepted. . . . It is high time we
should assume a more American tone while Europe is leaving
no stone unturned to vilify and traduce us, because the rotten
despotisms of Europe fear our example and hate us. . . .
America is the stronghold of the popular principle, Europe
of the despotic. These cannot unite; there can be, at present,
no sympathy."

Here was a major change of heart. When the forty-one-
year-old president of the National Academy returned from
his three angry European years, it would have been logical
for him to demand that American artists build their own idiom
on the popular principles he had so extolled. But Morse was
incapable of imagining a culture that was not imposed from
without and from above. "Is there not a tendency in the
democracy of our country," he asked himself, "for low and
vulgar pursuits? . . . Are not the refining influences of the
fine arts needed, doubly needed?" While abroad, he had
painted as a showpiece which he hoped would make his for-
tune in America a digest of European painting: *The Gallery
of the Louvre*, containing small copies of thirty-seven old
masters. The public proved uninterested. It was depressing,
he wrote, to be back in the United States.

Morse's cultural compass, having lost all direction, spun

with dizzy aimlessness. It was probably no coincidence that on the boat coming home from Europe he had become fascinated with a problem that had no relation to the fine arts, but much to business and money. He had conceived the idea of the telegraph. As his experiments matured slowly, he sparked the Know-Nothing movement with publications arguing that a plot against American democracy had been hatched by the Pope in conjunction with foreign despots; immigration, which allowed into the country trained Catholic conspirators, should be stopped. On this bigoted platform, he ran unsuccessfully for mayor of New York.

Finding it increasingly difficult to stick to his easel, he took personal pupils, secured at New York University the first chair of painting and sculpture in an American college, and gave public lectures on art. "If I can in my day enlighten the public mind so as to make it easier for those who come after me, I don't know but I shall have served my country as effectively as by painting pictures which might be appreciated a hundred years after I am gone." Since Daguerre's invention of photography presented an easy way to record likenesses, he became a pioneer in its importation. Yet he still hoped to be rescued by a major commission for historical pictures.

When, in 1835, Congress resolved to fill four more panels in the rotunda of the Capitol, Morse pointed out that, since he had studied for seven years in Europe, he was the obvious painter. When, two years later, Congress gave the commissions to others, Morse publicly renounced art. His friends at the National Academy rushed into the breach by subscribing $3,000 for any example of the grand style he cared to undertake. At last in the position that he had always believed would enable him to realize his aesthetic ambitions, Morse started

a huge *The Signing of the First Compact on Board the May-flower*. He found himself turning with relief to his electrical experiments. He made a few sketches and then gave up.

Vanderlyn received one of the Congressional commissions Morse was refused. Sailing to Paris, he hired French artists to do the actual painting on his *The Landing of Columbus*. He returned home reluctantly, and in the many years that followed—he did not die till 1852—created nothing of importance. "No one but a professional quack," he explained, "could live in America."

In 1841, a young artist wandering through New York University found himself in a studio marked by "indubitable signs of unthrift and neglect. The statuettes, busts, and models of various kinds were covered with dust and cobwebs; dusty canvases were faced to the walls. . . . Judge of my astonishment," he wrote, to learn that the studio "belonged to the president of the National Academy, the most exalted position, in my youthful fancy, it was possible to obtain."

Morse resigned from the presidency in 1845, and four years later wrote his epitaph as a painter. "The very name of pictures produces a sadness of heart I cannot describe. Painting has been a smiling mistress to many, but she has been a cruel jilt to me. I did not abandon her; she abandoned me. I have scarcely taken any interest in painting for many years. Will you believe it? When last in Paris, in 1845, I did not go into the Louvre nor did I visit a single picture gallery. I sometimes indulge in a vague dream that I may paint again. It is rather the memory of past pleasures, when hope was enticing me onward to deceive me at last. Except some family portraits, valuable to me for their likenesses only, I could wish that

every picture I ever painted was destroyed. I have no wish to be remembered as a painter, for I never was a painter. My ideal for the profession was perhaps too exalted—I may say is too exalted. I leave it to others more worthy to fill the niches of art."

The drama that had started when West reached Italy in 1760 had come to its tragic end. West's generation, the first generation of American historical painters, had won international renown, and had led in the evolution of the European styles with which they had so suddenly become familiar. Their successors trod a better-worn path, and upon occasion began their careers brilliantly, but they all sank into sterility.

The earlier painters had grown up in Colonial times. Subjects of the British Empire, they moved to London as modern Americans might move from Ohio to New York; inhabitants of European provinces, they traveled through Italy as men examining their ancestral past. Since they considered the great traditions of Western art their natural inheritance, they felt free to modify what they saw until it expressed their own personalities and experiences. Applying knowledge to belief, they worked with sincerity and power.

After the establishment of independence, Americans thought of themselves as a people apart. Painters no longer identified themselves with European culture, yet they realized that true richness of technique was not included in what they now considered their heritage. Wishing the United States to win the respect of older nations, they were embarrassed by the homespun verities of their native art. But, on reaching Europe, they did not feel enough at home to adapt their discoveries to their needs: they felt they must either reject totally or accept without change. When they rejected, they limited

their possibilities; when they accepted, they abandoned the truth of temperaments that had been shaped in the New World.

The contrasting attitudes of the two generations were strengthened by other historical considerations. Until the end of the eighteenth century, American and Western European social development moved in parallel lines, with America a little ahead in those aspects of thought linked to equalitarianism. Our Revolution was hailed by English Whigs, French philosophers, Italian poets; German and Polish liberals hurried across the ocean to join Washington's army. When West and Copley painted from their native convictions, they expressed the forward movement of European life.

The explosion in France changed all that. Although the Napoleonic wars troubled the United States, they brought little of the destruction, the stifling terror that existed overseas. And after the Congress of Vienna, America seemed a different world. In Europe, the watchword was oppression, the answer discontent that broke out in bloody and abortive revolutions. At home, the watchword was expanding prosperity, and there was no angry answer at all.

The favorite American dream evoked an old-time Italy: classic statues, Renaissance canvases, Mediterranean skies which had colored Titian's vision, peasants who preserved a pristine innocence. Americans who crossed the ocean found that these visions did not merge automatically with their own experience. The statues were of strange gods, the canvases seemed pagan or Catholic propaganda, the skies shone on groves of olive trees, the peasants had been brutalized by despots. Hard pressed to achieve a synthesis, artists from West through Morse turned for help to their living colleagues.

Always American life was closest to the English, and the same was true of art. Except on rare occasions, painters ignored their Italian contemporaries. French painting was considered mannered; nor did Vanderlyn's influence or the pro-Gallic bias of the Jeffersonians change the verdict. In 1818, the *Analectic Magazine* expressed the general view when it stated that the French school "is quite distinct from truth and nature, being a curious combination of old theatrical taste with pedantic affectation of antique simplicity and smooth hardness." The Romantic painting that appeared first in England appealed naturally to Americans.

Yet even English life moved away from American. When our painters were first conquering London, Adam Smith's *Wealth of Nations* was popularizing optimistic conclusions based on conditions both regions shared. But in the early nineteenth century, British economic thought was dominated by the pessimism of Malthus and Ricardo. Malthus's fear that a rising birth rate would reduce all to want, Ricardo's concern lest the concentration of wealth in the hands of a few would crush progress, had no relevance to a continent so vast that its complete exploitation lay in the unforeseeable future.

Although academic critics and painters clung tenaciously to the grand style, it was sickening everywhere. Increasingly unable to find "the ideal" in contemporary life, European practitioners warmed over Biblical and classical visions. Americans, ignoring the happier state of their society, followed the Europeans into subject matter that was completely unsuited to their land. In the United States, Puritan prejudices undermined religious art; classicism was not a deep American experience. As the English-born architect Benjamin Henry Latrobe explained, ancient mythology was known to so few

that "an allegorical picture stands in as much need of inter-
pretation as Indian talk."

West had used classicism not as an end in itself but as a
traditionally accepted style with which to shatter the meta-
phors of baroque painting. As soon as the battle was won,
he had moved in directions more fruitful to his own genera-
tion. During the early nineteenth century, Latrobe followed
a similar evolution in America. He brought with him to these
shores romantic modifications of classical building, and then
altered them further to suit the times and American needs.
Continuing this evolution, his native-born pupils, Robert Mills
and William Strickland, transmuted Greek temples into do-
mestic buildings convenient for ordinary men.

Morse and Vanderlyn made no similar effort for it would
have forced them to abandon the grand style. Historical
painting, as they practiced it, depended for "ideal effect" on
the conception that a hero, be he religious or temporal, was
an ideal man. When Washington died in 1799, he was
mourned as just such an exalted personage, immune to the
emotions and the pettiness of the mob, as a historical painter
needed for his protagonist. But this vision was erased almost
instantly by Parson Weems, whose immensely popular biog-
raphy made the father of our country over into a successful
Sunday-school graduate, a bourgeois figure suited only to
genre. Such unwillingness to regard heroes as a separate
order of creation, forced the infallible to relinquish human
shape. God could no longer be visualized as the perfect man,
the King of Kings.

As the historical mode became less vital on both sides of
the ocean, the pictures increasingly depended for their im-
pressiveness on size. In America, however, large canvases to

paint on were almost unprocurable, big studios were rare, and few rooms would hold the completed compositions. When North Carolina commissioned Sully to paint *Washington at the Delaware,* the portraitist could not bear to keep this bid for fame down to the specified dimensions. The picture was returned since it would not fit into the capitol.

Because of the many opportunities that existed for labor, there were few professional models of any sort. The nude presented overwhelming difficulties. You could look at yourself in a battery of mirrors but could not ask your wife to pose. Vanderlyn's *Ariadne* found an eventual purchaser in the young engraver, Asher B. Durand, who needed a naked female form that could be studied conveniently and without embarrassment.

The painters themselves were uneasy with the human body. Thus the Society of Artists of the United States denounced the exhibits of undraped casts staged by the classical-minded connoisseurs as "altogether inconsistent with the purity of republican morals." Vanderlyn was typical when he painted the nude with the intention of making a shocking exhibition piece. Although the public flocked to see such displays, they piously denounced what they had so eagerly scanned. Assured that Wertmüller's *Danae* was "dangerous even for a woman to look at," Neal conjured her up in his imagination as "such a naked woman, so full of languor, richness, and beauty [as] has not often been met with in this world." Prudery, attended as always by prurience, stood between Americans and that unabashed knowledge of the living figure necessary for figure painters.

Imported pictures considered "old masters" gave unfair competition to native historical art because, in addition to

having more prestige, they were cheaper. The fourteen contemporary American paintings owned by the Boston Athenaeum in 1833 had cost $7,523, the thirteen "old masters," $1,815. Correggio's *Charity* was worth $100, Trumbull's *Sortie Made by the Garrison of Gibraltar,* $2,016. While a living artist had to be reimbursed for his time, a picture dealer needed only to make a profit over what he had himself paid. Since American incomes were still relatively small, only the European canvases that European connoisseurs spurned journeyed across the ocean—but the labels were impressive. Auctioneers commonly offered in a single afternoon "masterpieces" by the dozen, Titians and Raphaels mounting the block between Lancrets and Teniers. New York's leading art dealer, Michael Paff, frequented pawnshops with amazing results. To prove that Michelangelo had created a *Last Supper,* he demonstrated that the number of stones painted in the floor equaled the letters in Buonarroti.

Before the days of systematic connoisseurship, misattribution flourished abroad as well as at home. Since the intellectual component of a picture—its composition, its sentiment—were considered most important, even Goethe made little distinction between originals and copies. Vanderlyn was not overly provincial when he wrote from Paris, "A fine copy from Michelangelo . . . is the only great work of that master I have yet seen." However, the United States suffered from having practically no good "old masters" to show up the bad ones. The mirrors of European art available in America were distorting mirrors, like those in a penny arcade.

It was recognized that many of the pictures were frauds. While admiring as genuine a Rubens and a David, Neal stated that not one of the five *Holy Families* exhibited in 1827 at the

American Academy was "worth picking up in the street for a cover to a tea chest"; the "Van Dycks" were "Van Ditches." Yet it would never have occurred to Neal to deny the authority of the all-over glow given off by the yellowed daubs. The portraitist Henry Inman commanded the neophytes in the National Academy School, "prefer rather to doubt the justice of your own impressions, should they be unfavorable, than to impeach the great tribunals of taste." The abject admiration that was required was more likely to confuse than to instruct.

In the eighteenth century, painters had been less troubled by inapplicable ideas and bad models, partly because American art was still dominated by an artisan attitude that put practice first, theory second. Craft-trained painters who dedicated themselves to the historical mode seem to have felt that in America the difficulties would be insuperable; West and Copley stayed abroad. The former artisans who did not reach Europe or who returned home from foreign travels reacted to high talk of the grand style by feeling that that direction was closed to them. We may regret that they did not forge boldly ahead toward a figure-painting tradition of their own, yet they avoided affectation. They concentrated on what they believed they could do well, making use of methods they were competent to handle.

The first major case of frustration in American art was the first gentleman, John Trumbull. For years he was an exception, crying to deaf ears his message of sterility and doom, but after the War of 1812, when other members of his class were ranked around him either as connoisseurs or academically trained painters, his point of view became dominant. Theory took over from practice; the successful creation of pictures was considered less important than taste.

Painting became a refuge for aristocratic hopes that had been wounded by the Revolution, had scrambled back into the saddle during the Federal period, had been unhorsed by Jefferson, lacerated by the embargo, outraged by the War of 1812, and were now in danger of being overwhelmed by new forces marching in from the West behind that plebeian on horseback, Andrew Jackson. Money and political power could no longer characterize an elite—so many strange people had secured money and power—but there remained taste.

If taste was to be a distinguishing characteristic, it could not arise from the people or be truly satisfactory to them; it had to be superimposed from above. This the gentleman painters resolved to do, and so loud were their voices, so sweet their song, that they carried with them painters of lesser birth and of artisan training. How could men engaged in what had long been considered a lower-class trade resist the invitation of their social betters to join a Society of Seers?

The mass of the painters were further driven into a sense of unity with their vocal leaders by a prejudice that the aspirations of the elite churned up in the nation. The revolutionary low-church philosophy many Americans had brought with them from Europe had denounced art as an ally of aristocratic pretensions and of Catholicism. In the Colonies, this attitude had gradually become quiescent because it had been applicable to nothing in American life, but now taste was being used as a weapon by new claimants to worldly superiority.

"National prejudices are unfavorable to the fine arts," Latrobe complained in an oration to the Society of Artists. "Many of our citizens who do not fear that they will enervate our minds and corrupt the simple republican character of our pursuits and enjoyments, consider the actual state of society

unfit for their introduction; more dread a high grade of perfection in the fine arts as a certain indication of the loss of political liberty, and the concentration of wealth and power in the hands of the few." Latrobe's defense was predicated on the history of republican Greece and Rome.

As De Tocqueville pointed out, a society is likely to base its moral imperatives on the furtherance of those aspects of life it considers most important. Absorbed in material expansion, Americans commonly disapproved of what they considered useless frills. This included art as the academies preached it, but, most significantly, not art that they themselves found interesting. They admired historical painting that was linked to their concerns by a moral or patriotic message. It was the connoisseurs not the crowd who objected to paintings of American life and landscape; and the people took particularly to their hearts that art form which best served them, the portrait.

Paradoxically, portraiture, although predicated on respect for the individual, was throughout the Western world being weakened by too much individualism. This was particularly true in equalitarian America.

Of necessity, a commercial portrait is a collaboration between the artist who creates and the sitter who must be pleased. As long as the partners share common attitudes, the result can be happy. In the nineteenth century, traditional imperatives of behavior became so relaxed that, although the objective remained a socially acceptable image, no one was sure what that image was. Furthermore, the artists no longer felt honored by the patronage of the rich and important; they resented expressing any personality not their own. Soon serious painters would keep dominion in their studios by refusing

pay for likenesses, paying models to pose. Allston's "ideal portraits" pointed in this direction, revealed the dangers as well as the advantages.

Stuart had communicated to his pupils and followers his own resentment of sitters' suggestions, but not the motives behind it. His determination to paint faces exactly as he saw them had grown from a profound belief that it was a marvelous and important thing to record personalities on canvas. But his pupils and followers lacked this faith; they mourned with Morse that portraiture deprived them of "independence" and "loftiness of purpose," put them "on a par with the commonest barterers of goods." They yearned, however unavailingly, for the gentlemanly life, high taste, the grand style. They resented portrait work and they could not do it really well.

Dedicated to an art form they could not practice, practicing an art form in which they did not believe, the early nineteenth-century painters lost to literature that pre-eminent place in American culture which their profession had up till then held.

During the Colonial and Federal periods, writing had been primarily a by product of religious and political controversies; literary forms were practiced as an avocation by gentlemen who imitated the European books they could so easily obtain. When in the early nineteenth century, gentlemen finally became professional men of letters, they were less self-conscious than the well-born painters, because authorship had never been practiced by artisans and was not associated in the American mind with trade. Furthermore, the distribution pattern for books turned them for support not to individual connoisseurs but to a broad public. They were encouraged by

the general interest, both here and abroad, in American things to express their own experiences and beliefs. This, in turn, gave them a product to sell that could not be overwhelmed by competition from European writers, and kept them from slavish dependence on foreign models.

Rising from below rather than superimposed from above, the Romantic movement found everywhere its first major expression in literature. Everywhere, connoisseurs fought rearguard actions against this bourgeois taste. At different rates of speed in different cultures, but always slowly, critics of painting gave in to the subject matter of the new poets (landscape) and of the novelists (genre). England headed the procession, and there two men of American experience were among the leaders. Leslie and Newton did not feel, as West and Copley had done, that they could straddle the ocean. Like their colleagues in the United States, they ignored American life.

In 1825, an old man who had known in his youth the joys of untrammeled creation was stopped, as he walked down a New York street, by some pictures displayed in a store window: three wildly vital canvases of unadorned American scenery. John Trumbull hurried into the shop and asked the name of the artist. It was a name he had never heard: Thomas Cole. "This youth," Trumbull said, "has done what all my life I have attempted in vain!" He bought a picture and persuaded his friends to buy the others.

A change that is long overdue strikes with the force of a river that has smashed a dam. Hymns to the beauty of the North American continent flooded from hundreds of studios; they were soon joined by enthusiastic depictions of American life. Everything that the historical painters had most opposed

was manifest in the work of the young landscape and genre painters. Their techniques were crude, based not on the great achievements of the past but on the popular topographical tradition; their subject matter was unknown to the old masters, and they depicted it with little striving toward the ideal; their emotion sprang raw from simple breasts. Although it was natural that the public, which had long desired such pictures, should be thrilled, the connoisseurs and the older painters would, it seemed certain, respond with Herculean wrath. Their failure to do so is the final proof that the historical tradition was bankrupt.

The connoisseurs, forgetting their lust for a private refinement of taste, were caught up in the general excitement. The older painters either admired with Trumbull or abdicated with Morse. Morse was still an active artist when the new movement burst into the sunlight of acclaim, and, as president of the National Academy, he presided over the exhibitions which the so-called "Hudson River School" captured. When the crowds passed his own contributions by—even the results of his Italian studies—his response was less outrage than bewilderment and sorrow. Even as he denounced the new, popular taste he gave in to it by turning to invention.

Thus died an affectation that had stifled a full generation of American painters. But affectation itself was not dead. It remains to this day the greatest single deterrent to art in the United States.

Acknowledgments

I AM GRATEFUL to the John Simon Guggenheim Memorial Foundation for a grant that enabled me to complete this book, and the Lowell Institute for inviting me to deliver a series of lectures based on the manuscript.

The New-York Historical Society and the Frick Art Reference Library have accorded me hospitality. I wish to thank in particular Dr. Fenwick Beekman, president of The New-York Historical Society; R. W. G. Vail, director; Miss Dorothy C. Barck, librarian; and the following members of their staff: Wayne Andrews, Charles E. Baker, Miss Geraldine Beard, Miss E. Marie Becker, Arthur B. Carlson, Miss Betty K. Ezequelle, Richard J. Koke, Wilmer R. Leach, Miss Carolyn Scoon, Sylvester Vigilante, David H. Wallace, and William D. Wright. I am also grateful to Miss Helen Clay Frick, director of the Frick Art Reference Library, Mrs. Hannah Johnson Howell, librarian, Miss Hope Mathewson and Miss Muriel Steinbach of the staff.

The New York Society Library, the New York Public Library, the Pennsylvania Academy of the Fine Arts, the Historical Society of Pennsylvania, and many other institutions have assisted me in my research.

Bernard Berenson first interested me in art history and has been an inspiration ever since. I have profited from the friendship and advice of the late William Sawitzky. Among the many other scholars who have helped me are: Miss Louise Averill, Harry MacNeill Bland, Henry Seidel Canby, Mrs. Irwin F. Cortelyou, Miss Bartlett Cowdrey, Miss Miriam Danzinger, Marshall David-

249

son, Miss Louisa Dresser, Mabel L. Eiseley, Lloyd Goodrich, George C. Groce, Julius Held, MacGill James, Mr. and Mrs. Louis B. Jones, Mrs. Nina Fletcher Little, Mrs. Barbara Neville Parker, Wilbur D. Peat, the late John Marshall Phillips, J. Hall Pleasants, Edgar Preston Richardson, Miss Anna Wells Rutledge, Paul J. Sachs, Mrs. William Sawitzky, Charles Coleman Sellers, Theodore Sizer, Victor D. Spark, Mrs. Louise Hall Tharp, Miss Elizabeth Townsend.

BIBLIOGRAPHIES

AND SOURCE REFERENCES

The bibliographies and source references are designed to be consulted as a unit. After the bibliography of general sources there are further bibliographies arranged alphabetically by artists. Then come source references in which citations for specific quotations and details are placed under identifying headings in the order in which the topics appear in the text.

Complete citations for the abbreviations used will be found in the bibliographies. It is assumed that the reader will conclude that the full title of "Dunlap, *History*" can be found among the general references, of "Flagg, *Allston*," under "Washington Allston." However, to the abbreviation "Farington, *Diary*" the key word "(West)" is added to indicate that the book is listed under "Benjamin West."

Bibliography of General Sources

Allen, Edward B., *Early American Wall Painting*, New Haven, 1926

Baltimore Museum of Art, *250 Years of Painting in Maryland*, catalogue of an exhibition, Baltimore, 1945

Barker, Virgil, *American Painting: History and Interpretation*, New York, 1950

Belknap, Henry Wycoff, *Artists and Craftsmen of Essex County, Massachusetts*, Salem, 1927

Bolton, Theodore, *Early American Portrait Draughtsmen in Crayons*, New York, 1923; *Early American Portrait Painters in Miniature*, New York, 1921

Born, Wolfgang, *American Landscape Painting*, New Haven, 1948; *Still Life Painting in America*, New York, 1947

Cahill, Holger, editor, *American Folk Art*, catalogue of an exhibition at the Museum of Modern Art, New York, 1932

Cowdrey, Bartlett, compiler, *American Academy and Art Union Exhibition Record*, New York, 1953, 2 vols.; *National Academy of Design Exhibition Record, 1826-1860*, New York, 1943, 2 vols.

Cummings, Thomas S., *Historic Annals of the National Academy of Design*, Philadelphia, 1865

Cunningham, Allan, *The Lives of the Most Eminent British Painters*, annotated by Mrs. Charles Heaton, London, 1879, vols. I-II

Dickson, Harold E., *A Working Bibliography of Art in Pennsylvania*, mimeographed, Harrisburg, Pa., 1948

Dictionary of American Biography, New York, 1928-1936, 20 vols.

253

Dictionary of National Biography, London, 1885-1901, 66 vols.

Dreppard, Carl W., *American Drawing Books*, New York, 1946; *American Pioneer Arts and Artists*, Springfield, Mass., 1942

Dunlap, William, *Diary*, edited by Dorothy C. Barck, New York, 1930, 3 vols.; *History of the Rise and Progress of the Arts of Design in the United States*, New York, 1834, 2 vols. Dover reprint, 1969.

Durand, John, *The Life and Times of A. B. Durand*, New York, 1894

Einstein, Lewis David, *Divided Loyalties, Americans in England During the War of Independence*, Boston, 1933

Fairman, Charles E., *Arts and Artists of the Capitol of the United States of America*, Washington, 1927

Fielding, Mantle, *Dictionary of American Painters, Sculptors, and Engravers*, Philadelphia, 1926

Flexner, James Thomas, *America's Old Masters*, New York, 1939 (Dover reprint, 1967); *First Flowers of Our Wilderness: American Painting, the Colonial Period*, Boston, 1947 (Dover reprint, 1968); *A Short History of American Painting*, Boston, 1950

Ford, Alice, *Pictorial Folk Art, New England to California*, New York, 1949

Gottesman, Rita Susswein, *The Arts and Crafts in New York*, New York, vol. I, *1726-1776*, 1938, vol. II, *1777-1799*, 1954

Grant, Maurice Harold, *Chronological History of Old English Landscape Painters*, London, 1926?-1947, 3 vols.; *A Dictionary of British Landscape Painting*, Leigh-on-the-Sea, England, 1952

Graves, Algernon, *A Dictionary of Artists Who Have Exhibited Works in the Principal Exhibitions of Oil Painting from 1760 to 1880*, London, 1884; *Royal Academy of Arts, a Complete Dictionary of the Contributors and Their Work*, London, 1905-1906, 8 vols.; *The Society of Artists of Great Britain, 1760-1791, The Free Society of Artists, a Complete Dictionary*, London, 1907

Groce, George C., in collaboration with The New-York Historical Society, "Dictionary of Artists in America, 1564-1860," manuscript being edited by David H. Wallace, assistant editor of the Society

Hagen, Oskar, *The Birth of the American Tradition of Art*, New York, 1940

Henderson, Helen W., *The Pennsylvania Academy of the Fine Arts*, Boston, 1911

Irving, Pierre M., *Life and Letters of Washington Irving*, New York, 1862, 4 vols.

Karolick Collection of American Paintings, foreword by John I. H. Baur, Boston, 1949

Kelby, William, *Notes on American Artists, 1754-1820, Copies from Advertisements*, New York, 1922

Larkin, Oliver, *Art and Life in America*, New York, 1949

Lee, Cuthbert, *Early American Portrait Painters*, New Haven, 1929

Lester, Charles Edward, *The Artists of America*, New York, 1840

Lipman, Jean, *American Primitive Painting*, New York, 1942

Lipman, Jean, and Winchester, Alice, *Primitive Painters in America, 1750-1950*, New York, 1950

Little, Nina Fletcher, *American Decorative Wall Painting*, Sturbridge, Mass., 1952

Mather, Frank J., Morey, Charles R., and Henderson, William J., *The American Spirit in Art*, vol. XII, *The Pageant of America*, New Haven, 1927

Morgan, John Hill, *Gilbert Stuart and His Pupils*, New York, 1939

Morgan, John Hill, and Fielding, Mantle, *Life Portraits of Washington*, Philadelphia, 1931

Muther, Richard, *History of Modern Painting*, New York, 1907, 4 vols.

Neal, John, *Observations on American Art*, edited with notes by H. E. Dickson, State College, Pa., 1943

Pleasants, J. Hall, *Four Late Eighteenth Century Anglo-American Landscape Painters*, Worcester, Mass., 1943

Prime, Alfred Coxe, *The Arts and Crafts in Philadelphia, Maryland, and South Carolina, 1721-1785, Gleanings from Newspapers,* Topsfield, Mass., 1929, series II, *1786-1800,* 1932

Richardson, Edgar Preston, *American Romantic Painting,* New York, 1944; *The Way of Western Art,* Cambridge, Mass., 1939

Richmond Portraits, catalogue of an exhibition at the Valentine Museum, Richmond, Va., 1942

Rutledge, Anna Wells, *Artists in the Life of Charleston,* Philadelphia, 1949

Sartain, John, *The Reminiscences of a Very Old Man,* New York, 1899

Sawitzky, William, "Early American Painting," unpublished lectures given at New York University, 1940-41, which the author attended

Sears, Clara Endicott, *Highlights among Hudson River Artists,* Boston, 1947; *Some American Primitives,* Boston, 1941

Stauffer, David McNealy, *American Engravers on Copper and Steel,* New York, 1907, 2 vols.

Swan, Mabel Munson, *The Athenaeum Gallery, 1827-1873,* Boston, 1940

Tuckerman, Henry Theodore, *Artist-Life,* New York, 1847; *Book of the Artists,* New York, 1867

Walker, John, and James, MacGill, *Great American Paintings, 1729-1924,* New York, 1943

Wehle, Harry B., *American Miniatures, 1730-1850, with a Biographical Dictionary of Artists by Theodore Bolton,* New York, 1927

Weitencampf, Frank, "Early American Landscape Prints," *Art Quarterly,* vol. VIII, 1945, pp. 40-67

Whitley, William T., *Art in England, 1800-1820,* Cambridge, England, 1928; *Art in England (1821-1835),* Cambridge, England, 1930; *Artists and Their Friends in England, 1700-1799,* London, 1928, 2 vols.

Bibliographies Arranged by Artists

WASHINGTON ALLSTON (1779-1843): Allston, *Lectures on Art and Poems*, New York, 1850; Allston, *Outlines and Sketches,* engraved by I. & S. W. Cheney, Boston, 1850; Dana, Henry W. L., "Allston at Harvard" and "Allston in Cambridgeport," *Proceedings, Cambridge Historical Society*, 1948, pp. 13-67; Dunlap, *History*, vol. II, pp. 152-88; Flagg, Jared B., *The Life and Letters of Washington Allston*, New York, 1892; Jameson, Anna, "Washington Allston," *Athenaeum*, London, 1884, pp. 15, 39; Peabody, Emily P., *Last Evening with Allston and Other Papers*, Boston, 1886, pp. 43-45; Richardson, Edgar P., *Washington Allston*, Chicago, 1948; Ware, William, *Lectures on the Work and Genius of Washington Allston*, Boston, 1850

EZRA AMES (1768-1836): Bolton, Theodore, and Cortelyou, Irwin F., *Ezra Ames of Albany, with a Catalogue of His Works by Irwin F. Cortelyou*, New York, 1954

JOHN JAMES AUDUBON (1785-1851): Audubon, original drawings at The New-York Historical Society; Audubon, *Birds of America*, London, 1827-1838, 4 vols.; Audubon, *Journal*, Boston, 1929, 2 vols.; Audubon, *Letters*, Boston, 1930, 2 vols.; Ford, Alice, *Audubon's Animals*, New York, 1950; Ford, *Audubon's Butterflies, Moths and Other Studies*, New York, 1952; Herrick, Francis Hobart, *Audubon the Naturalist*, New York, 1917, 2 vols.; Peattie, Donald C., *Audubon's America*, Boston, 1940; Rourke, Constance, *Audubon*, New York, 1936

GEORGE BECK (1748/9-1812): "A Biographical Memoir of the Late George Beck," *Portfolio*, series 4, vol. II, 1813, pp. 117-22; Grant, *Dictionary;* Grant, *History*, vol. II, p. 221; Pleasants, *Four;* Pleasants, J. Hall, "George Beck, an Early Baltimore Landscape Painter," *Maryland Historical Magazine*, vol. XXXV, 1940, pp. 241-43

HENRY BENBRIDGE (1743-1812): Hart, Charles Henry, "The Gordon Family Painted by Henry Benbridge," *Art in America*, vol. VI, 1918, pp. 191-200; Roberts, William, "An Early American Artist, Henry Benbridge," *Art in America*, vol. VI, 1918, pp. 96-101; Rutledge, Anna Wells, "Henry Benbridge (1743-1812?), American Portrait Painter," *American Collector*, vol. XVII, October, 1948, pp. 8-10, 23, November, 1948, pp. 9-11, 23

WILLIAM JAMES BENNETT (1747-1844): Dunlap, *History*, vol. II, pp. 274-75; Grant, *Dictionary;* Stauffer, *Engravers*, vol. I, pp. 23-28, vol. II, pp. 19-20; Weitencampf, *Landscape*

THOMAS BIRCH (1779-1851): Birch, William, & Son, *City of Philadelphia as It Appeared in the Year 1800*, Philadelphia, 1800; Dunlap, *History*, vol. II, pp. 259-60; *Karolick*, pp. 111-23; Sears, *Highlights*, pp. 24-25; Stauffer, *Engravers*, vol. II, p. 22

WILLIAM RUSSELL BIRCH (1755-1834): Birch, William, *The Country Seats of the United States*, Philadelphia, 1809; Birch, William, *Délice de la Grande Bretagne*, London, 1791; Birch, William, & Son, *op. cit.;* Dunlap, *History*, vol. I, p. 432; Graves, *Dictionary;* Stauffer, *Engravers*, vol. I, pp. 28-38, vol. II, p. 22

JOHN S. BLUNT (1798-1835): *Karolick*, pp. 124-27; Little, Nina Fletcher, "John S. Blunt," *Antiques*, vol. LIV, 1948, pp. 172-74

MATHER BROWN (1761-1831): Coburn, Frederick W., "Mather Brown," *Art in America*, vol. XI, 1923, pp. 252-60; Einstein, *Divided*, pp. 387-90; Hart, Charles Henry, "Notes on Gawen Brown and His Son . . . Mather Brown," *Proceedings, Massachusetts Historical Society*, vol. XLVII, 1913, pp. 32-34;

Lee, *Painters*, pp. 283-93; Park, Lawrence, "Mather Brown's Portrait of John Adams," *Proceedings, Massachusetts Historical Society*, vol. LI, 1917, pp. 105-07

CHARLES CATTON (1756-1819): American Academy, *Catalogues*; Grant, *History*, vol. I, pp. 148-49; Kelby, *Notes*, p. 57

WINTHROP CHANDLER (1747-1790): Flexner, James Thomas, "An Eighteenth-Century Artisan Painter," *Magazine of Art*, vol. XL, 1947, pp. 274-78; Little, Nina Fletcher, "Winthrop Chandler," *Art in America*, vol. XXV, 1947, pp. 77-168; Little, "Recently Discovered Paintings by Chandler," *Art in America*, vol. XXXVI, 1948, pp. 81-97

WILLIAM CLARKE (active 1780's-1800's): Baltimore Museum, *Maryland*, pp. 28-29, Prime, *Arts*, vol. II, pp. 5, 31

JOHN SINGLETON COPLEY (1738-1815): Amory, Martha Babcock, *The Domestic and Artistic Life of John Singleton Copley*, Boston, 1882; Bayley, Frank W., *The Life and Works of John Singleton Copley Founded on the Work of Augustus Thorndike Perkins*, Boston, 1915; Copley, and Pelham, Henry, *Letters and Papers, 1739-1776*, Boston, 1914; Dunlap, *History*, vol. I, pp. 103-30; Flexner, James Thomas, *John Singleton Copley*, Boston, 1948; Flexner, *First Flowers*, pp. 194-243; Parker, Barbara Neville, and Wheeler, A. B., *John Singleton Copley, American Portraits*, Boston, 1938

JOSEPH H. DAVIS (active 1832-1837): Spinney, Frank J., "Joseph H. Davis," *Antiques*, vol. XLIV, 1943, pp. 177-80; Spinney, "Joseph H. Davis," Lipman and Winchester, *Primitive*, pp. 97-105; Spinney, "The Method of Joseph H. Davis," *Antiques*, vol. XLVI, 1944, p. 73

ABRAHAM DELANOY, JR. (c.1740-c.1790): Dunlap, *History*, vol. I, pp. 161, 250, 255; Gottesman, *Arts*, vol. I, p. 1; Sellers, *Peale Life*, see index

WILLIAM DUNLAP (1766-1839): Coad, Oral Sumner, *William Dunlap*, New York, 1917; Dunlap, "Autobiography," in Dunlap, *History*, vol. I, pp. 244-311; Dunlap, *Diaries*; Woolsey, Theo-

dore S., "The American Vasari," *Yale Review*, vol. III, 1914, pp. 778-89

JOHN DURAND (active 1760's-1780's): Barker, *Painting*, p. 173; Dunlap, *History*, vol. I, p. 144-45; "Durand's Children of Garret and Helena de Nyse Rapalje," *Antiques*, vol. LI, 1947, pp. 174-75; Gottesman, *Arts*, vol. I, pp. 1-2; Thorne, Thomas, "America's Earliest Nude?" *William and Mary Quarterly*, 3d series, vol. VI, 1949, pp. 565-68

RALPH EARL (1751-1801): Goodrich, Lloyd, "Ralph Earl," *Magazine of Art*, vol. XXXIX, 1946, pp. 2-8; Gottesman, *Arts*, vol. II, p. 5; Phillips, John Marshall, "Ralph Earl, Loyalist," *Art in America*, vol. XXXVIII, 1949, pp. 187-89; Sawitzky, William, *Ralph Earl, Catalogue of an Exhibition, Whitney Museum of American Art, Worcester Art Museum, 1945-6;* Yale University Gallery of Fine Arts, *Connecticut Portraits by Ralph Earl*, foreword by William Sawitzky, New Haven, 1935

ALVAN FISHER (1792-1863): Burroughs, Alan, "A Letter from Alvan Fisher," *Art in America*, vol. XXXII, 1944, pp. 117-25; Dunlap, *History*, vol. II, pp. 264-65; Johnson, Charlotte Buel, "The European Tradition and Alvan Fisher," *Art in America*, vol. XLI, 1953, pp. 79-87; *Karolick*, pp. 258-61; Neal, *Observations*, p. 40; Sears, *Highlights*, pp. 26-31; Swan, *Athenaeum*, pp. 22-23

ROBERT FULTON (1765-1815): Colden, Cadwallader David, *The Life of Robert Fulton*, New York, 1817; Dickinson, Henry Winran, *Robert Fulton, Engineer and Artist*, London, 1913; Flexner, James Thomas, *Steamboats Come True*, New York, 1944; Sutcliffe, Alice Crary, *Robert Fulton and the Claremont*, New York, 1909

JOHN MASON FURNESS (1763-1804): advertisements in *Columbian Sentinel*, Boston, 1785, and *Independent Chronicle*, Boston, 4/21/1785; Bayley, Frank W., *Little Known Early American Portrait Painters*, n.p., n.d., no. 3; Dunlap, *History*, vol. II, p. 472.

WILLIAM GROOMBRIDGE (1748-1811): Grant, *Dictionary;* Grant, *History,* vol. I, pp. 147-48; Pleasants, *Four*

FRANCIS GUY (*c.*1760-1820): Peale, Rembrandt, "Reminiscences," *Crayon,* vol. III, 1856, p. 5; Pleasants, *Four;* Stiles, Henry R., *A History of the City of Brooklyn,* Brooklyn, vol. II, 1869, pp. 88-89, 99-105

CHESTER HARDING (1792-1866): Dunlap, *History,* vol. II, pp. 289-95; Harding, *A Sketch of Chester Harding, Artist, Drawn by His Own Hand,* Boston, 1929, enlarged reissue of the autobiography Harding originally called *My Egistography;* information from Wilbur D. Peat

EDWARD HICKS (1780-1849): Bye, Arthur Edwin, "Edward Hicks, Painter Preacher," *Antiques,* vol. XXIX, 1936, pp. 13-16; Ford, Alice, *Edward Hicks,* Philadelphia, 1952; Held, Julius, "Edward Hicks and the Tradition," *Art Quarterly,* vol. XIV, 1951, pp. 121-36; Hicks, *Memoirs of the Life and Religious Labors of Edward Hicks,* Philadelphia, 1851; Kees, Ann, "The Peaceable Painter," *Antiques,* vol. LII, 1947, pp. 252, 254

JOHN HILL (1770-1850): Hill, Day and Account Books, mss., The New-York Historical Society; Hill, *Drawing Book of Landscape Scenery,* New York and Charleston, 1821; Hill, *A Series of Progressive Lessons Intended to Elucidate the Art of Flower Painting,* Philadelphia, 1818; Stauffer, *Engravers,* vol. I, pp. 221-27, vol. II, pp. 126-27; Weitencampf, Frank, "John Hill and American Landscape in Aquatint," *American Collector,* vol. XVII, July, 1948, pp. 6-8; Weitencampf, *Landscape*

JOHN WESLEY JARVIS (1781-1840): Bolton, Theodore, and Groce, George C., Jr., "John Wesley Jarvis: An Account of His Life and the First Catalogue of His Work," *Art Quarterly,* vol. I, 1928, pp. 299-321; Dickson, Harold E., *John Wesley Jarvis . . . with a Checklist of His Works,* New York, 1949

RICHARD JENNYS (active 1760's-1790's): Dods, Agnes M., "Newly Discovered Portraits by J. William Jennys," *Art in America,*

vol. XXXIII, 1945, pp. 5-12; Dods, "More About Jennys," *Art in America*, vol. XXXIV, 1946, pp. 114-16; Sherman, Frederic Fairchild, *Richard Jennys, New England Portrait Painter*, Springfield, Mass., 1941; Whitmore, William H., *Notes Concerning Peter Pelham . . . and His Successors Prior to the Revolution*, Cambridge, Mass., 1867, p. 21

JARED JESSUP (active 1800's-1810's): information from Nina Fletcher Little; Little, *Decorative*, see index

JOSHUA JOHNSTON (active 1790's-1820's): Hunter, William Hervey, "Joshua Johnston," *American Collector*, vol. XVII, February, 1948, pp. 6-8; Pleasants, J. Hall, *An Early Baltimore Negro Portrait Painter*, Windham, Conn., 1940

MATTHEW HARRIS JOUETT (1787-1827): Jonas, E. A., *Matthew Harris Jouett, Kentucky Portrait Painter*, Louisville, 1938; Jouett, "Notes Taken from Conversations on Painting with Gilbert Stuart," in Morgan, *Stuart*, pp. 81-93; Martin, Mrs. William H., *Catalogue of All Known Paintings by Matthew Harris Jouett*, Louisville, 1939; Price, Samuel Woodson, *The Old Masters of the Bluegrass*, Louisville, 1902; Wilson, Samuel M., "Matthew Harris Jouett, Kentucky Portrait Painter," *Filson Club Historical Quarterly*, vol. XIII, 1939, pp. 75-96; Wilson, "Additional Notes on Matthew Harris Jouett," *Filson Club Historical Quarterly*, vol. XIV, 1940, pp. 1-16, 65-102

FREDERICK KEMMELMEYER (active 1780's-1810's): Morgan and Fielding, *Washington*, p. 199; Prime, *Arts*, vol. II, pp. 17, 51

JOHN LEWIS KRIMMEL (1789-1821): *Analectic Magazine*, vol. XVI, 1820, p. 421; *Catalogue of a Sale at Doggett's Repository of Arts*, Philadelphia, 11/22/1821; Dunlap, *History*, vol. II, pp. 234-38; Henderson, *Academy*, pp. 33-35; Jackson, Joseph, "The American Hogarth," *International Studio*, vol. XCIII, 1929, pp. 33-36, 86, 88

CHARLES R. LESLIE (1794-1859): Dunlap, *History*, vol. II, pp. 239-50; Flagg, *Allston;* Irving, *Irving;* Leslie, *Autobiographical Recollections*, edited by Tom Taylor, Boston, 1860

WILLIAM MERCER (*c.*1773-*c.*1850): Peale, Rembrandt, "Reminiscences," *Crayon,* vol. I, 1854, p. 370; Sellers, *Peale Life,* see index

SAMUEL F. B. MORSE (1791-1872): Mabee, Carleton, *The American Leonardo, a Life of Samuel F. B. Morse,* New York, 1943; Morse, Edward Lind, *Samuel F. B. Morse, His Letters and Journals,* Boston and New York, 1914, 2 vols.; Prime, Samuel I., *The Life of Samuel F. B. Morse,* New York, 1875; Wehle, Harry B., *Samuel F. B. Morse,* catalogue of an exhibition at the Metropolitan Museum, New York, 1932

REUBEN MOULTHROP (1763-1814): *Antiques,* vol. III, 1928, p. 404; *Connecticut Journal,* New Haven, 9/4/1793; Gottesman, *Arts,* vol. II, pp. 389, 393; Stiles, Ezra, *Literary Diary,* New York, vol. III, 1901, see index

JOHN NEAGLE (1796-1865): Barker, Virgil, "John Neagle," *The Arts,* vol. VIII, 1925, pp. 7-23; Dunlap, *History,* vol. II, pp. 372-77; Fitzgerald, Thomas, "John Neagle, the Artist," *Lippincott's Magazine,* vol. I, 1868, pp. 477-91; Lynch, M., "John Neagle's Diary," *Art in America,* vol. XXXVII, 1949, pp. 79-99; Patrick, Ranson P., "John Neagle, Portrait Painter and Pat Lyon, Blacksmith," *Art Bulletin,* vol. XXXIII, 1951, pp. 187-92; Pennsylvania Academy, *Catalogue of an Exhibition of Portraits by John Neagle,* Philadelphia, 1925; Rich, Daniel Catton, "A Landscape by John Neagle," *Bulletin, Chicago Art Institute,* vol. XXIX, 1935, pp. 78-79

GILBERT STUART NEWTON (1794-1835): Dunlap, *History,* vol. I, p. 165, vol. II, pp. 300-06; *Gentleman's Magazine,* vol. IV, 1835, pp. 438-39; Morgan, *Stuart,* pp. 42-45; Redgrave, Richard and Samuel, *Century of Painters of the English School,* London, 1866, vol. II, pp. 347-48; references under Leslie

JEREMIAH PAUL (died 1820): *Connoisseur,* vol. CXXXII, 1954, pp. 184-85; Dickson, H. E., "Notes on Jeremiah Paul," *Antiques,* vol. LI, 1947, pp. 392-93; Dreppard, Carl W., "Newly Found Painting, The Peale Children," *Art in America,* vol.

264 Bibliographies Arranged by Artists

XXXII, 1944, pp. 52-54; Dunlap, *History*, vol. I, pp. 417-18, vol. II, p. 75; Prime, *Arts*, vol. II, pp. 19, 31

CHARLES WILLSON PEALE (1741-1827): Flexner, *Masters*, pp. 171-244, 349-50; Peale, "Autobiography," ms. at American Philosophical Society (page references are to typescript); Sellers, Charles Coleman, *Charles Willson Peale*, Philadelphia, 1947, 2 vols.; Sellers, *Portraits and Miniatures by Charles Willson Peale*, Philadelphia, 1952; information from Mr. Sellers

JAMES PEALE (1749-1831): Baur, John I. H., "The Peales and the Development of American Still Life," *Art Quarterly*, vol. III, 1940, pp. 81-92; Brockway, Jean Lambert, "The Miniatures of James Peale," *Antiques*, vol. XXII, 1932, pp. 130-34; Lee, *Painters*, pp. 267-77; Pennsylvania Academy, *Catalogue of an Exhibition of Portraits by Charles Willson Peale and James Peale and Rembrandt Peale*, Philadelphia, 1923; Sellers, *Peale*, see index; Sherman, Frederic Fairchild, "James Peale's Portrait Miniatures," *Art in America*, vol. XIX, 1931, pp. 208-21; Sherman, "Portraits in Oil by James Peale," *Art in America*, vol. XXI, 1933, pp. 114-21; Sherman, "Hitherto Unpublished Miniatures by James Peale," *Art in America*, vol. XXIV, 1936, pp. 162-65

RAPHAELLE PEALE (1774-1825): Baur, *op. cit.;* Bury, E., "Raphaelle Peale (1774-1825), Miniature Painter," *American Collector*, vol. XVII, August, 1948, pp. 6-9; Peale, Rembrandt, "Reminiscences," see below; *Richmond Portraits*, pp. 172-73, 226; Sellers, *Peale Life*, see index

REMBRANDT PEALE (1778-1860): Baltimore Municipal Museum, *Catalogue of an Exhibition of Paintings by Rembrandt Peale*, Baltimore, 1937; Dunlap, *History*, vol. II, pp. 50-58; Lester, *Artists*, pp. 198-231; Peale, Rembrandt, "Reminiscences," *Crayon*, vol. I, 1854, pp. 22-23, 81-82, 161-63, 226-27, 290-91, vol. II, 1855, pp. 127, 175, 207, vol. III, 1856, pp. 5-6, 100-01, 163-65; Pennsylvania Academy, *op. cit.;* Sellers, *Peale Life*, see index

ROBERT EDGE PINE (1730-1788): Dunlap, *History,* vol. I, pp. 316-
20; Morgan and Fielding, *Washington,* pp. 83-88; Peale,
Rembrandt, "Reminiscences," *Crayon,* vol. III, 1856, p. 5;
Prime, *Arts,* vol. II, pp. 26-29; Whitley, *Artists,* see index

EUNICE PINNEY (1770-1848): Lipman, Jean, "Eunice Pinney," *Art
Quarterly,* vol. VI, 1943, pp. 213-21; Lipman and Winches-
ter, *Primitive,* pp. 22-30; Warren, William L., "Richard Brun-
ton," *Art in America,* vol. XLI, 1953, pp. 74-77

CHARLES PEALE POLK (1767-1822): Prime, *Arts,* vol. I, p. 7, vol. II,
pp. 29-31; *Richmond Portraits,* p. 242; Sellers, *Peale Life,* see
index

MATTHEW PRATT (1734-1805): Bolton, Theodore, and Binsse,
Harry Lorin, "Pratt, Painter of Colonial Portraits and Sign
Boards," *Antiquarian,* vol. XVII, September, 1931, pp. 20-24;
Dunlap, *History,* vol. I, pp. 98-103, Pennington, Jo, "Matthew
Pratt, Painter," *International Studio,* vol. LXXIX, 1924, pp.
259-63; Sawitzky, William, *Matthew Pratt,* New York, 1942

WILLIAM MATTHEW PRIOR (1800-1873): *Karolik,* pp. 452-55;
Little, Nina Fletcher, "William M. Prior, Artist, and His In-
laws, the Painting Hamblens," *Antiques,* vol. LIII, 1948, pp.
44-48; Little, "William M. Prior," Lipman and Winchester,
Primitive, pp. 80-89; Lyman, Grace Adams, "William M.
Prior, the Painting Carrot Artist," *Antiques,* vol. XXVI, 1934,
p. 180; Sears, *Primitives,* pp. 32-49

ARCHIBALD (1765-1835) and ALEXANDER (1772-1841) ROBERTSON:
Cleveland, Edith Robertson, "Archibald Robertson and His
Portraits of Washington," *Century Magazine,* vol. XL, 1890,
pp. 3-13; Dunlap, *History,* vol. I, pp. 395-403; Goddard, Mrs.
Warren J., *Archibald Robertson, the Founder of the First
Art School in America,* n.p., n.d.; New York *Diary and Eve-
ning Register,* 11/1/1794; Robertson, Archibald, *Elements of
the Graphic Arts,* New York, 1802; Robertson, Emily, editor,
*Letters and Papers of Andrew Robertson . . . also a Trea-
tise on the Art by His Eldest Brother, Archibald Robertson,*
London, n.d.; Stillwell, John E., "Archibald Robertson, Mini-

aturist," *New-York Historical Society Bulletin,* vol. XIII, 1929, pp. 1-33

HENRY SARGENT (1770-1845): Addison, Julia de Wolf, "Henry Sargent, a Boston Painter," *Art in America,* vol. XVII, 1929, pp. 279-84; Dunlap, *History,* vol. II, pp.58-63; Neal, *Observations,* pp. 7-8; Sargent, Emma Worcester, and Sargent, Charles Sprague, *Epes Sargent and His Descendants,* Boston, 1923, pp. 190-91; Swan, *Athenaeum,* pp. 39-40

JOSHUA SHAW (1776-1860): Cummings, *Academy,* pp. 288-89; Dunlap, *Diary,* vol. III, pp. 501, 527; Dunlap, *History,* vol. II, p. 320; Grant, *Dictionary;* Grant, *History,* vol. II, pp. 230-31; Graves, *Dictionary; Karolick,* pp. 477-78; Sartain, *Reminiscences,* pp. 16, 176; Shaw, *A New and Original Drawing Book,* Philadelphia, 1816; Shaw, *Picturesque Views of American Scenery,* Philadelphia, 1820

JOSEPH STEWARD (1750-1822): *Antiques,* vol. LV, 1949, p. 370; *Connecticut Historical Society Bulletin,* vol. XVIII, January-April, 1953; Dunlap, *History,* vol. II, p. 151

CHARLES GILBERT STUART (1787-1813); Morgan, *Stuart,* pp. 46-48; Swan, Mabel M., "Gilbert Stuart in Boston," *Antiques,* vol. XXIX, 1936, p. 66

GILBERT STUART (1755-1828): Dunlap, *History,* vol. I, pp. 161-223; .Flexner, *Masters,* pp. 247-312, 324-26; Flexner, James Thomas, *Gilbert Stuart, A Great Life in Brief,* to be published by Alfred A. Knopf, New York; Jouett, Matthew Harris, "Notes Taken . . . on Conversations on Painting with Gilbert Stuart," in Morgan, *Stuart,* pp. 80-93, see below; Mason, George C., *The Life and Works of Gilbert Stuart,* New York, 1879; Morgan, John Hill, *Gilbert Stuart and His Pupils,* New York, 1939; Park, Lawrence, *Gilbert Stuart, an Illustrated Descriptive Catalogue,* New York, 1926, 4 vols.; Whitley, William T., *Gilbert Stuart,* Cambridge, Mass., 1932

THOMAS SULLY (1783-1872): Biddle, Edward, and Fielding, Mantle, *The Life and Works of Thomas Sully,* Philadelphia, 1921; Dunlap, *History,* vol. II, pp. 101-41; Hart, Charles

Henry, "Thomas Sully's Register of Portraits, 1801-1871," *Pennsylvania Magazine of History and Biography*, vol. XXXII, 1908, pp. 385-432; Pennsylvania Academy, *Catalogue of Memorial Exhibition of Portraits by Thomas Sully*, Philadelphia, 1922; Sully, *Hints to Young Painters*, Philadelphia, 1873; Sully, "Recollections of an Old Painter," *Hours at Home*, vol. X, 1873, pp. 69-74; Sully, "Register of Portraits," ms. at Historical Society of Pennsylvania; Tuckerman, *Artists*, pp. 158-62

JOHN TRUMBULL (1756-1843): Morgan, John Hill, *Paintings by John Trumbull at Yale University of Historic Scenes & Personages Prominent in the American Revolution*, New Haven, 1920; Sizer, Theodore, *The Works of Colonel John Trumbull*, New Haven, 1950; Trumbull, *Autobiography, Reminiscences, and Letters*, New Haven, 1841; *The Autobiography of Colonel John Trumbull*, edited by Theodore Sizer, New Haven, 1953 (the Sizer edition contains many valuable notes and appendixes by the editor, but omits the documents Trumbull quoted in his appendixes. Unless otherwise stated, page references refer to the Sizer edition); Wier, John F., *John Trumbull, a Brief Sketch of His Life*, New York, 1901

JOHN VANDERLYN (1775-1852): *Description of the Panoramic View of the Palace and Gardens of Versailles Painted by Mr. Vanderlyn*, New York, 1819; Dunlap, *History*, vol. II, pp. 31-42; Grossman, Robert, "Life of John Vanderlyn," two incomplete versions covering the years 1796-1802, 1805-1807, the first written c.1849, the second probably immediately after Vanderlyn's death, mss. at The New-York Historical Society; "John Vanderlyn," *Putnam's Monthly*, vol. XVIII, 1854, pp. 593-95; Kip, William I., "Recollections of John Vanderlyn," *Atlantic Monthly*, vol. XIX, 1867, pp. 228-35; Pritchard, Kathleen H., "John Vanderlyn and the Massacre of Jane McCrae," *Art Quarterly*, vol. X, 1947, pp. 361-70; Miller, Lillian Beresnack, "John Vanderlyn and the Business of Art," *New York History*, vol. XXXII, 1951, pp. 33-44;

Review of the Biographical Sketch of John Vanderlyn Published by William Dunlap, New York, 1838, either by Vanderlyn or written under his supervision, as there are rough drafts in his handwriting among his papers; Schoonmaker, Marius, *History of Kingston*, New York, 1888, pp. 459-62; Tuckerman, *Artists*, pp. 126-35; Vanderlyn papers at The New-York Historical Society

WILLIAM GUY WALL (1792-after 1860): Comstock, Helen, "Watercolors in the Hudson River Portfolio," *Connoisseur*, vol. CXX, 1947, pp. 42-43; Dunlap, *History*, vol. II, pp. 321-22; Graves, *Index;* Rowe, L. E., "William G. Wall," *Antiques*, vol. IV, 1923, pp. 18-22; Shelley, Donald A., "William Guy Wall and His Watercolors for the Historic Hudson River Portfolio," *New-York Historical Society Quarterly*, vol. XXXI, 1947, pp. 25-45; Strickland, W. G., *Dictionary of Irish Artists*, Dublin and London, 1913, vol. II; Wall, *Hudson River Portfolio*, New York, 1822-23; Weitencampf, *Landscape*, p. 62

ADOLPH-ULRICH WERTMÜLLER (1751-1811): Benisovich, Michel N., "Roslin and Wertmüller," *Gazette des Beaux Arts*, 6th series, vol. XXV, 1944, pp. 221-30; Benisovich, "The Sale of the Studio of Adolph-Ulrich Wertmüller," *Art Quarterly*, vol. XVI, 1953, pp. 20-39; Morgan and Fielding, *Washington*, pp. 203-06; Peale, Rembrandt, "Adolph Ulrich Wertmüller," *Crayon*, vol. II, 1855, p. 207

BENJAMIN WEST (1738-1820): Farington, Joseph, *The Farington Diaries*, London, 1922-1927, 8 vols.; Flexner, James Thomas, "Benjamin West's Pennsylvania Neo-Classicism," *New-York Historical Society Quarterly*, vol. XXXIX, 1952, pp. 473-81; Flexner, *First Flowers*, see index; Flexner, *Masters*, see index; Galt, John, *The Life, Studies and Works of Benjamin West*, London, 1820, 2 vols.; Sawitzky, William, "The American Work of Benjamin West," *Pennsylvania Magazine of History and Biography*, vol. LXII, 1938, pp. 433-62; West papers at Historical Society of Pennsylvania

MICAH WILLIAMS (active 1810's-1820's): information from Irwin
F. Cortelyou

WILLIAM WINSTANLEY (active 1790's-1810's): Dunlap, *History,*
vol. I, pp. 200, 394-95; Gottesman, *Arts,* vol. II, pp. 23-24, 29;
Grant, *Dictionary;* Graves, *Dictionary;* Pleasants, *Four
ants, Four*

JOHN A. WOODSIDE (1781-1832): Jackson, Joseph, "John A. Wood-
side, Philadelphia's Glorified Sign Painter," *Pennsylvania
Magazine of History and Biography,* vol. LVII, 1933, pp. 58-
65; *Public Ledger,* Philadelphia, 2/28/1852; *State Gazette,*
Trenton, N. J., 3/1/1852

Source References

CHAPTER ONE

INTERVIEW WITH KING: Peale, C. W., *Autobiography*, p. 95

WEST ON ARISTOCRATIC IDEAS: *Pennsylvania Magazine of History and Biography*, vol. XVIII, 1894, p. 222

PAINTER *vs*. TAILOR: Dunlap, *History*, vol. I, p. 39

WEST AND "APOLLO": Cunningham, *Lives*, vol. I, p. 297

MORALITY AND ART: Galt, *West*, vol. II, p. 97

ART INFLAMES BIGOTRY: *Public Characters of 1805*, London, 1805, pp. 534-35

NEOCLASSICISM: Locquin, Jean, *Peinture d'Histoire en France de 1747 à 1785*, Paris, 1912; Locquin, "Le Retour à l'Antique dans l'École Française avant David," *La Renaissance de l'Art Français et des Industries de Luxe*, vol. V, 1922, pp. 473-81

"VENUS DE MEDICI": Galt, *West*, vol. II, p. 101

"DEATH OF SOCRATES": Flexner, *West's Neo-Classicism*

REYNOLDS ON WEST'S POPULARITY: *Pennsylvania Magazine of History and Biography*, vol. L, 1926, pp. 246-47

RHYMING REVIEWER: *The Exhibition*, London, 1766

CANNOT BUY MODERN PICTURES: Lester, *Artists*, p. 86

TACITUS QUOTATION: Tacitus, *Annals*, London, 1903, p. 108

WEST ON KING'S TASTE: Farington, *Diaries*, (West), vol. II, p. 132

REYNOLDS'S THEORIES: Reynolds, Joshua, *Third Discourse*

WEST POPULAR IDOL: Whitely, *Artists*, vol. I, p. 220

CHAPTER TWO

PAINTERS ARE BORN SUCH: Peale, C. W., *Autobiography*, p. 189

PEALE ON LONDON CAREER: Sellers, *Peale*, vol. I, p. 83

PITT ENGRAVING: A *Description of the Picture and Mezzotinto of Mr. Pitt Done by Charles Willson Peale of Maryland,* broadside, n.d., n.p.

TRUMBULL ON ENGRAVINGS: Trumbull, *Autobiography,* p. 13

ADAMS ON PEALE: Adams, John, *Letters to His Wife,* Boston, vol. I, 1841, p. 155

PLAYMATE ON STUART: Waterhouse, Benjamin, quoted in Dunlap, *History,* vol. I, p. 197

TRUMBULL ON "PAULUS AEMILIUS": Trumbull, *Autobiography,* p. 15

EARL'S BATTLE PAINTINGS: Sawitzky, William, "Ralph Earl's Historical Painting," *Antiques,* vol. XXVIII, 1935, pp. 98-100

TRUMBULL RESIGNS: Trumbull, *Autobiography,* p. 36

PEALE ON HIS REVOLUTIONARY ACTIVITIES: Flexner, *Masters,* p. 197

CHAPTER THREE

"DEATH OF WOLFE": Addison, A., "Legend of West's Death of Wolfe," *College Art Journal,* vol. V, 1945, pp. 23-25, vol. VI, 1946, p. 140; Mitchell, Charles, "Benjamin West's 'Death of General Wolfe' and the Popular History Piece," *Journal of the Warburg Institute,* vol. XVII, 1944, pp. 20-33; Todd, Ruthven, "Benjamin West vs. the History Picture," *Magazine of Art,* vol. XLI, 1948, pp. 301-05; Webster, J. Clarence, *Wolfe and the Artists,* Toronto, 1930; Wind, Edgar, "The Revolution of History Painting," *Journal of the Warburg Institute,* vol. II, 1938, pp. 116-27

WEST ON WOLFE: Galt, *West,* vol. II, pp. 48-49

WEST ON NELSON: Farington, *Diaries* (West), vol. IV, p. 151

"PENN'S TREATY": Brinton, Ellen Starr, "Benjamin West's Painting of Penn's Treaty with the Indians," *Bulletin of the Friend's Historical Association,* vol. XXX, 1941, pp. 99-189

WEST AND THE REVOLUTION: Cunningham, *Lives,* vol. I, pp. 313-14; Einstein, *Divided,* pp. 306-08; Galt, *West,* vol. II, pp. 70-71; West to King, Rufus, 5/28/1800, ms. at New-York Historical Society

COPLEY ON OLD MASTERS: Amory, *Copley,* p. 40; Copley, *Letters,* pp. 301-02

CYCLOPS' EYE: West to Price ?, 6/16/1797, ms. in Pennsylvania Historical Society

WALPOLE'S CRITICISMS: Graves, *Royal Academy*, vol. II, p. 159, vol. III, p. 184

WEST ABANDONS "CHATHAM": Walpole, Horace, *Letters*, Edinburgh, vol. V, 1906, p. 116

DAVID'S EXHIBITION: Goldwater, Robert, and Treves, Marco, *Artists on Art*, New York, 1945, pp. 207-09

CUNNINGHAM QUOTATION: Cunningham, *Lives*, vol. II, p. 240

WEST, COPLEY DUET: Whitely, *1800-1820*, p. 169

WEST'S PLAN TO PAINT REVOLUTION: *Pennsylvania Magazine of History and Biography*, vol. XXXII, 1908, pp. 11-12

ART LAST RESORT: Trumbull, *Autobiography*, p. 60

WEST ADVISES TRUMBULL: *Ibid.*, p. 90

TRUMBULL AND JEFFERSON: *Ibid.*, pp. 156-62

CHAPTER FOUR

WEST ON HIS OWN WORK: Fletcher, Ernest, editor, *Conversations of James Northcote R.A. with James Ward*, London, 1901, p. 174

WEST ON ART AND VIRTUE: Galt, *West*, vol. II, p. 85

WEST'S PUPILS: Smith, John Thomas, *Nollekens and His Times*, London, 1829, vol. II, p. 378

NORTHCOTE QUOTATION: Fletcher, *op. cit.*, pp. 153-54

TRY IT: Jouett, *Stuart*, p. 84.

ART AND MANUFACTURES: Dunlap, *History*, vol. I, pp. 83-84

DISCOURSE SENTIMENTS: Reynolds, Joshua, *Sixth Discourse*; Galt, *West*, vol. II, pp. 83, 116

WEST ON ITALIAN ART: Copley, *Letters*, pp. 195-97

VALUE OF AMERICAN TRAINING: *Ibid.*, pp. 118-19

WEST'S LANDSCAPES: Grant, *History*, vol. I, pp. 102-03, plate 64, vol. III, p. 21, plate 42; Grant, *Dictionary*, pp. 16-17

BATHING PLACE: Birch, William, *Délices de la Grande Bretagne*, London, 1791, plate 25; information from Helmut Von Erfa

WEST ABANDONS PORTRAITURE: Dunlap, *History*, vol. I, p. 396

STUART'S APPEAL TO WEST: Stuart to West, n.d., ms. in New-York Historical Society

STUART ON HISTORY PAINTING: Dunlap, *History,* vol. I, pp. 184-85

STUART ON GAINSBOROUGH: *Ibid.,* p. 217

ENGLISH CRITICS ON STUART: Whitely, *Stuart,* p. 57

REYNOLDS ON STUART'S PORTRAIT: Dunlap, *History,* vol. I, p. 184

BROWN'S REPUTATION: Whitely, *Artists,* vol. II, p. 100

EARL STUDIES WITH WEST: New York *Independent Journal,* 11/2/ 1785

CHAPTER FIVE

EARL RETURNS: New York *Independent Journal,* 11/2/1785

DUNLAP ON EARL: Dunlap, *History,* vol. I, pp. 223-24

DE TOCQUEVILLE QUOTATIONS: De Tocqueville, Alexis, *Democracy in America,* New York, 1840, vol. II, pp. 136-37

PRATT'S PARTNERSHIP: Prime, *Arts,* vol. II, p. 31

STUART LEAVES IRELAND: Herbert, J. D., *Irish Varieties of the Last Fifty Years,* London, 1836, p. 248

DUNLAP ON STUART'S PORTRAITS: Dunlap, History, vol. I, pp. 195-96

STUART ON FLESH TONES: Jouett, *Stuart,* p. 83

STUART LEADING PAINTER: Dunlap, *History,* vol. I, p. 214; Neal, *Observations,* p. 30; Whitely, *Stuart,* p. 149

JEROME BONAPARTE: Flexner, *Masters,* p. 299

COMMANDING TALENTS: Knapp, Samuel L., *American Biography,* New York, 1855, p. 326

MANTUA MAKER: Dunlap, *History,* vol. I, p. 218

NEAL ON STUART: Neal, *Observations,* p. 30

STUART'S METHODS AND AESTHETIC: Jouett, *Stuart;* Whitely, *Stuart,* p. 58

CHAPTER SIX

DURAND ADVERTISEMENT: Gottesman, *Arts,* vol. I, pp. 1-2

TRUMBULL PROSPECTUS: Trumbull, *Autobiography,* 1st edition, pp. 339-45

SUBSCRIPTION LIST: Trumbull, *Autobiography,* pp. 164, 171-72

FRENCH REVOLUTION: *Ibid.*, pp. 172-73

GILES AND JEFFERSON: Trumbull, *Autobiography*, 1st edition, pp. 169-72, 352

DISAPPROVAL OF AMERICAN REVOLUTION: Trumbull, *Autobiography*, p. 172

RETURNS TO ART: *Ibid.*, pp. 235, 239

EMBARGO: *Ibid.*, pp. 240-41

COMPLAINS OF AMERICA: Dunlap, *History*, vol. I, p. 371

TUTOR AND FATHER ON ART: Weir, *Trumbull*, pp. 5-6

CONNECTICUT AND ATHENS: Trumbull, *Autobiography*, pp. 82-83

VIRGINIA GOVERNOR: Flexner, *First Flowers*, p. 105

WASHINGTON ON TRUMBULL: Trumbull, *Autobiography*, 1st edition, pp. 345-46

DEVOTED HIS LIFE: Trumbull, *Autobiography*, p. 263

FAVORITE PHANTOM: *Ibid.*, p. 226

CHAPTER SEVEN

PEALE'S TRIUMPHAL ARCH: Peale, C. W., *Autobiography*, pp. 85-90

MOTION PICTURES: *Ibid.*, pp. 79-91

VISITOR DESCRIBES MUSEUM: Cutler, Manasseh, *Life, Journal, and Correspondence*, Cincinnati, vol. I, 1888, pp. 259 ff

MAN AND MONKEY: Peale, C. W., and Beauvois, A. M., *A Scientific and Descriptive Catalogue of Peale's Museum*, Philadelphia, 1796, p. 4

PEALE'S PANTHEISM: Peale, C. W., *Autobiography*, pp. 272, 379

HOBBIES: *Ibid.*, pp. 169, 183

HUMBOLDT AND MASTODON: *Ibid.*, pp. 279, 346, 359; *Pennsylvania Magazine of History and Biography*, vol. IX, 1885, pp. 130-32

CHAPTER EIGHT

COLUMBIANUM: Papers at Pennsylvania Historical Society; *The Constitution of the Columbianum or American Academy of Fine Arts*, Philadelphia, 1795; *The Exhibition of the Columbianum or American Academy*, Philadelphia, 1795; Prime,

Arts, vol. II, pp. 55-57 (gives bibliographical references to newspaper controversy); Sellers, *Peale,* vol. II, pp. 65-75

MAKES STUDY ABROAD UNNECESSARY: *Dunlap and Claypoole's American Daily Advertiser,* Philadelphia, 6/1/1795

FIELD LETTER: Field, Robert, to Gilmor, Robert, 1/13/1795, ms. at Pennsylvania Historical Society

CONTROVERSY QUOTATIONS: *Dunlap and Claypoole, op. cit.,* 2/26/1795; *Aurora and General Advertiser,* Philadelphia, 3/6/1795

GREATER SURVIVAL VALUE OF PORTRAITS: Flexner, *First Flowers,* pp. 148-49

PEALE STILL LIFES: Baur, *Peales;* Born, *Still Life,* pp. 12-16; Sellers, *Peale,* see index

"AFTER THE BATH": Sellers, *Peale,* vol. II, p. 390; Walker and James, *Painting,* p. 7

ROBERTSON QUOTATIONS: Robertson, *Elements,* p. 6; Robertson, *Letters,* pp. 39-40

LANDSCAPES IN MAGAZINES: Weitenkampf, *Landscape,* pp. 40-67

MINISINK: *New York Magazine,* vol. V, 1794, p. 323

MUSHANON: *American Universal Magazine,* vol. I, 1797, p. 39

PEALE ON GUY: Peale, Rembrandt, "Reminiscences," *Crayon,* vol. III, 1856, p. 5

GUY'S NEWSPAPER NOTICE: *The American,* Baltimore, 2/6/1819

ANDERSON QUOTATIONS: *The Observer,* Baltimore, vol. I, 1807, pp. 11, 381, 390-91

GUY'S REPLY: *Federal Gazette,* Baltimore, 11/17/1807

"WINTER SCENE" QUOTATION: Stiles, *Brooklyn,* (Guy)

CHAPTER NINE

AFRICAN WITCHES: Dunlap, *History,* vol. II, p. 153; Flagg, *Allston,* p. 5

COLLEGE PRANKS: Flagg, *Allston,* pp. 23, 28-29

IMPORTANCE OF SELF-CONFIDENCE: *Ibid.,* p. 20

TREATY OF WESTPHALIA: *Ibid.,* p. 29

READS ROMANCES: *Ibid.,* p. 27; Dunlap, *History,* vol. II, p. 154

THE STAGE: Richardson, *Allston,* p. 36

BANDITTI: Dunlap, *History*, vol. II, p. 156

POEM ON WASHINGTON: Flagg, *Allston*, p. 27

ALLSTON ON WEST: *Ibid.*, pp. 43-44

WEST AND EDWARD III: *Analectic Magazine and Naval Chronicle*, vol. VIII, 1816, pp. 42-43; Galt, *West*, vol. II, pp. 51-52, 213

"REVEALED RELIGION": Galt, *West*, vol. II, pp. 52-56, 209-13

FRENCH CRITICISM OF WEST: *Analectic, op. cit.*, pp. 44-46

WEST'S ENTHUSIASM FOR FRENCH REVOLUTION: Farington, *Diaries*, (West), vol. II, p. 21, vol. IV, pp. 49-50

ALLSTON ON ENGLISH PORTRAITISTS: Flagg, *Allston*, p. 45

COLORISTS AVOID STORYTELLING: Dunlap, *History*, vol. II, pp. 162-63

WEST AND LITERAL PAINTING: *A Description of Mr. West's Picture of Death on the Pale Horse*, London, 1816, p. 4

IRVING ON ALLSTON: Irving, *Irving*, vol. I, pp. 129-30; Irving, Washington, *Spanish Papers and Other Miscellanies*, New York, vol. II, 1867, pp. 143-50

COLERIDGE ON ALLSTON: Flagg, *Allston*, pp. 77, 115

ALLSTON ON COLERIDGE: Dunlap, *History*, vol. II, p. 167

WEST IS BITTER: *Analectic, op. cit.*, pp. 47-48

"CHRIST HEALING THE SICK": Farington, *Diaries*, (West), vol. VI, p. 248

LAWRENCE ON WEST: Smith, John Thomas, *Nollekens and His Times*, London, 1829, pp. 393-94

"CHRIST REJECTED": *Catalogue of Pictures Representing Christ Rejected, Christ Healing in the Temple . . . now Exhibiting in Pall Mall*, London, 1810

WEST ON HIS RELIGIOUS PICTURES: Galt, *West*, vol. II, pp. 193-98

MORSE ON COPLEY: Morse, *Morse*, vol. I, p. 47

ALLSTON DESCRIBES "DEAD MAN REVIVED": Flagg, *Allston*, p. 99

COLERIDGE'S OBJECTIVES: Richardson, *Allston*, p. 101

NERVOUS BREAKDOWN: Leslie, *Autobiography*, p. 51

WILL NO LONGER PAINT SAVIOR: Flagg, *Allston*, p. 120

NEW COLOR METHOD: Richardson, *Allston*, pp. 146, 177-78

THOUGHTS IN BOSTON HARBOR: Dunlap, *History*, vol. II, p. 183

CHAPTER TEN

VANDERLYN IN PARIS: Vanderlyn, John, to Vanderlyn, Peter, 12/30/
1796, 8/14/1797, 10/23/1797, and 7/13/1798, mss. in New-
York Historical Society

BURR ON VANDERLYN: Kip, *Vanderlyn*, p. 235

TRIES TO SELL "NIAGARAS": Vanderlyn, John, to Murray, Jóhn R.,
10/1/1804, ms. in New-York Historical Society; Miller, *Van-
derlyn*, p. 35

IN ENGLAND: Vanderlyn to ?, 1/10/1804, ms. in New-York His-
torical Society

"JANE MC CREA": Pritchard, *Vanderlyn*, pp. 361-70

"ANTIOPE": Miller, *Vanderlyn*, pp. 36-37

J. MORSE ON HOPE FOR SON: Morse, *Morse*, vol. I, p. 32

SOCIAL STANDING OF ART IN ENGLAND: *Ibid.*, pp. 45-47

LESLIE'S DRAWINGS OF ACTORS: Dunlap, *History*, vol. II, pp. 239-42;
The Mirror of Taste and Dramatic Censor, Philadelphia, vol.
III, 1811, pp. 245, 264-65, 331, vol. IV, 1811, pp. 209, 307

PAINTING OUT OF REVENGE: Morse, *Morse*, vol. I, p. 133

INTELLECTUAL BRANCH: Morse, *Morse*, vol. I, p. 132

OPPOSITION TO MODERN POETS: Leslie, *Autobiography*, p. 194

"MURDER": *Ibid.*, p. 188

MORSE ON FRENCH: Morse, *Morse*, vol. I, pp. 91, 114

ARGUMENTS AGAINST MORSE RETURNING HOME: Morse, *Morse*, vol. I,
pp. 128-32

MORSE ON ART AND TRADE: *Ibid.*, p. 164

MORSE ON HOMECOMING: *Ibid.*, pp. 176-78

ALLSTON ON LESLIE'S GRISLY PICTURES: Flagg, *Allston*, p. 122

LESLIE EXHIBITION: Pennsylvania Academy, *Exhibition of Mr. Les-
lie's Picture of the Murder of Rutland, with a Series of Orig-
inals and Copies from His First Commencement of the Art*,
Philadelphia, 1816

NEWTON AND HISTORICAL PAINTING: Dunlap, *History*, vol. II, pp.
301-02

PAINTINGS FROM "MERRY WIVES": Flagg, *Allston*, pp. 73, 146-47;
Leslie, *Autobiography*, p. 206

CHAPTER ELEVEN

COPLEY QUOTATION: Flexner, *Masters*, p. 125

SHAKESPEARE GALLERY: *A Catalogue of the Pictures, etc., in the Shakespeare Gallery*, New York, 1802; Irving, Washington, and others, *Salmagundi*, New York, 1860, p. 15 n

AMERICAN ACADEMY: Papers in New-York Historical Society; Cowdrey, *American Academy;* Cummings, *National Academy*, see index; Dickson, *Jarvis*, see index; Howe, Winifred E., *A History of the Metropolitan Museum of Art*, New York, 1913, pp. 7-35

OBJECTS OF AMERICAN ACADEMY: Cowdrey, *op. cit.*, p. 11

FIG LEAVES: *Ibid.*, p. 12

PENNSYLVANIA ACADEMY: Henderson, *Pennsylvania Academy*

PEALE'S PLANS: *Pennsylvania Magazine of History and Biography*, vol. IX, 1885, pp. 121-30

OBJECT OF PENNSYLVANIA ACADEMY: Henderson, *op. cit.*, p. 5

FULTON'S PICTURES: *Pennsylvania Magazine of History and Biography*, vol. IX, 1885, p. 129

SOCIETY OF ARTISTS: *The Constitution of the Society of Artists of the United States*, Philadelphia, 1810; Dunlap, *History*, vol. I, pp. 421-22; Henderson, *op. cit.*, pp. 29-35

VANDERLYN EXPELLED: Dunlap, *History*, vol. II, pp. 276-77

TUCKERMAN ON VANDERLYN: Tuckerman, *Book*, p. 121

MORSE'S PLANS ON RETURN: Morse, *Morse*, vol. I, pp. 176-77, 183

MORSE STUDIES: *Ibid.*, pp. 221, 248

DUNLAP'S HISTORICAL PICTURES: Dunlap, *History*, vol. I, pp. 296-97, 301

PEALE'S POEM: Lester, *Artists*, pp. 217-18

"COURT OF DEATH": *Ibid.*, p. 209; *Daily Herald*, Newburyport, Mass., 10/25/1853; Neal, *Observations*, pp. 20-21

"CAPUCHIN CHAPEL": Dunlap, *History*, vol. II, pp. 134-35; Mabee, *Morse*, pp. 83-84; Ripert, Emile, *François-Marius Granet*, Paris, n.d., pp. 71-73

CHAPTER TWELVE

ALLSTON DESCRIBES "BELSHAZZAR": Irving, *Spanish*, (Allston), pp. 146-47

"BELSHAZZAR" ALMOST FINISHED: Flagg, *Allston*, p. 144

"OTRANTO": *Ibid.*, pp. 209-10

BARN: *Ibid.*, pp. 347-48

JAMESON: Jameson, *Studies*, (Allston), p. 352

COURTSHIP: Dana, *Allston*, p. 34

MY ELEMENT: Flagg, *Allston*, p. 304

"BELSHAZZAR" FIRST VIEWED: *Ibid.*, pp. 333-34

JAMES ON ALLSTON: James, Henry, *William Wentworth Story and His Friends*, Boston, vol. I, 1904, p. 308

EMERSON ON ALLSTON: Rusk, Ralph L., editor, *Letters of Ralph Waldo Emerson*, New York, vol. III, 1939, p. 182

ALLSTON DREAMS RATHER THAN DOES: Flagg, *Allston*, pp. 67, 138-39

PICTURES DESTROYED: Jameson, *op. cit.*, p. 335

IDEAL PORTRAITS: Allston, *Lectures*, pp. 331-32; Peabody, *Allston*, pp. 43-55; information from Louise Hall Tharp

BLAMES FAILURE ON DEBT: Flagg, *Allston*, pp. 129, 231, 288-89

REFUSES MONEY: *Ibid.*, pp. 314-15, 349-50; Peabody, *Allston*, pp. 1-2

ARTISTS SHOULD BE REFINED: Flagg, *Allston*, p. 215

RELIGIOUS VIEWS: *Ibid.*, p. 120; Dana, Richard Henry, "Preface," Allston, *Lectures*, p. vi; Peabody, *Allston*, pp. 6-13

ATTITUDE TOWARD AMERICA: Flagg, *Allston*, pp. 230, 290, 367

FIRST IMPRESSIONS: Dunlap, *History*, vol. II, pp. 158-59

STORY ON ALLSTON: James, *op. cit.*, pp. 297-98

BOSTON HISTORIAN ON ALLSTON: Dexter, Arthur, "The Fine Arts in Boston," *Memorial History of Boston*, Boston, vol. IV, 1883, pp. 392-97

LOWELL QUOTATION: Dana, *Allston*, p. 46

CHAPTER THIRTEEN

ATHENAEUM EXHIBITION: Swan, *Athenaeum*, p. 31

LESLIE ON MODES OF PAINTING: Dunlap, *History*, vol. II, pp. 301-02; Flagg, *Allston*, p. 168; Leslie, *Autobiography*, pp. xlviii, 40

LESLIE'S GENTILITY: Taylor, Tom, "Introduction," Leslie, *Autobiography*, pp. xiv, xl-xli

IRVING ON OLD CUSTOMS: Irving, "Christmas," in *Sketch Book*

"IPSIS ANGLIS ANGLIOR": Taylor, *op. cit.*, p. xxxii

ARTISTS INFLUENCE IRVING: Irving, *Irving*, vol. I, p. 367, vol. III, pp. 55, 224

ITALIANS ONLY SUITABLE MODELS: Kip, *Vanderlyn*, p. 231

SKETCH CLUB: Cummings, *National Academy*, pp. 110-13; Durand, *Durand*, pp. 90-97

JARVIS AS HUMORIST: Jarvis, Illustrations in Paulding, James Kirke, *The Diverting History of John Bull and Brother Jonathan*, Philadelphia, 1827; Frontispiece in Huggins, J. R. D., *Hugginiana or Huggins' Fancy*, New York, 1908; Neal, *Observations*, pp. 6, 78-80

ALLSTON ON STILL LIFE: Dunlap, *History*, vol. II, p. 163

ROBERTSON QUOTATIONS: Kelby, *Notes*, pp. 35-36, 43

MONOCHROMATIC DRAWINGS: Flexner, James Thomas, "Monochromatic Drawing, a Forgotten Branch of American Art," *Magazine of Art*, vol. XXXVIII, 1945, pp. 62-65

CHAPTER FOURTEEN

POPULARITY OF PORTRAITS: Dickson, *Jarvis*, p. 86; Irving, Washington, and others, *Salmagundi*, first paper; Neal, *Observations*, p. 42

STUART AS TEACHER: Jouett, *Stuart*; Morgan, *Stuart*

VERNACULAR DENOUNCED: Flexner, *Masters*, p. 300; Neal, *Observations*, p. 43

MYSTERIOUS MARRIAGES: Dunlap, *History*, vol. II, p. 77

JARVIS vs. WEST: Dickson, *Jarvis*, p. 108

NEAL ON JARVIS: Neal, *Observations*, p. 6

HARDING'S FIRST PORTRAITS: Harding, *Sketch*, p. 18

SLOWED BY PHILADELPHIA ART: Dunlap, *History*, vol. II, p. 291

HARDING PAINTS BOONE: Van Ravensway, Charles, "A Rare Midwestern Print," *Antiques*, vol. XLIV, 1943, pp. 77, 93

HARDING ON HIS POPULARITY: Dunlap, *History*, vol. II, p. 292

HARDING'S REACTIONS TO LONDON ART: Harding, *Sketch,* pp. 47-48, 55, 75-76

REMBRANDT PEALE ON ORNAMENTS: Lester, *Artists,* p. 203

POTATO AND PEACH: Dunlap, *History,* vol. I, pp. 220-21

PRIOR ADVERTISEMENTS: Little, *Prior,* pp. 44-45

VANDERLYN ON PORTRAITURE: Vanderlyn, John, to Vanderlyn, John, Jr., 9/9/1825, ms. in New-York Historical Society

SULLY ON STUART: Dunlap, *History,* vol. II, p. 115

SULLY ON FLATTERY: Sully, *Hints,* p. 38

"QUEEN VICTORIA": Biddle and Fielding, *Sully,* pp. 52-57; Sully, *Recollections,* pp. 70-71

MORSE ON LAFAYETTE: Morse, *Morse,* vol. I, p. 272

NOSE *vs.* MOUTH: Sully, *Hints,* p. 39

CHAPTER FIFTEEN

HICKS ON MOTHER: Hicks, *Memoirs,* p. 3

ON YOUTHFUL INDISCRETIONS: *Ibid.,* pp. 35-38

ON ART: *Ibid.,* pp. 71, 149

ON PREACHING: *Ibid.,* pp. 63-65

DENOUNCES SOPHISTICATION: *Ibid.,* pp. 19-20

AUDUBON ON DAVID: Herrick, *Audubon,* vol. I, p. 175

CRITICISM IN ENGLAND: *Ibid.,* vol. I, p. 359

AUDUBON ON HIS ART: *Ibid.,* vol. I, pp. 339, 366, 369, 373, 395, 438, vol. II, p. 7

CHAPTER SIXTEEN

BEGGARS NOT CHOOSERS: Dunlap, *History,* vol. II, pp. 279-80

BRYANT QUOTATION: Bryant, William Cullen, *Funeral Oration Occasioned by the Death of Thomas Cole,* New York, 1848, p. 15

MORSE ON EUROPEAN STUDY: Cummings, *National Academy,* pp. 43-44

REPLY: *Ibid.,* pp. 45-54

ALLSTON ON MORSE AND EUROPE: Flagg, *Allston,* p. 238

MORSE ON RELIGION AND ART: Morse, *Morse,* vol. I, pp. 352, 399

MORSE ON AMERICA *vs.* EUROPE: *Ibid.,* pp. 343, 349, 395, 426-29

DEPRESSED ON RETURN: *Ibid.*, vol. II, pp. 26-27

ON ART PROPAGANDA: *Ibid.*, p. 23

VANDERLYN DENOUNCES AMERICA: Kip, *Vanderlyn*, p. 233

MORSE'S STUDIO VISITED: Morse, *Morse*, vol. II, p. 163

MORSE'S ARTISTIC EPITAPH: *Ibid.*, p. 31

FRENCH ART DENOUNCED: *Art Quarterly*, vol. XVI, 1953, pp. 34-35

LATROBE ON MYTHOLOGY: Rutledge, *Charleston*, p. 158

NUDES: Henderson, *Academy*, pp. 30-31; Neal, *Observations*, p. 33

OLD MASTERS LESS VALUABLE: Swan, *Athenaeum*, pp. 16-17

COPIES *vs.* ORIGINALS: Information from Julius Held; Lester, *Artists*, pp. 214-15; Vanderlyn, John, to Vanderlyn, Peter, 8/14/1797, ms. at New-York Historical Society

MICHAEL PAFF: Durand, *Durand*, p. 00, Huntington, Daniel, *Asher B. Durand*, New York, 1887, p. 14

NEAL ON AMERICAN ACADEMY EXHIBITION: Neal, *op. cit.*, pp. 43-45

INMAN QUOTATION: Cummings, *op. cit.*, pp. 117-18

LATROBE ON PREJUDICE: Latrobe, Henry B., *Anniversary Oration Pronounced before the Society of Artists of the United States, 1811*, n.d., pp. 4-5

MORSE ON PORTRAITURE: Cummings, *op. cit.*, p. 58

TRUMBULL DISCOVERS COLE: Dunlap, *History*, vol. II, pp. 359-60

Catalogue of Illustrations

Dates are cited only when they could be ascertained with accuracy or within a few years. If the medium is not specified, the picture was executed in oil on canvas. In stating dimensions, height is given before width. Unless otherwise indicated, photographs reproduced were received from the owners of the original pictures.

ALLSTON, WASHINGTON: *Belshazzar's Feast* (study for); 1817; oil on millboard; 25½" x 34¼"; Allston Trust; photograph, Museum of Fine Arts, Boston. PLATE 65

The Buck's Progress, No. III—Midnight Fray with a Watchman; 1796; pen and water color on paper; 9½" x 11⅝"; Mrs. Frank M. Clark; photograph, E. P. Richardson from H. W. L. Dana. PLATE 53

The Dead Man Revived by Touching the Bones of the Prophet Elijah; 1811-13; 156" x 132"; Pennsylvania Academy of the Fine Arts, Philadelphia. PLATE 57

Elijah in the Desert; 1818; 50" x 70"; Museum of Fine Arts, Boston. PLATE 58

Jeremiah Dictating His Prophecy of the Destruction of Jerusalem; 1819-20; 89¾" x 74¾"; Yale University Art Gallery. PLATE 69

Moonlit Landscape; 1819; 24″ x 35″; Museum of Fine Arts, Boston. PLATE 66

The Poor Author and the Rich Bookseller; 1809-11; 31″ x 27⅞″; Museum of Fine Arts, Boston. PLATE 55

Rosalie; 1835; 38⅛″ x 28⅝″; Society for the Preservation of New England Antiquities, Boston; photograph, Museum of Fine Arts, Boston. PLATE 68

Self-portrait; 1805; 31½″ x 26½″; Museum of Fine Arts, Boston. PLATE 67

AMERICAN SCHOOL: *Sarah Hobbs;* c.1830; oil on green fabric; 32½″ x 25¾″; James Thomas Flexner; photograph, Metropolitan Museum of Art, New York. PLATE 92

Mrs. J. B. Sheldon of Unionville, Ohio; c.1825; oil on panel; 41″ x 30½″; Edgar William and Bernice Chrysler Garbisch Collection, National Gallery of Art, Washington, D. C.; photograph, Downtown Gallery, New York. PLATE 93

Young Ladies' Seminary, Va.; 30″ x 39″; Edgar William and Bernice Chrysler Garbisch; photograph, Old Print Shop, New York. PLATE 81

Young Lady; c.1830; oil on panel; 17″ x 13⅛″; Art Institute of Chicago. PLATE 91

AMES, EZRA: *Dolly Madison;* 29″ x 24″; New-York Historical Society. PLATE 90

AUDUBON, JOHN JAMES: *Trumpeter Swan;* water color on paper; 23″ x 37¾″; New-York Historical Society. PLATE 102

BIRCH, THOMAS: *Penn's Treaty Tree;* c.1800; 39″ x 50″; Historical Society of Pennsylvania, Philadelphia; photograph, Detroit Institute of Arts. PLATE 74

BLUNT, J. S.: *Topsail Schooner in Sheltered Waters;* oil on panel; 16″ x 22″; Donald T. Hood; photograph, Nina Fletcher Little. PLATE 75

CHANDLER, WINTHROP: *Dr. William Glysson;* c.1780; 56" x 48"; Campus Martius Memorial Museum, Columbus, Ohio; photograph, Ohio State University. PLATE 23

Overmantel, View of a City; oil on panel; 27" x 45"; Irwin P. Dorward, Petersham, Mass.; photograph, Nina Fletcher Little. PLATE 24

COPLEY, JOHN SINGLETON: *The Death of Chatham;* 1779-80; 89" x 120"; Tate Gallery, London. PLATE 13

Mary Elizabeth Martin; 1771; 45½" x 40"; Addison Gallery of American Art, Phillips Academy, Andover, Mass. PLATE 17

The Three Princesses; c.1785; 20½" x 15½"; Mrs. Robert Treat Paine III; photograph, Frick Art Reference Library. PLATE 18

Watson and the Shark; 1778; 72⅛" x 90¼"; National Gallery of Art, Washington, D. C. PLATE 14

DAVIS, JOSEPH H.: *The Tilton Family;* 1837; water color on paper; 15" x 19"; Colonial Williamsburg, Williamsburg, Va. PLATE 94

DOUGLASS, LUCY: *The Royal Psalmist;* c.1810; water color on paper; 17¾" x 25½"; Edith G. Halpert, Downtown Gallery, New York. PLATE 82

EARL, RALPH: *Daniel Boardman;* 1789; 81⅞" x 55⅜"; National Gallery of Art, Washington, D. C., gift of Mrs. W. Murray Crane. PLATE 25

British Troops at Concord; 1775; 29½" x 38½"; Concord Antiquarian Society; photograph, Frick Art Reference Library. PLATE 8

Roger Sherman; c.1775-77; 64⅞" x 49¾"; Yale University Art Gallery. PLATE 6

Lady Williams and Child; 1783; 50¼" x 39¾"; Metropolitan Museum of Art, New York. PLATE 21

FEKE, ROBERT: *William Bowdoin;* 1748; 50½" x 40"; Bowdoin College Museum of Fine Arts; Brunswick, Me. PLATE 31

FURNESS, JOHN MASON: *John Vinal;* c.1780-90; 50" x 45⅝"; Brooklyn Museum, Brooklyn, N. Y. PLATE 22

GROOMBRIDGE, WILLIAM: *English Landscape;* 1811; 36½" x 49½"; Maryland Historical Society, Baltimore; photograph, Frick Art Reference Library. PLATE 50

GUY, FRANCIS: *Bolton* (front view); c.1805; 24" x 34"; Clapham Murray, Jr., and William H. Murray; photograph, Frick Art Reference Library. PLATE 51

> *Winter Scene in Brooklyn;* 1816-17; 58¾" x 75"; Brooklyn Museum, Brooklyn, N. Y. PLATE 52

HARDING, CHESTER: *Samuel Cartmill Christy;* 1821; 29" x 23¼"; Mrs. Howard Benoist; photograph and information, Wilbur D. Peat. PLATE 89

HICKS, EDWARD: *Peaceable Kingdom;* 17½" x 23⅜"; Worcester Art Museum, Worcester, Mass. PLATE 100

> *Penn's Treaty with the Indians;* 17¾" x 23¾"; Robert W. Carle; photograph, Frick Art Reference Library. PLATE 101

JARVIS, JOHN WESLEY: *William Samuel Johnson;* 1814; 33½" x 26½"; Columbia University, New York; photograph, Frick Art Reference Library. PLATE 88

JESSUP, JARED (attributed to): *Overmantel, Burk Tavern, Bernardston, Mass.;* c.1813; oil on panel; 32" x 66"; Pocumtuck Valley Memorial Association, Deerfield, Mass.; photograph, Nina Fletcher Little. PLATE 48

JOUETT, MATTHEW HARRIS: *Edward Shippen;* c.1830's; oil on panel; 30" x 24½"; E. Shippen Willing; photograph, Frick Art Reference Library. PLATE 87

KEMMELMEYER, FREDERICK: *General George Washington Reviewing the Western Army at Fort Cumberland;* 1794; 18" x 23";

Hall Park McCullough; photograph, Bland Gallery, New York. PLATE 44

KRIMMEL, JOHN LEWIS: *A Country Wedding;* c.1814; 16″ x 22″; Pennsylvania Academy of the Fine Arts, Philadelphia. PLATE 79

LESLIE, CHARLES R.: *Actors' Duel: Mr. Jefferson and Mr. Blissett;* 1811; wash on paper; 4¾″ x 6⅜″; New York Public Library. PLATE 61

The Murder of Rutland; 1815; 96″ x 80″; Pennsylvania Academy of the Fine Arts, Philadelphia. PLATE 63

Sophia Western; 24″ x 17″; Pennsylvania Academy of the Fine Arts, Philadelphia. PLATE 76

MORSE, SAMUEL F. B.: *The Artist's Family;* 1823; 43¾″ x 34¼″; Mrs. Mabel Morse; photograph, Metropolitan Museum of Art, New York. PLATE 98

The Dying Hercules; 1813; 96¼″ x 78¼″; Yale University Art Gallery. PLATE 64

The Morse Family; c.1810; water color on paper; 19″ x 23″; Smithsonian Institution, Washington, D. C. PLATE 62

View from Apple Hill; c.1828-29; 22⅜″ x 29½″; Stephen C. Clark; photograph, Metropolitan Museum of Art, New York. PLATE 70

MOULTHROP, REUBEN: *Reverend Ammi Ruhamah Robbins;* 59⅛″ x 59⅛″; Yale University Art Gallery. PLATE 28

NEAGLE, JOHN: *Pat Lyon at His Forge;* 1826-27; 93¾″ x 80″; Boston Athenaeum; photograph, Museum of Fine Arts, Boston. PLATE 78

NEWTON, GILBERT STUART: *The Dull Lecture;* 25″ x 30″; owner unknown; photograph, Frick Art Reference Library. PLATE 77

PAUL, JEREMIAH: *Children at Play;* 1795; 38″ x 49″; Kennedy Galleries, Inc., New York. PLATE 45

PEALE, CHARLES WILLSON: *The Exhuming of the Mastodon;* 1806-08; 60″ x 72″; Municipal Museum, Baltimore; photograph, Metropolitan Museum of Art, New York. PLATE 43

Governor Thomas Johnson and Family; 1772; 48″ x 58½″; C. Burr Artz Library, Frederick, Md.; photograph, Frick Art Reference Library. PLATE 4

James Peale; 1822; 27″ x 36″; Detroit Institute. PLATE 42

Rachel Weeping; 1772; 37½″ x 32¼″; Charles Coleman Sellers; photograph, Museum of Fine Arts, Boston. PLATE 5

Benjamin Rush; 1783; 50¼″ x 40″; Henry Francis du Pont Winterthur Museum, Delaware; photograph, Frick Art Reference Library. PLATE 27

PEALE, JAMES: *James Peale and His Family;* 1795; 31″ x 33″; Pennsylvania Academy of the Fine Arts, Philadelphia. PLATE 29

Still Life; oil on panel; 18½″ x 26½″; Worcester Art Museum, Worcester, Mass. PLATE 47

PEALE, RAPHAELLE: *Still Life;* 1818; 10¼″ x 13¾″; Detroit Institute of Arts. PLATE 46

PENNSYLVANIA DUTCH ARTIST: *Crucifixion;* 1800; water color on paper; 13½″ x 10½″; Metropolitan Museum of Art, New York. PLATE 99

PINNEY, EUNICE: *Two Women;* c.1810; water color on paper; 11″ x 14¾″; New York State Historical Association, Cooperstown, N. Y. PLATE 84

POLK, CHARLES PEALE: *Mrs. Isaac Hite and James Madison Hite, Jr.;* c.1799; 60″ x 40¾″; Maryland Historical Society, Baltimore; photograph, Frick Art Reference Library. PLATE 30

PRATT, MATTHEW: *Cadwallader Colden and Warren de Lancey;* c.1774-75; 50″ x 40″; Peter de Lancey Swords; photograph, Frick Art Reference Library. PLATE 7

ROBERTSON, ARCHIBALD (attributed to): *The Collect or Fresh Water Pond;* 1798; water color on paper; 17″ x 22″; Edward W. C. Arnold Collection, Metropolitan Museum of Art, New York; photograph, Museum of the City of New York. PLATE 49

SARGENT, HENRY: *The Tea Party;* early 1820's; 64¼″ x 52½″; Museum of Fine Arts, Boston. PLATE 85

SHAW, JOSHUA: *The Deluge; c.* 1813; 48″ x 65¾″; Metropolitan Museum of Art. PLATE 72

STEWARD, JOSEPH: *John Phillips;* 1793; 79½″ x 68½″; Dartmouth College, Hanover, N. H. PLATE 26

STUART, GILBERT: *Nathaniel Bowditch;* 1827; 29½″ x 24½″; James H. Bowditch; photograph, Museum of Fine Arts, Boston, PLATE 37

*William Ellery Channing; c.*1825; 29½″ x 24½″; Mrs. John A. Jeffries; photograph, Museum of Fine Arts, Boston. PLATE 86

*Horatio Gates; c.*1794; 44¼″ x 35⅞″; Mrs. Charles A. Pfeffer; photograph, Metropolitan Museum of Art, New York. PLATE 32

*Francis and Saunders Malbone; c.*1770-72; 35″ x 43″; Francis Malbone Blodget; photograph, Frick Art Reference Library. PLATE 10

Mrs. George Plumsteaд; 1800; 29″ x 24″; Pennsylvania Academy of the Fine Arts, Philadelphia. PLATE 33

Sir Joshua Reynolds; 1784; 36″ x 30″; Mellon Collection, National Gallery of Art, Washington, D. C. PLATE 19

George Washington (Athenaeum Portrait); 1796; 42″ x 34½″; Boston Athenaeum; photograph, Museum of Fine Arts, Boston. PLATE 36

George Washington (Lansdowne Portrait); *c.*1796; 90″ x 60″; Pennsylvania Academy of the Fine Arts, Philadelphia. PLATE 35

George Washington (Vaughan Portrait); 1795; 29″ x 23¼″;

Mellon Collection, National Gallery of Art, Washington, D. C. PLATE 34

SULLY, THOMAS: *Fanny Kemble as Beatrice;* 1833; 30" x 25"; Pennsylvania Academy of the Fine Arts, Philadelphia. PLATE 93

Lady with a Harp: Eliza Ridgely; 1818; 84⅜" x 56⅛"; National Gallery of Art, Washington, D. C., gift of Maude Monell Vetlesen. PLATE 97

TRUMBULL, JOHN: *The Battle of Princeton* (preliminary composition); 1786-87; 25¼" x 36⅜"; Yale University Art Gallery. PLATE 39

The Battle of Princeton; begun 1787; 20⅛" x 29⅛"; Yale University Art Gallery. PLATE 40

Robert Benson; 1804; 30¾" x 24½"; New-York Historical Society. PLATE 41

The Death of General Montgomery at Quebec; 1786; 24⅝" x 37"; Yale University Art Gallery. PLATE 15

The Declaration of Independence; 1786-90; 20" x 30"; Yale University Art Gallery. PLATE 38

Sir John Temple; c.1784; 49½" x 38"; Canajoharie Library and Art Gallery, Canajoharie, N. Y.; photograph from Macbeth Gallery. PLATE 20

The Jonathan Trumbull Family; 1777; 38" x 48"; Yale University Art Gallery. PLATE 9

VANDERLYN, JOHN: *Ariadne;* 1814; 69" x 88"; Pennsylvania Academy of the Fine Arts, Philadelphia. PLATE 60

The Death of Jane McCrea; 1803; 32½" x 26½"; Wadsworth Atheneum, Hartford, Conn. PLATE 59

Niagara; 1827?; 54¼" x 90½"; State House Association, Kingston, N. Y.; photograph, Metropolitan Museum of Art, New York. PLATE 71

Mrs. Marinus Willett and Child; 36⅝" x 28⅛"; Metropolitan Museum of Art, New York. PLATE 95

WALL, WILLIAM G.: *View Near Fort Montgomery;* water color on paper; 14" x 21"; New-York Historical Society. PLATE 75

WEST, BENJAMIN: *Agrippina with the Ashes of Germanicus;* 1768; 64½" x 94½"; Yale University Art Gallery. PLATE 2; detail, PLATE 3

Christ Rejected; c.1815; 81" x 164"; Pennsylvania Academy of the Fine Arts, Philadelphia. PLATE 56

Death on a Pale Horse; 1802; 21" x 36"; Pennsylvania Museum of Art, Philadelphia. PLATE 54

Death of Socrates (detail); c.1796; 34" x 41"; Mrs. Thomas H. A. Stites; photograph, Frick Art Reference Library. PLATE 1

The Death of Wolfe; 1770, 60½" x 84"; National Gallery of Canada; photograph, Pennsylvania Museum of Art, Philadelphia. PLATE 11

Colonel Guy Johnson; c.1775-1800; 79¼" x 54½"; Mellon Collection, National Gallery of Art, Washington, D. C. FRONTISPIECE

Penn's Treaty with the Indians; c.1771; 75½" x 108¾"; Pennsylvania Academy of the Fine Arts, Philadelphia. PLATE 12

Woodcutters in Windsor Great Park; 1795; 28" x 36"; John Herron Art Institute, Indianapolis, Ind. PLATE 16

WHITCOMB, SUSAN: *Mount Vernon;* 1842; water color; 17½" x 21¼"; Colonial Williamsburg, Williamsburg, Va. PLATE 83

WOODSIDE, J. A.: *Country Fair;* 1824; 20" x 26"; the late Harry T. Peters; photograph, Metropolitan Museum of Art, New York. PLATE 80

Index

Index